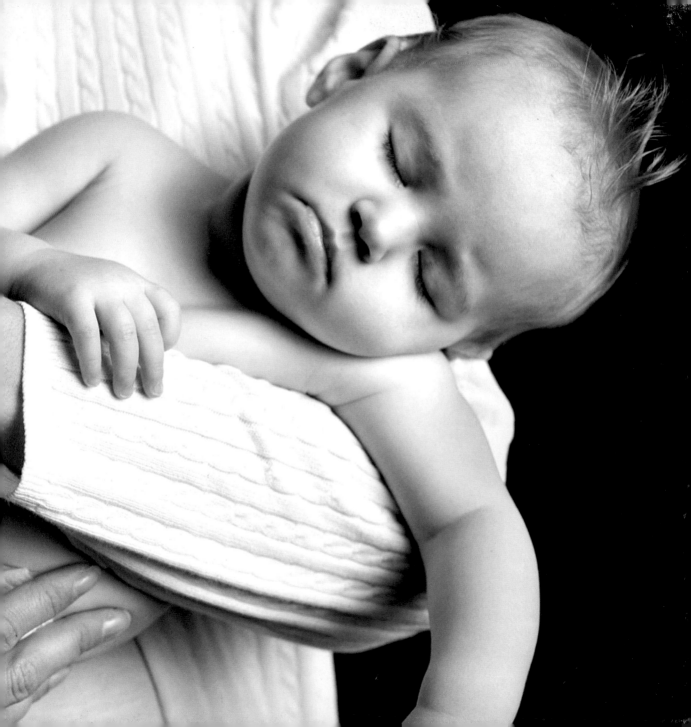

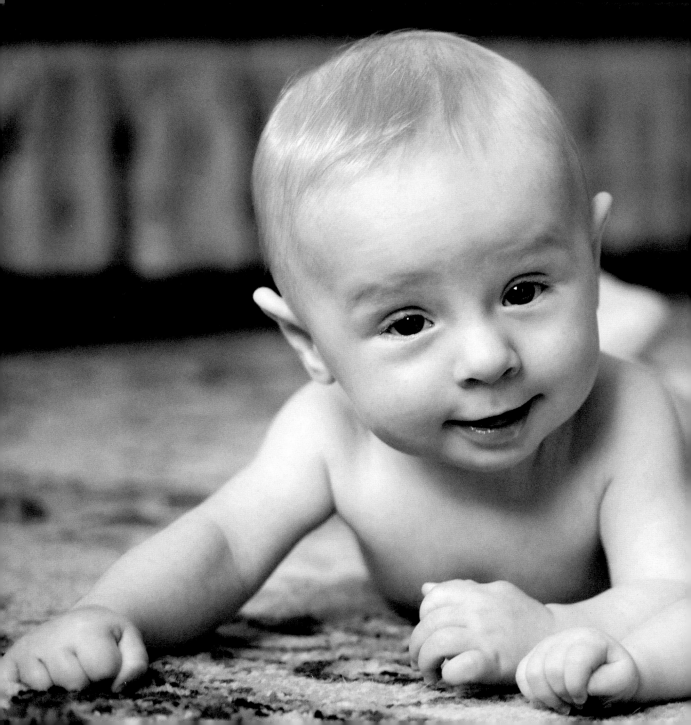

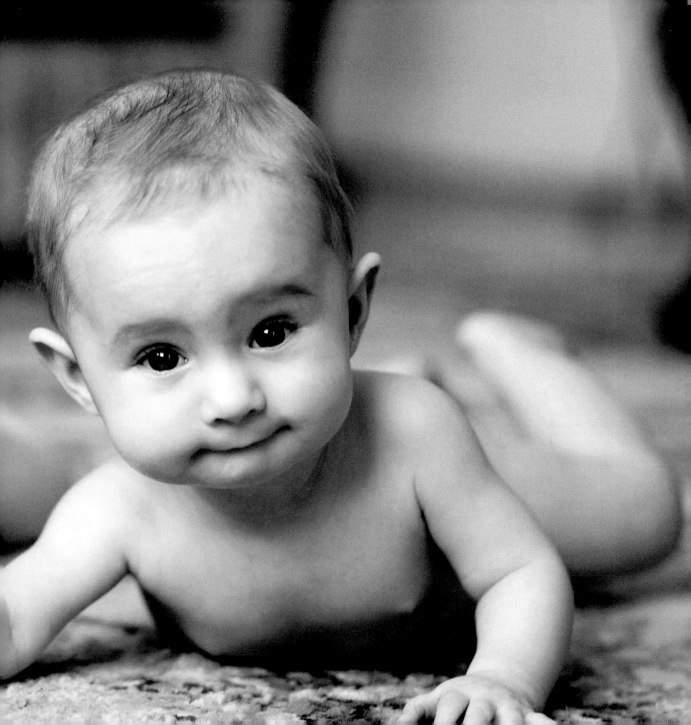

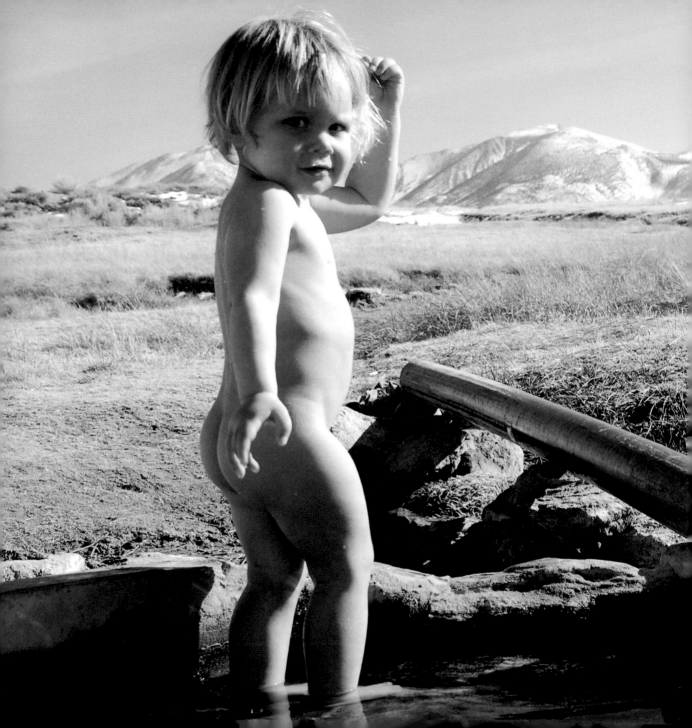

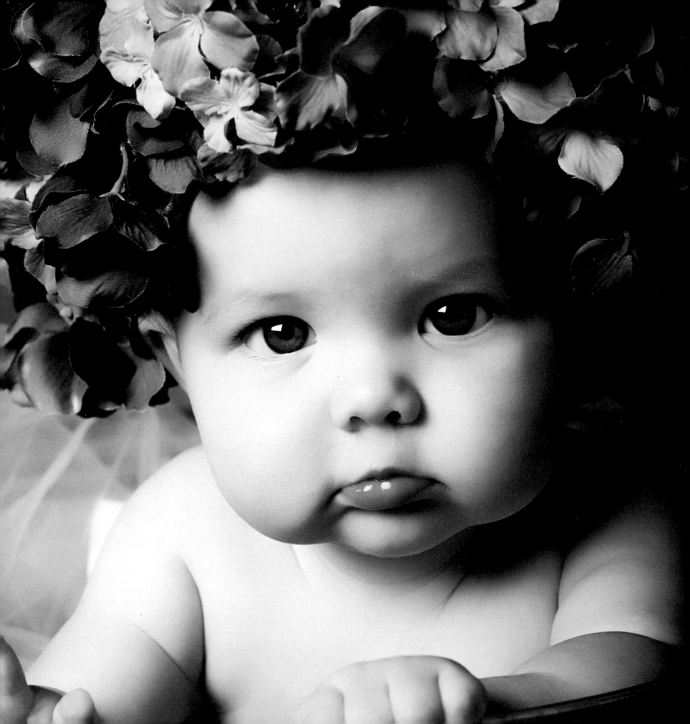

THE BIG BOOK
OF
BABIES

EDITED BY J.C. SUARÈS

WELCOME
BOOKS

NEW YORK • SAN FRANCISCO

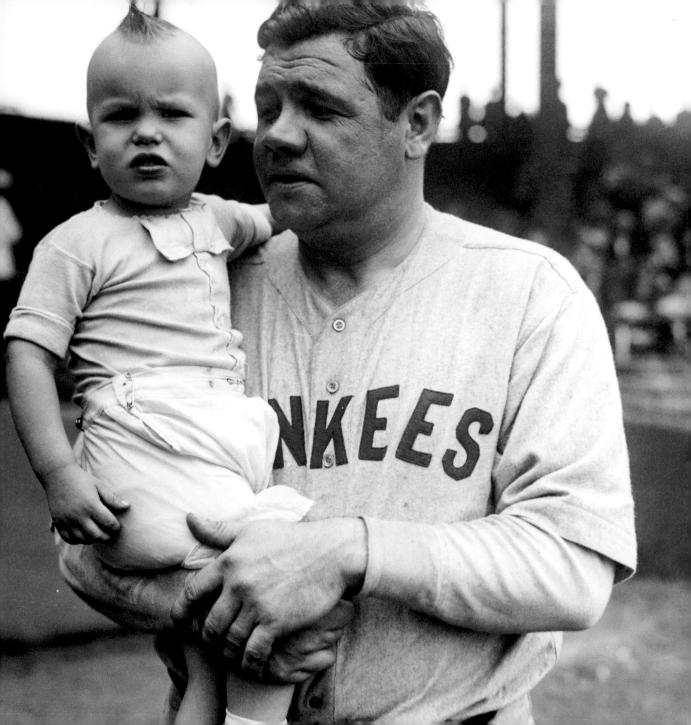

AS A BABY IN ALEXANDRIA, EGYPT, I went to sleep every night listening to the Arab music coming from the coffee house across the street. It stayed with me for years. When Egyptian taxi drivers in New York ask me if I mind the Arab music, to their great surprise, I give them a list of my favorite singers, starting with the legendary Om Kalsoom. My first words as a toddler were German, French, and Arabic. My parents spoke French to each other. My mother spoke only German to me. And Hanem, my beloved nanny, only spoke Arabic. I had blond hair until I was four years old.

I was born in the Jewish hospital in Alexandria three months before the first battle of El Alamein, sixty-six miles away. There, on July 1st, 1942, Erwin Rommel's Afrika Korps, determined to take the Suez Canal to the east of us and thereby cripple the Allies' supply lines, was stopped by the tanks, land mines, guns, airplanes, and infantry of the British Empire. The second battle took place a few months later, from October 23 to November 6, when

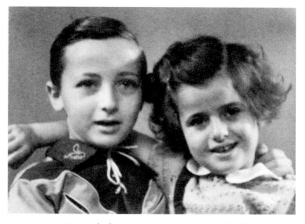

J.C. with his sister, Josee, c. 1950

Churchill's appointee, General Bernard Montgomery—with the help of a thousand guns and 300 American tanks and troops from Australia, New Zealand, and Britain—chased the Germans out of Egypt for good.

My mother was no stranger to the Nazis. Her family had been jailed for several weeks in Germany in 1933 on trumped-up tax accusations. Soon after, she abandoned everything she had and everyone she knew for Italy and then Egypt. Now, once again, she had to run, this time with a newborn son. Her plan was simple. She and my father would each take a suitcase and head with me in tow as far south as they would have to go to evade the Germans. Cairo first, then Khartoum in Sudan, and further south if necessary, as far as Nyasaland (now Malawi) where my mother's brother was living as a game warden in a hut in the middle of nowhere.

But there were complications. They were stateless. No passports, no papers of any kind except for birth certificates. And although not born prematurely, I was dangerously small. The hospital report says that I weighed just over a kilo and a half, less than four pounds. In fact, the doctor who delivered me had made it clear that I didn't stand much of a chance.

The trains became more and more rickety as we headed south, and the summer heat surely must have been unbearable. As medical supplies and food became more precious, my parents decided to stop in a small pension in a remote desert village south of Cairo. There we waited until the Germans were chased out of the country. We returned to Alexandria in December. Miraculously, I survived. I weighed more and was healthy. But growing up, I remained the smallest kid in my classes.

— J.C. Suarès

I don't remember who said this, but there really are places in the heart you don't even know exist until you love a child.

—ANN LAMONT

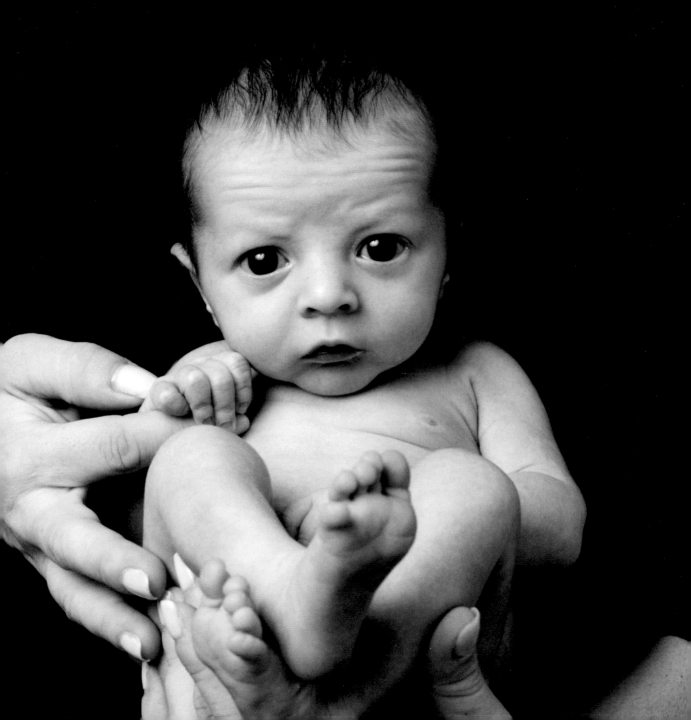

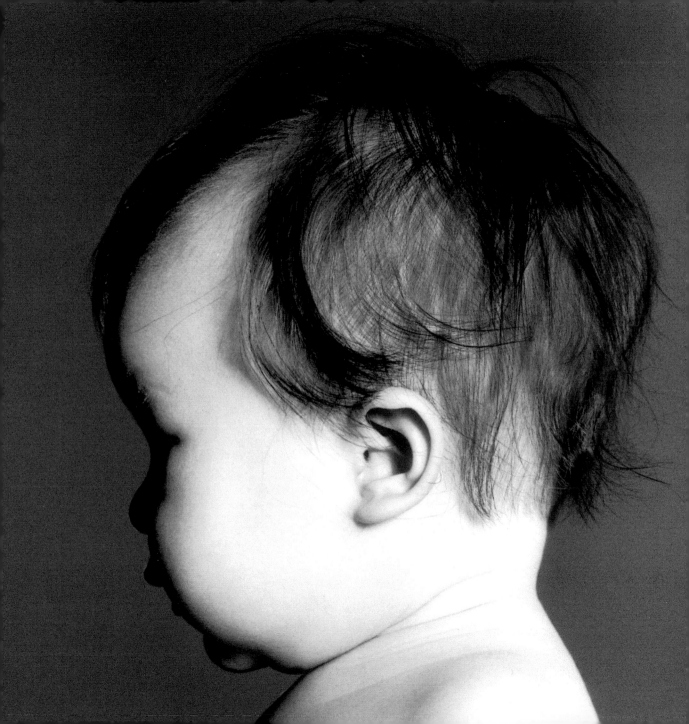

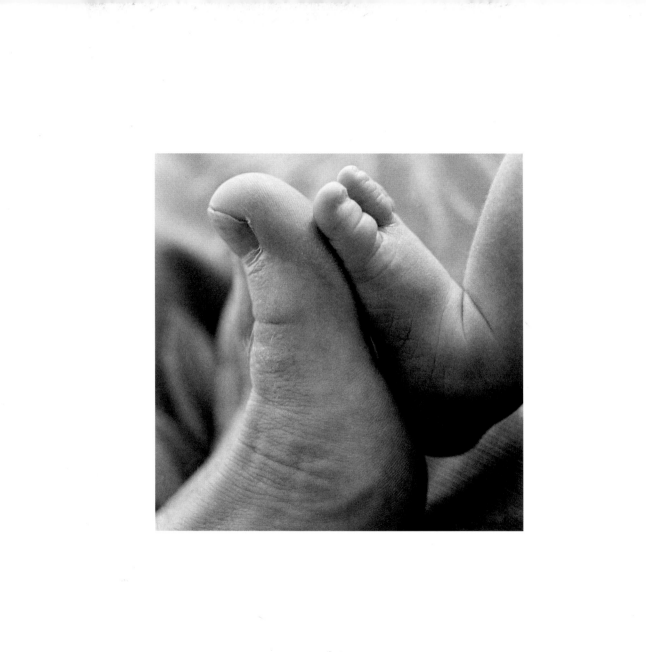

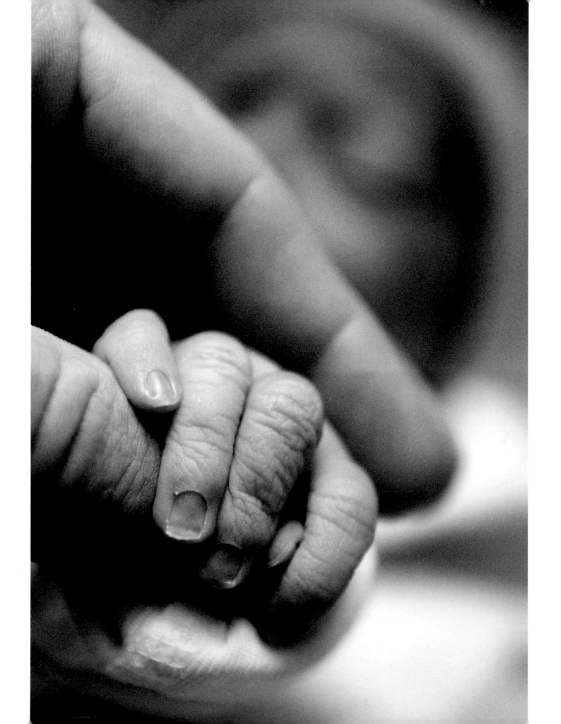

She was born that I might give her a first foot in this world and might help her want to live in it. She is here through me, and I am responsible for her.

—LAURIE LEE

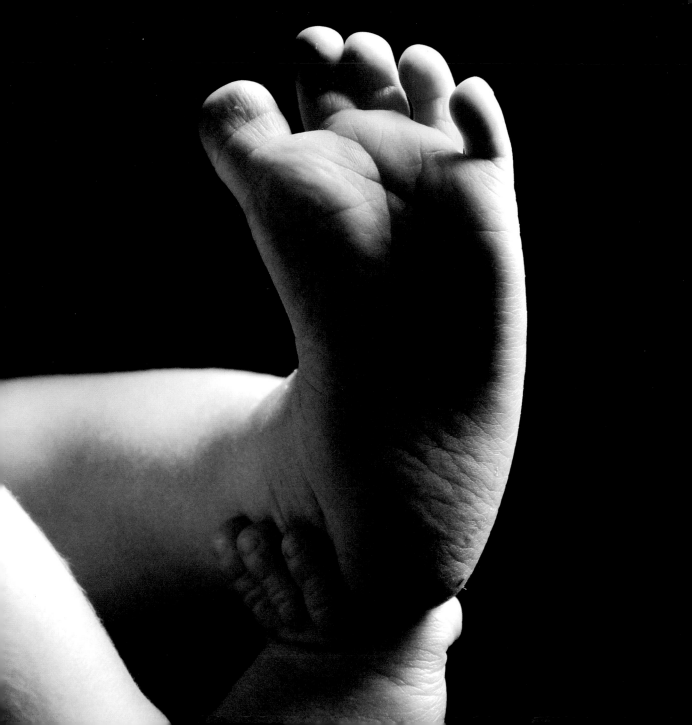

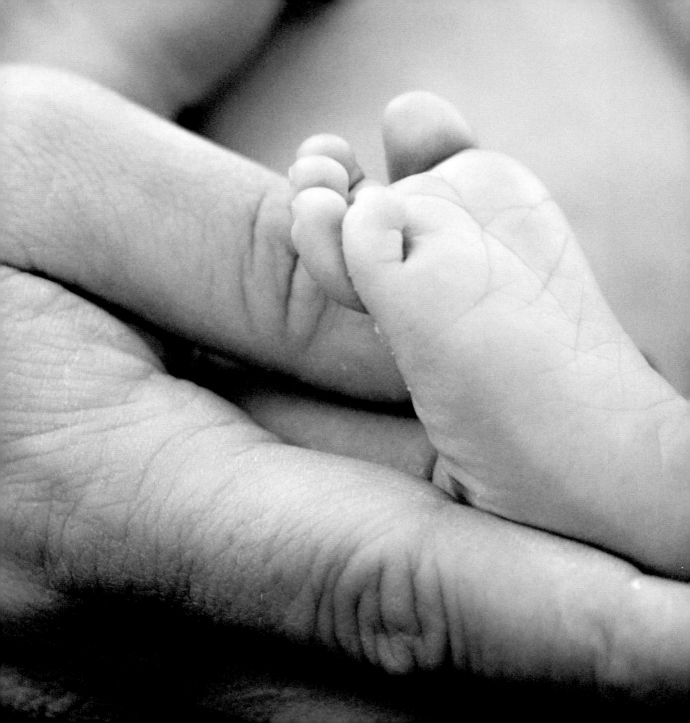

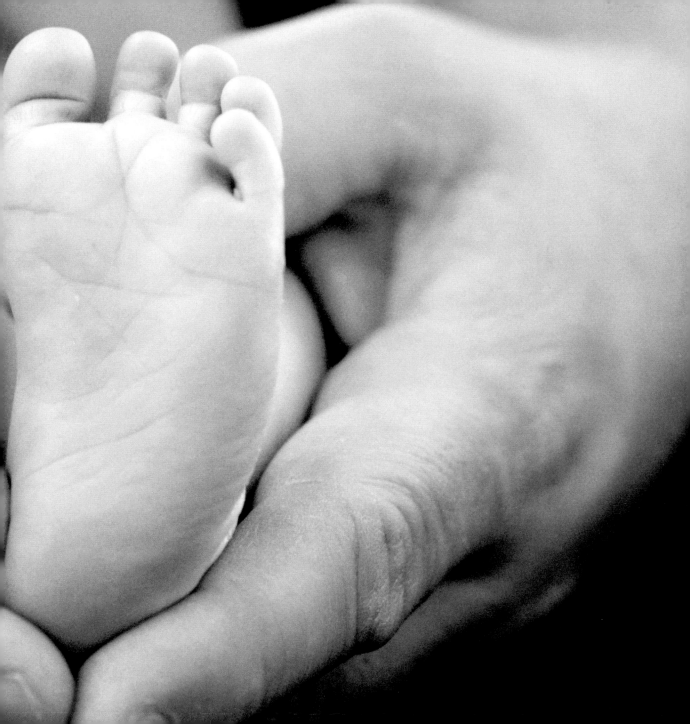

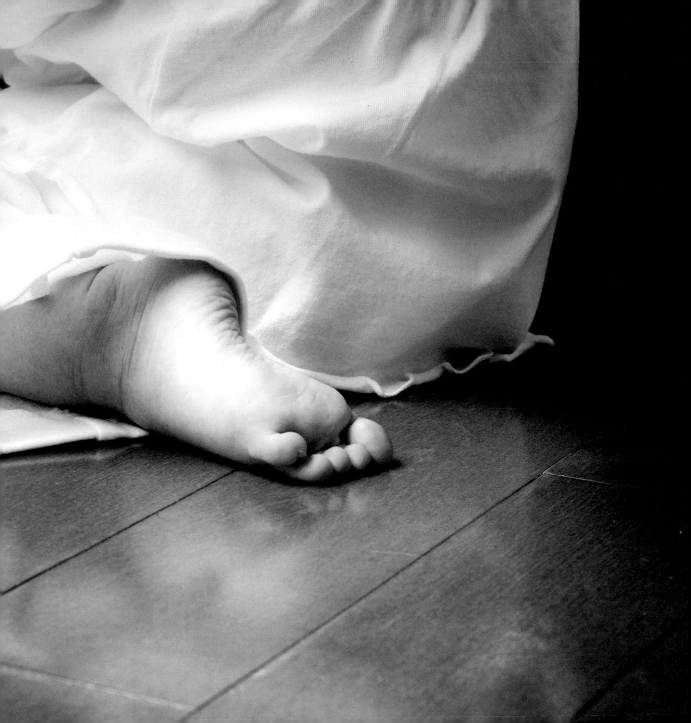

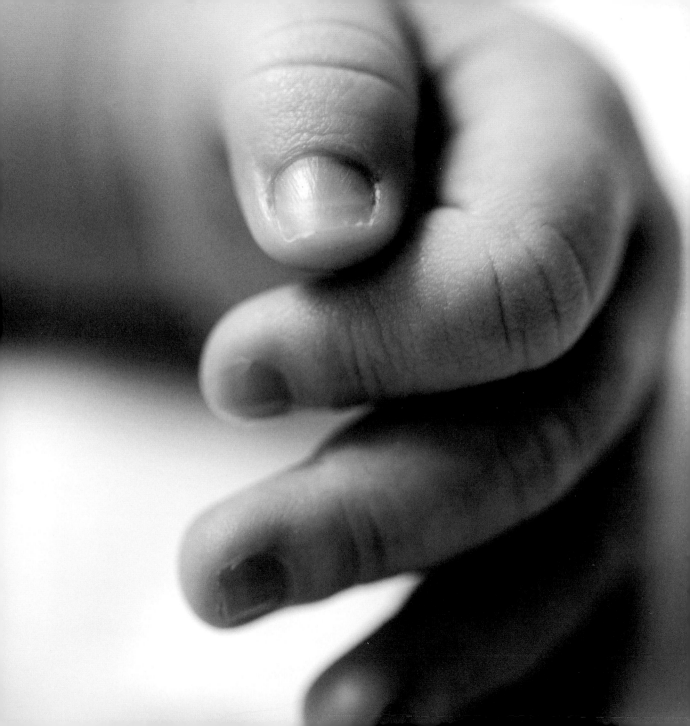

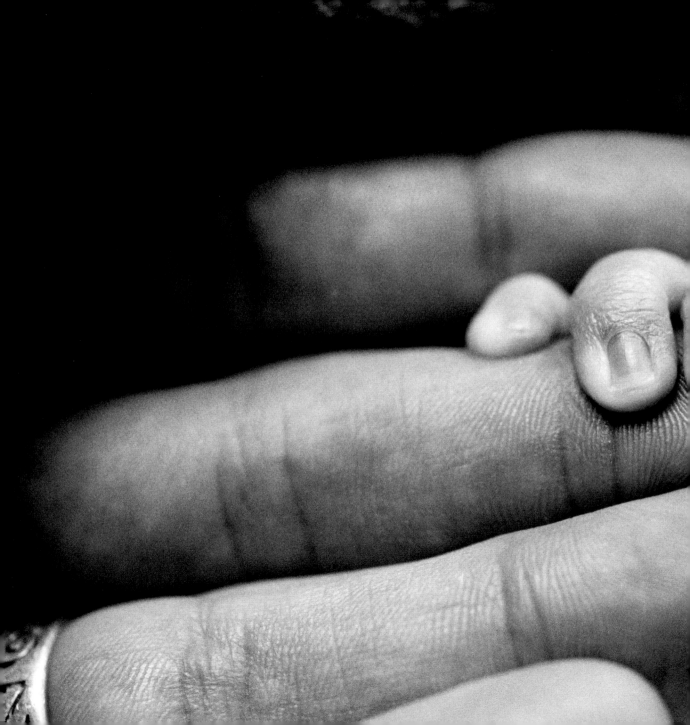

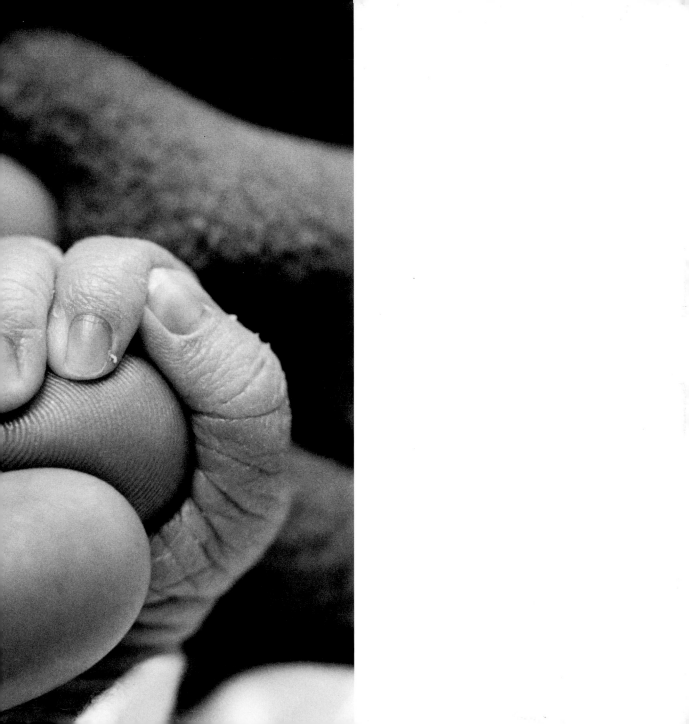

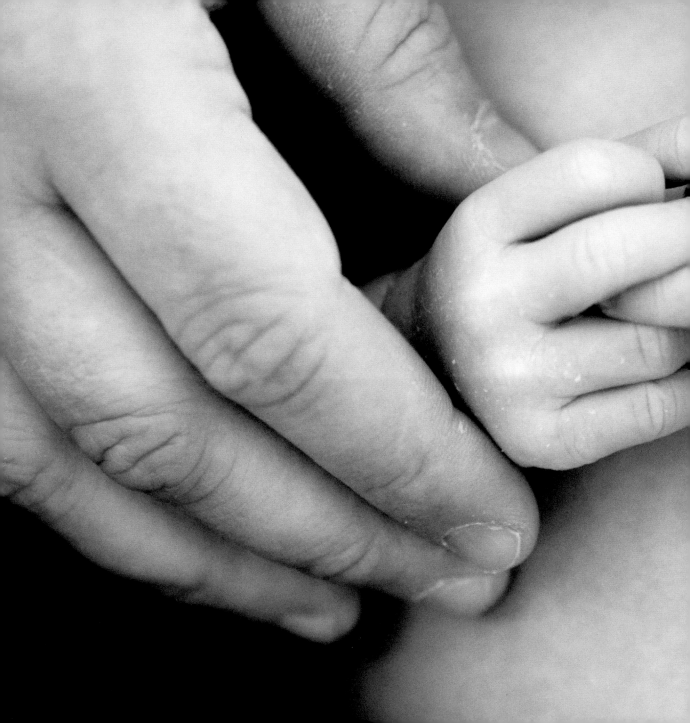

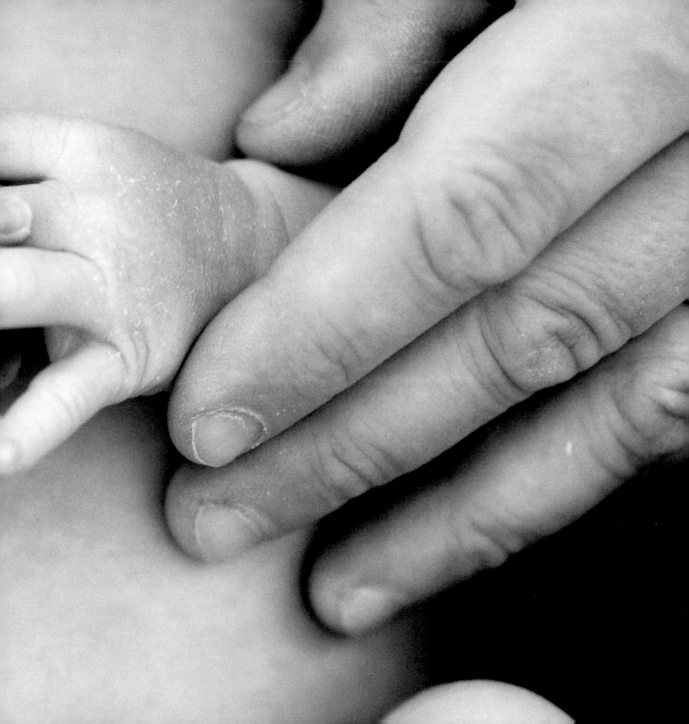

"What's miraculous about a spider's web?"
said Mrs. Arable. "I don't see why you say
a web is a miracle—it's just a web."
"Ever try to spin one?"

—E. B. WHITE

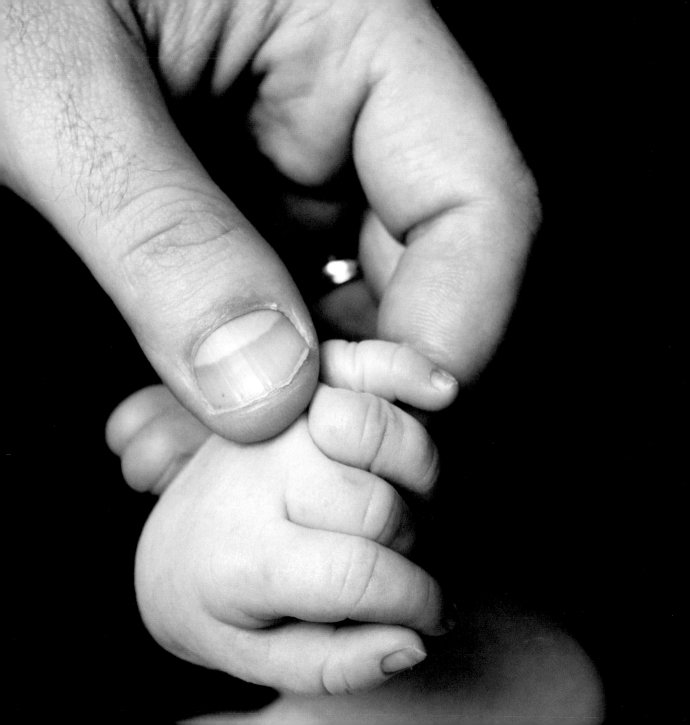

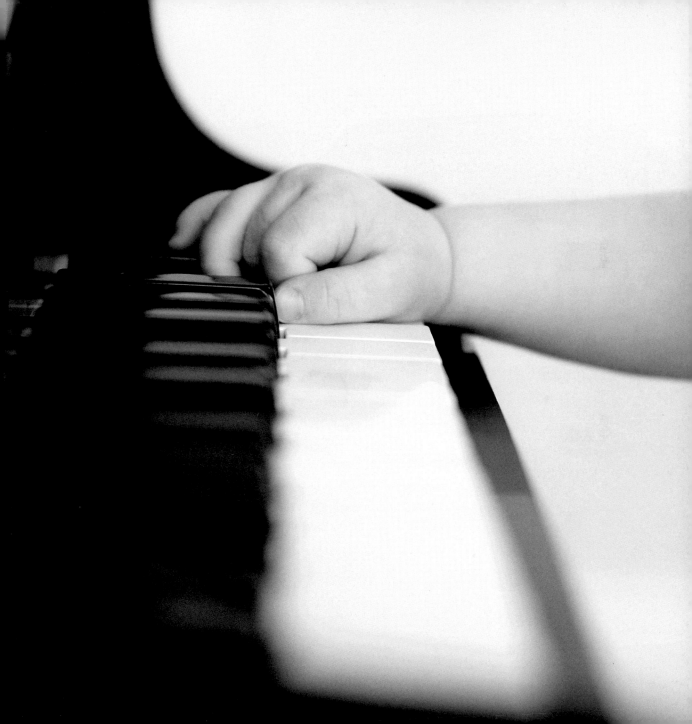

LETTER FOR LUKE

I know this will sound crazy: I totally did not expect you. I realize I had the whole pregnancy to expect you. Maybe I did not really believe you were coming. There were about twenty storage boxes in your room when you were born. I worked almost until the day you arrived. And, I didn't take your dad to the hospital for the "the tour" until two days before your due date. When we got there for the tour, everyone just looked at us like we were crazy.

On April 4, I went into labor at 5:25 A.M. I made your aunt take statistics all day, because that is what I know how to do. When we got to the hospital that night at midnight, I figured, "Even though this is painful, it isn't time YET. I'll probably go home. This is probably false labor." They looked at me in triage, and told me I was going to the delivery room. You arrived at 5:09 P.M. after twenty minutes of pushing.

You were wonderful, handsome, charming, and beautiful. I laughed. Your father cried. Your aunt passed out. And I just laughed. After much patience, years of waiting for you, years of relationships, years of working on my other life (the life before you), you got here. You actually got here, and changed everything.

—TERESA SANTAMARIA
Information Technology Systems Analyst

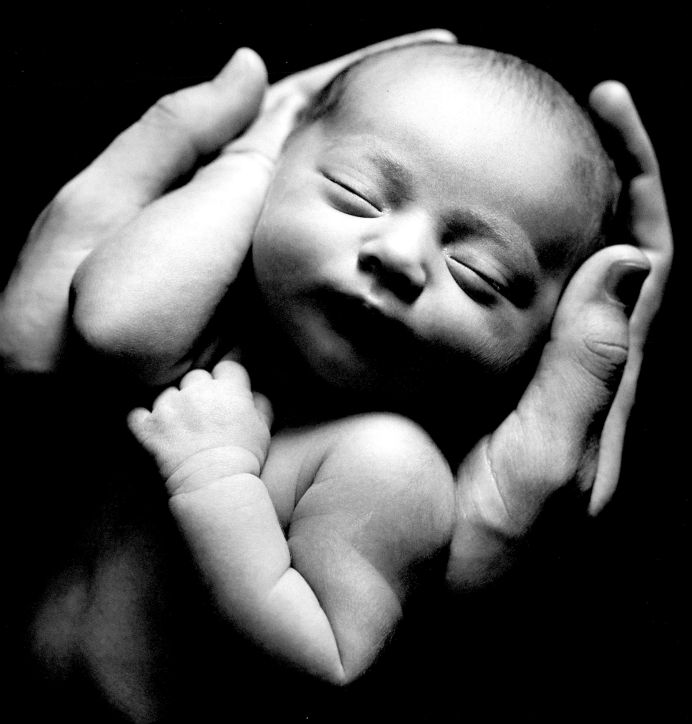

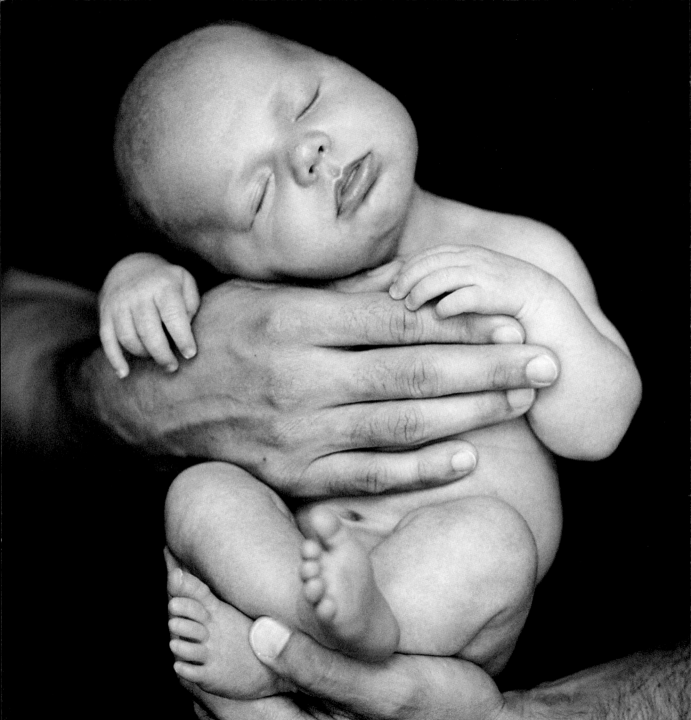

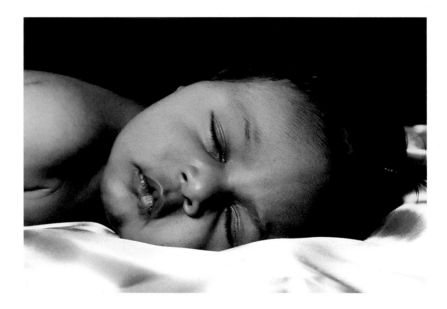

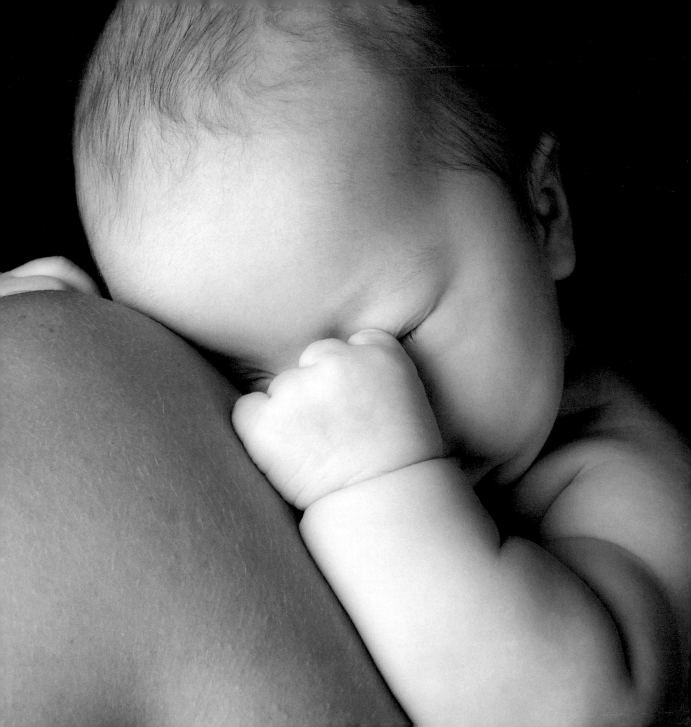

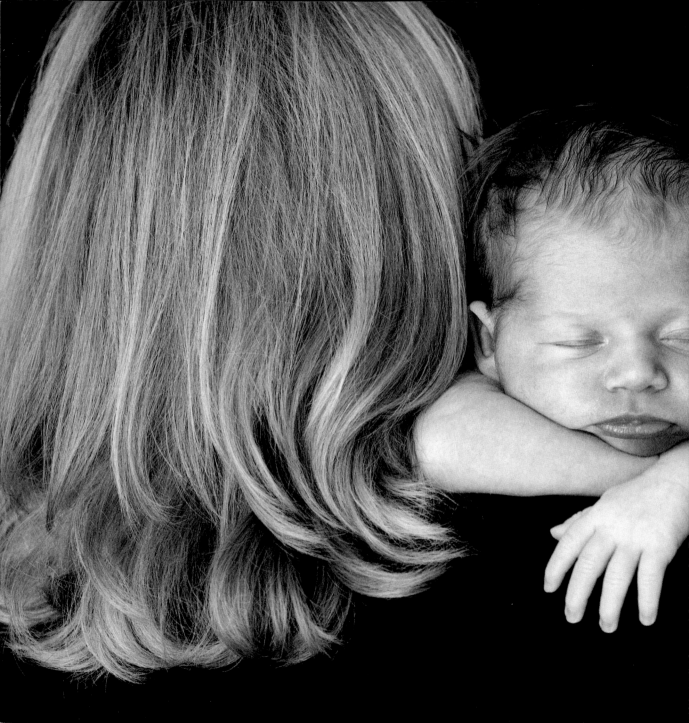

Love me—I love you,

Love me, my baby;

Sing it high, sing it low,

Sing it as may be.

Mother's arms under you;

Her eyes above you;

Sing it high, sing it low.

Love me—I love you.

—CHRISTINA ROSSETTI

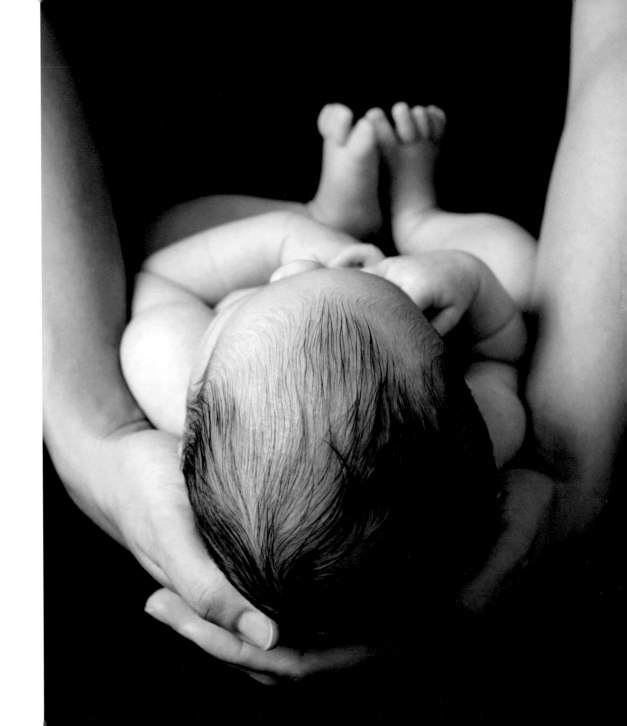

FEAR FACTOR

After my daughter was born, a friend and co-worker of mine sent the following message around to my teammates and clients via e-mail. I think it speaks for itself:

<<Great news! Sean and Karin George welcomed a baby daughter Isabella yesterday and all are well. In Sean's words, "I have snowboarded down Everest, swam in open water with great whites, and sky-dived from the outer atmosphere with nothing more than an open bed sheet. Yet, I was never so scared as the moment I first held my newborn!!!">>

—SEAN GEORGE
Credit Trader

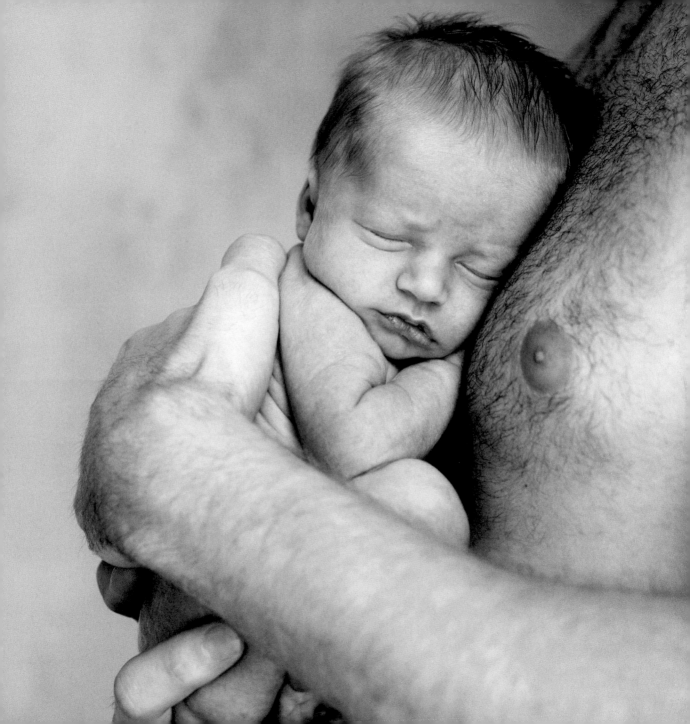

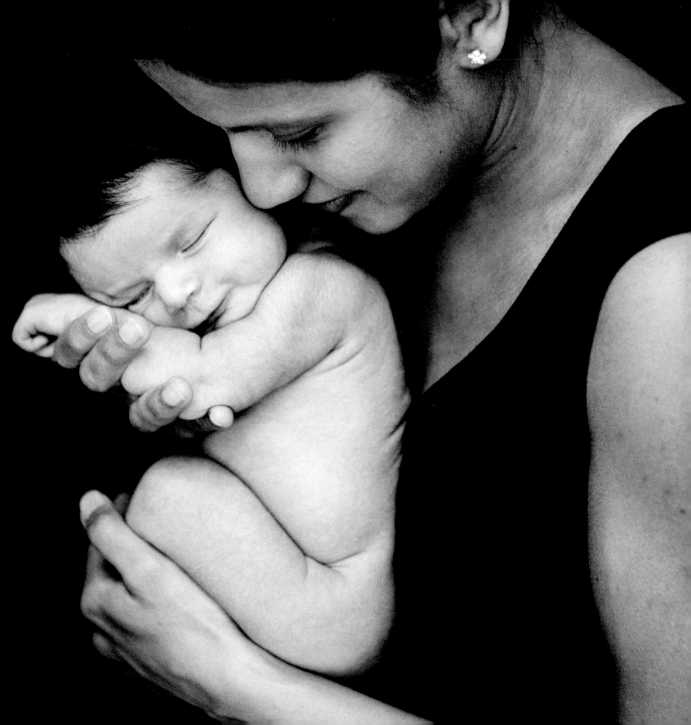

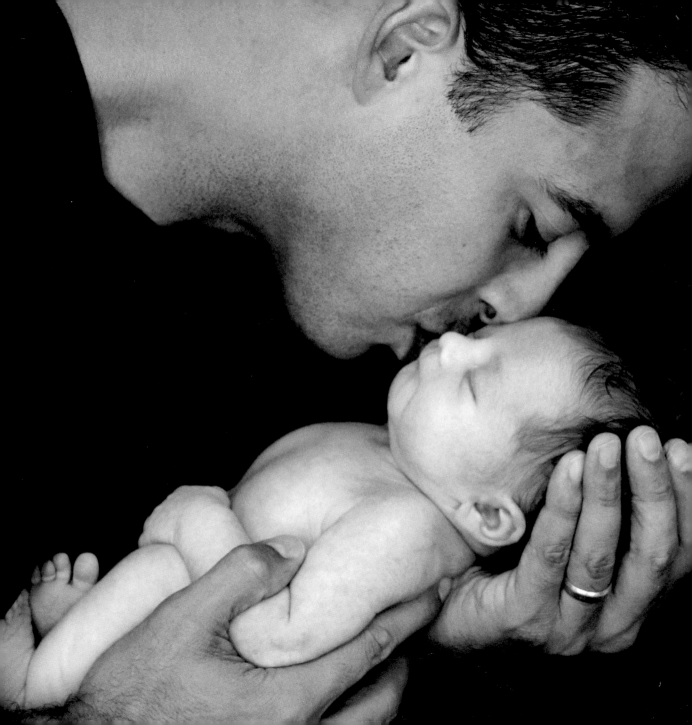

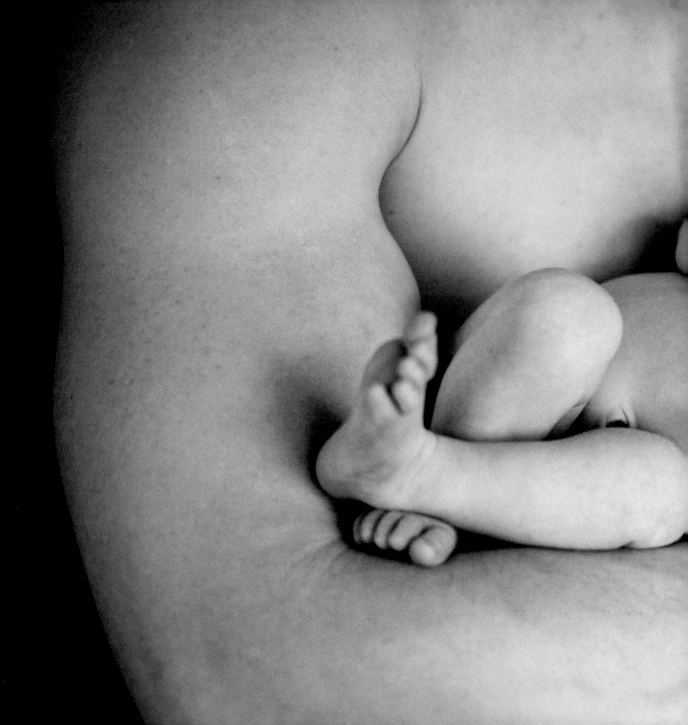

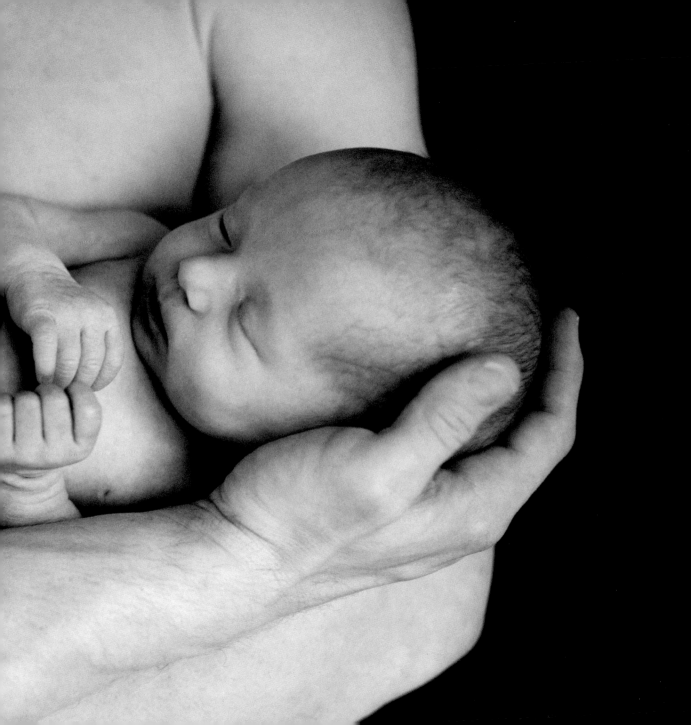

There never was a child so lovely
but his mother was glad to get him asleep.

—RALPH WALDO EMERSON

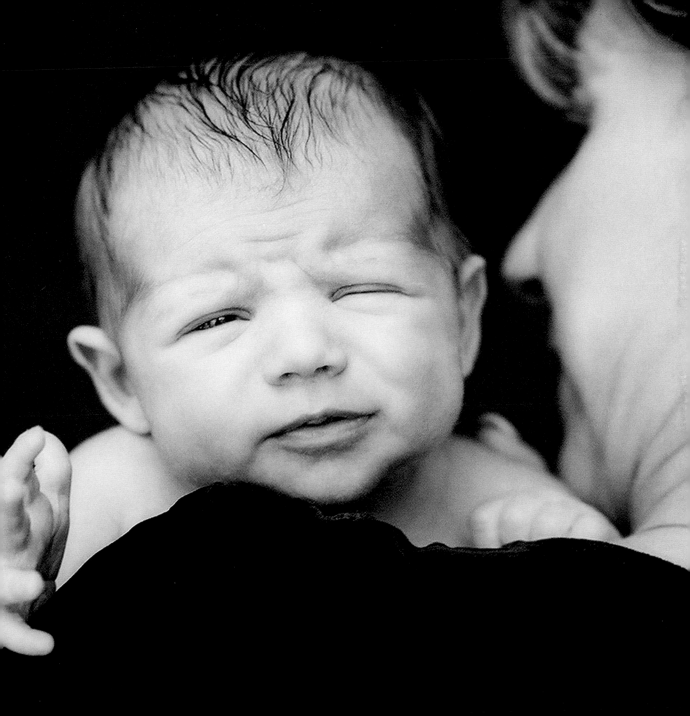

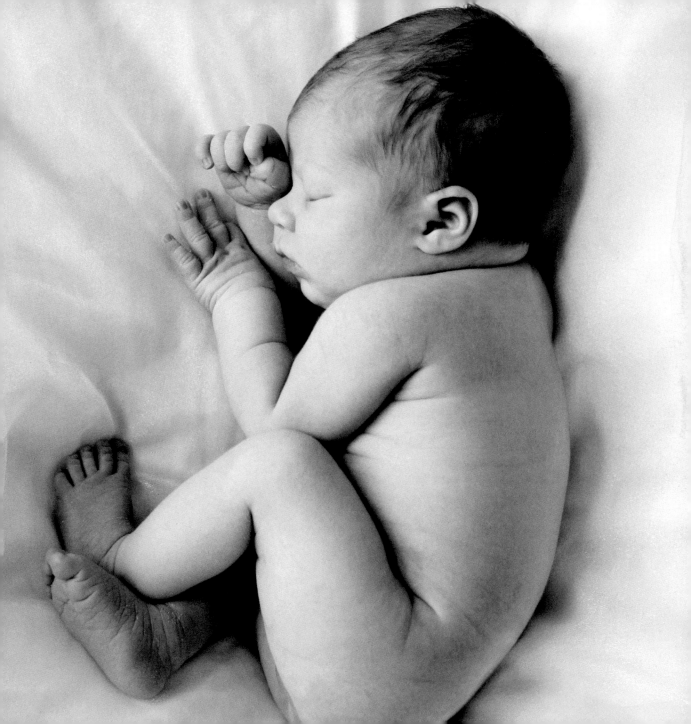

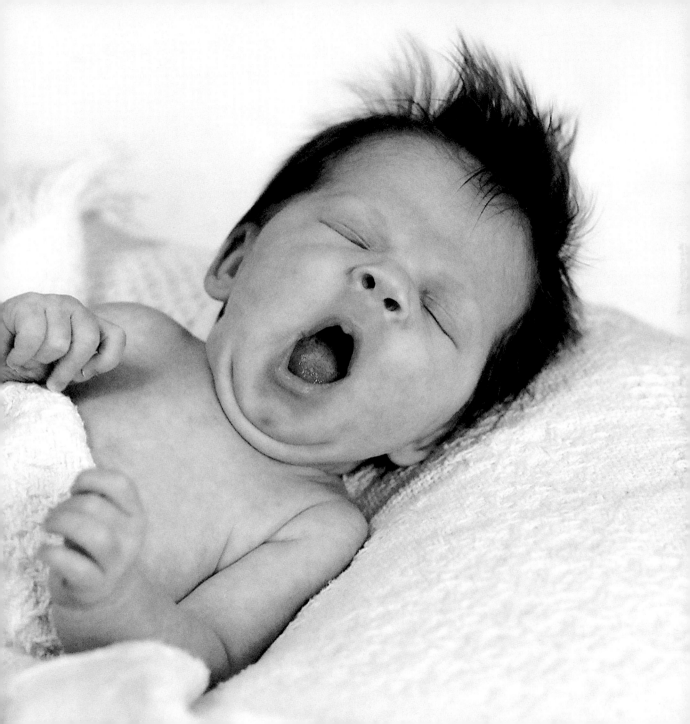

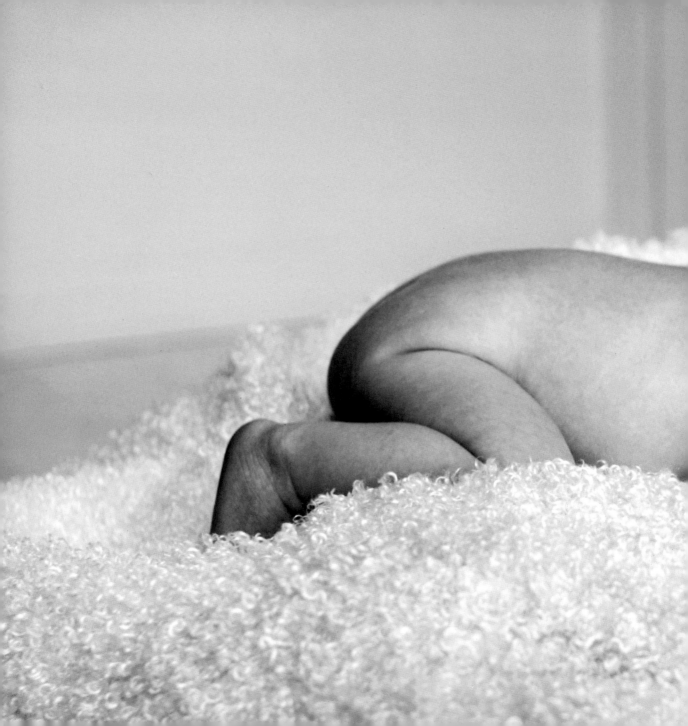

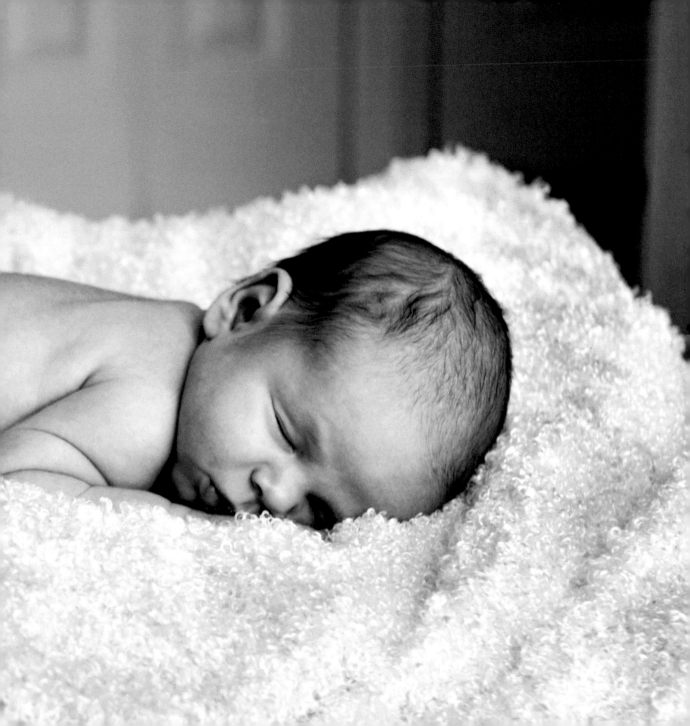

Nothing happens unless first a dream.

—CARL SANDBURG

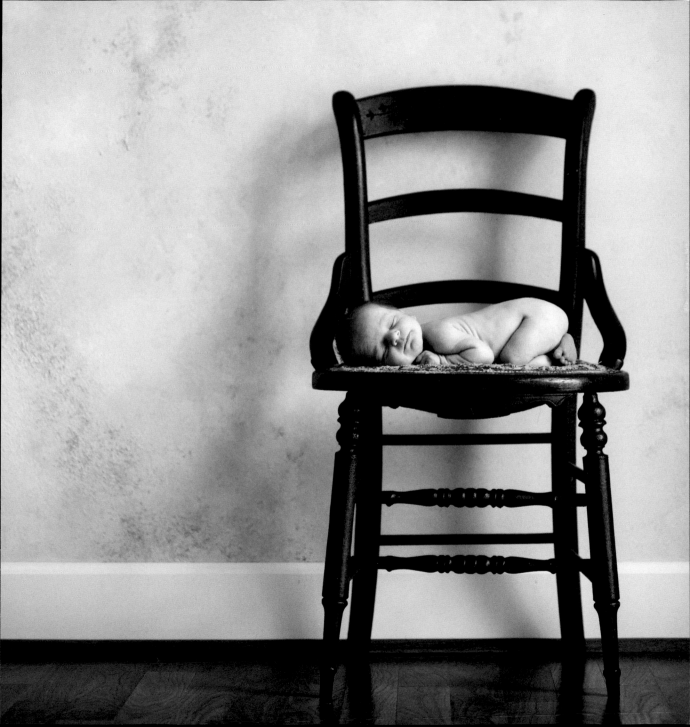

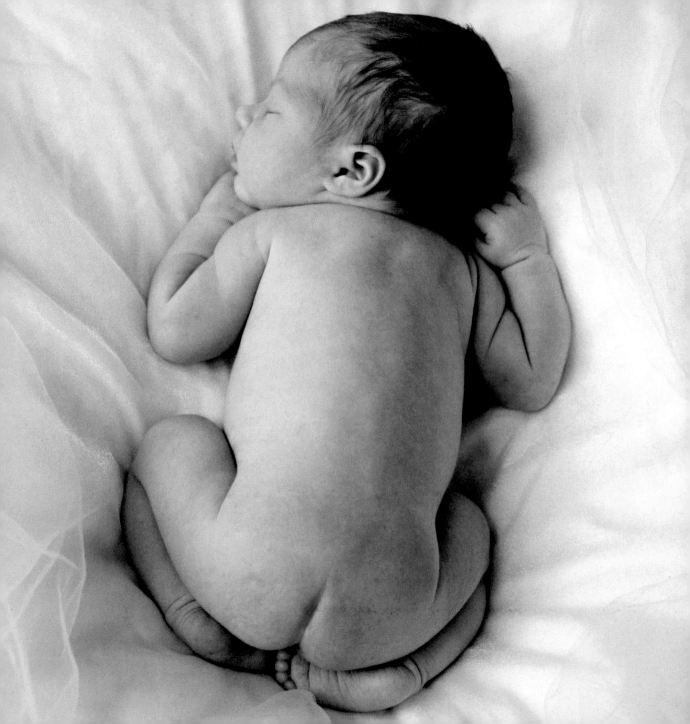

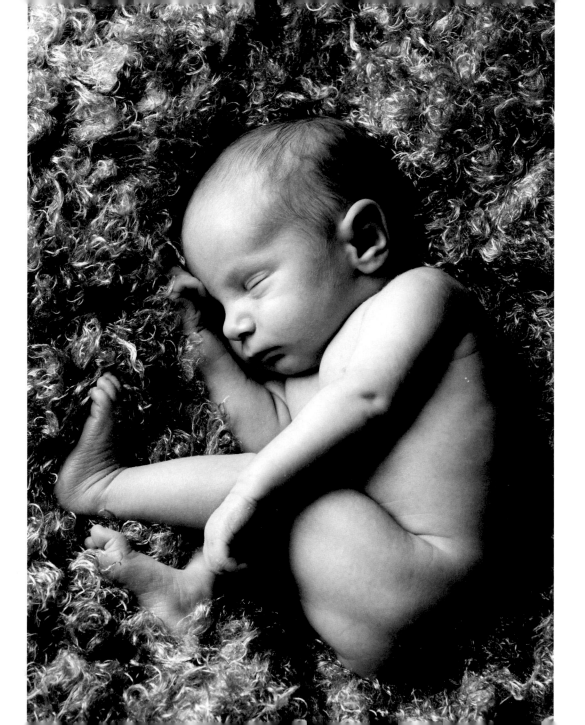

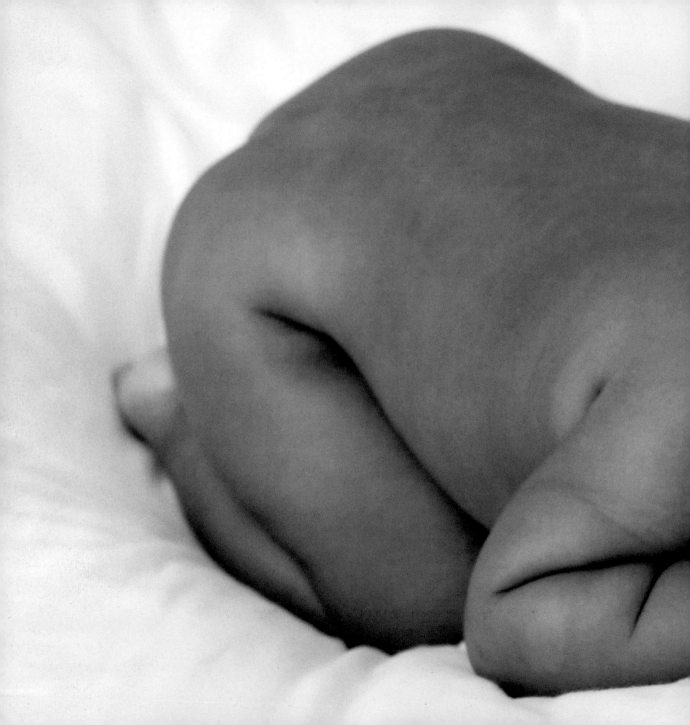

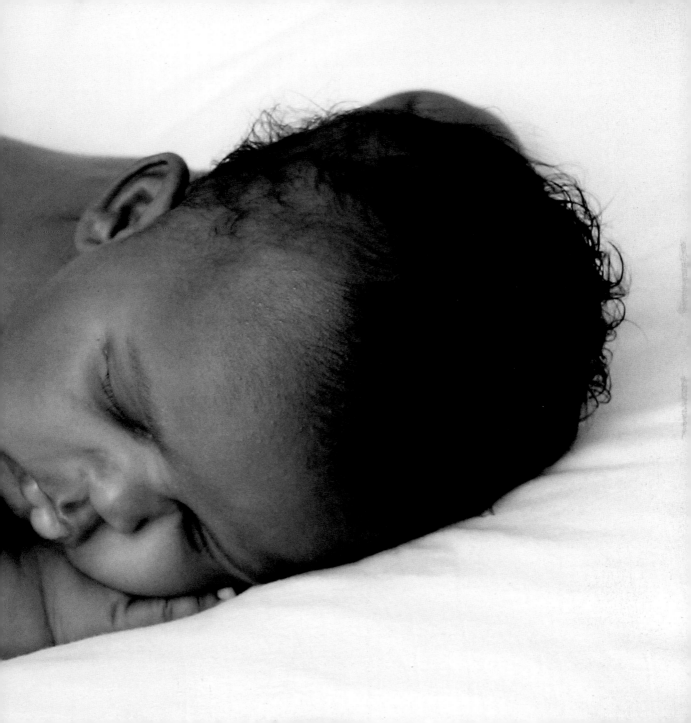

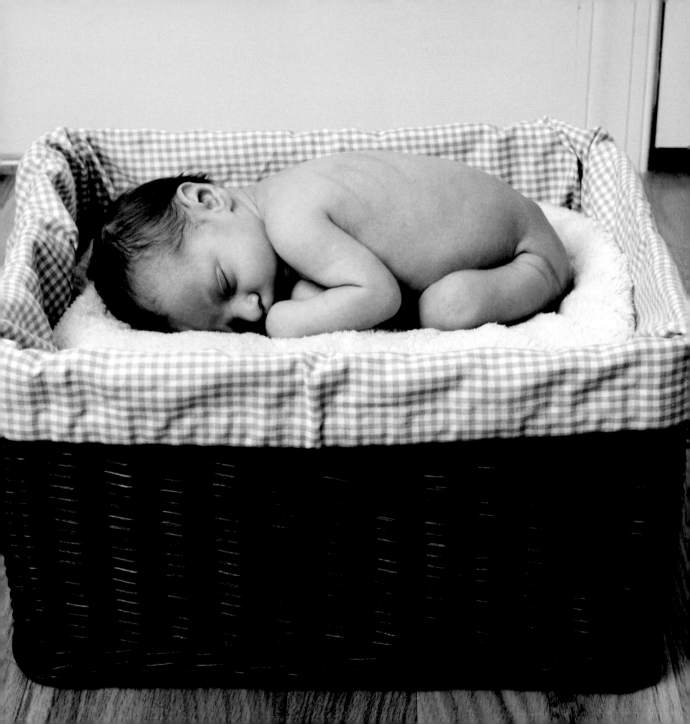

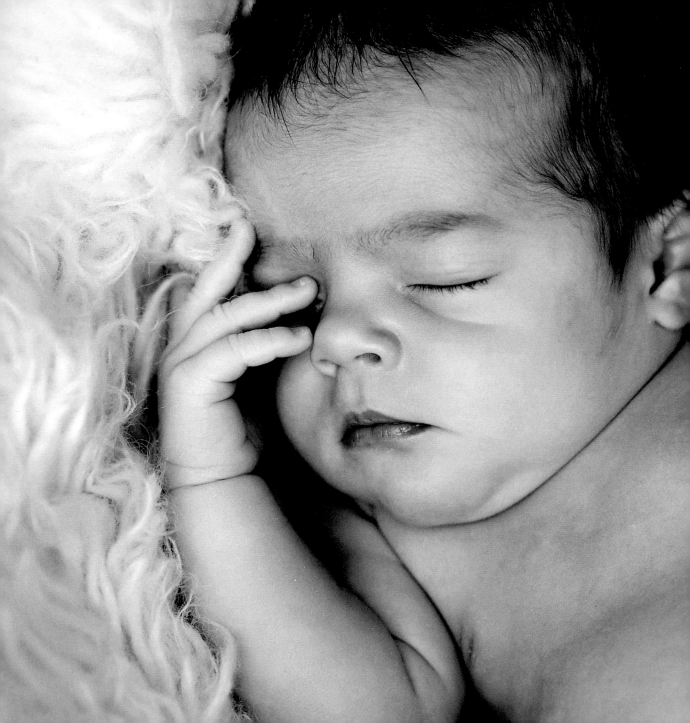

VARIETIES OF SLEEPING EXPERIENCE

Since our baby's arrival I've thought about sleep more than I ever did before, and it's possible that I've thought about sleep more than I've actually slept. I've realized that sleep which once seemed like a single undifferentiated state actually has a great many shades and varieties, each with its own particular feeling and distinct effects on the following day. Examples include the foggy Night of Endless Fretting (Is my baby's head too big? How especially bad is it that he vomited mango chunks through his nose?); the bitter 3 A.M. Wake Up! Can't Go Back to Sleep;

the ridiculous Midnight and 2 A.M. and 3:30 A.M. Wake-Ups with Hardly Any Sleep Between; the soul-sapping Is That Faint Mysterious Noise My Baby Crying? I Don't Think So, but What Is It?; the excruciating Baby's Asleep and Everything Is Okay, So Why Can't I Sleep?; the desperate and guilt-stained Pretending to Sleep So Maybe My Spouse Will Tend to the Crying Baby Even Though It Is My Turn; and of course the mind-altering half sleep of Baby's Fussing in a Way that Can't Be Ignored but Doesn't Really Require Investigation and It Goes On and On. Just to name a few.

Our baby does a funny thing when he sleeps. On his stomach with head turned as if he were putting an ear to the ground to listen for the rumble of distant strollers, he draws his legs under himself so that his butt is high in the air. It's cute to see and I love it, not least because it means I can go back to sleep.

—NICK ARVIN
Writer

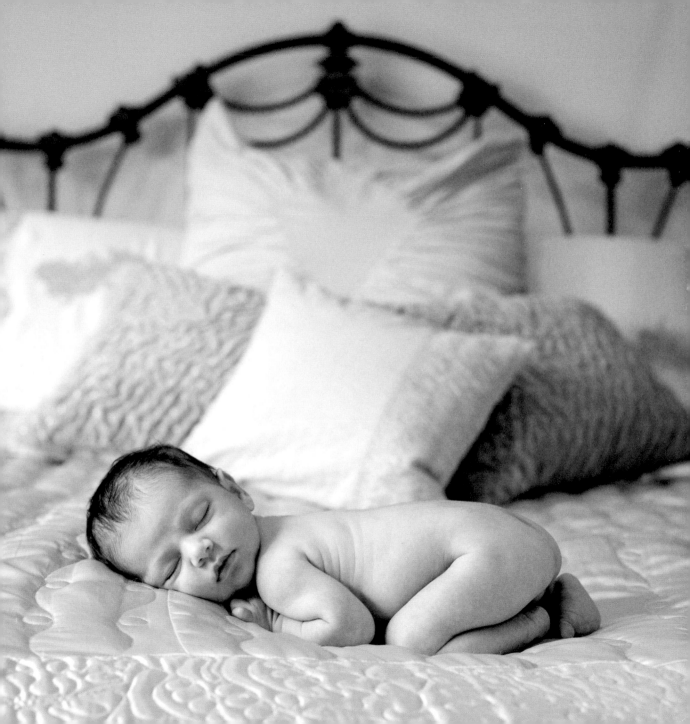

Did you ever stop to think, and forget to start again?

—A. A. MILNE

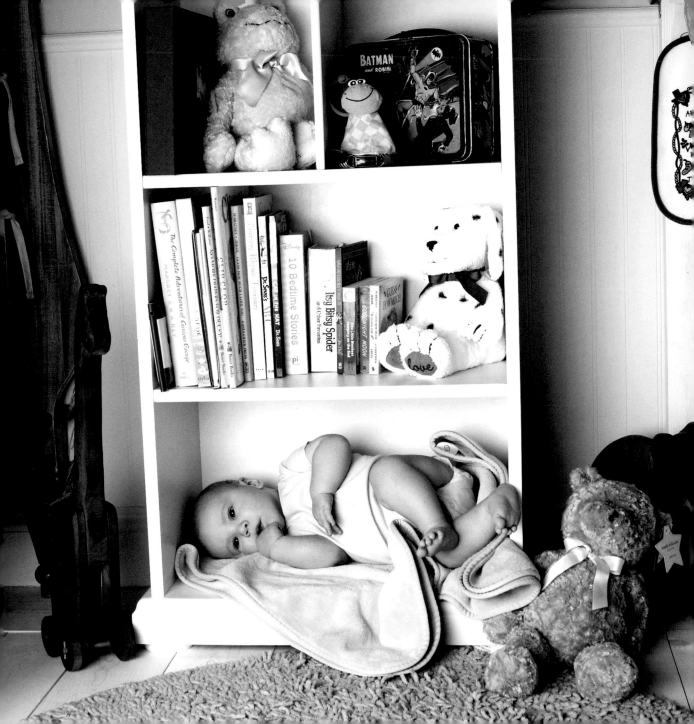

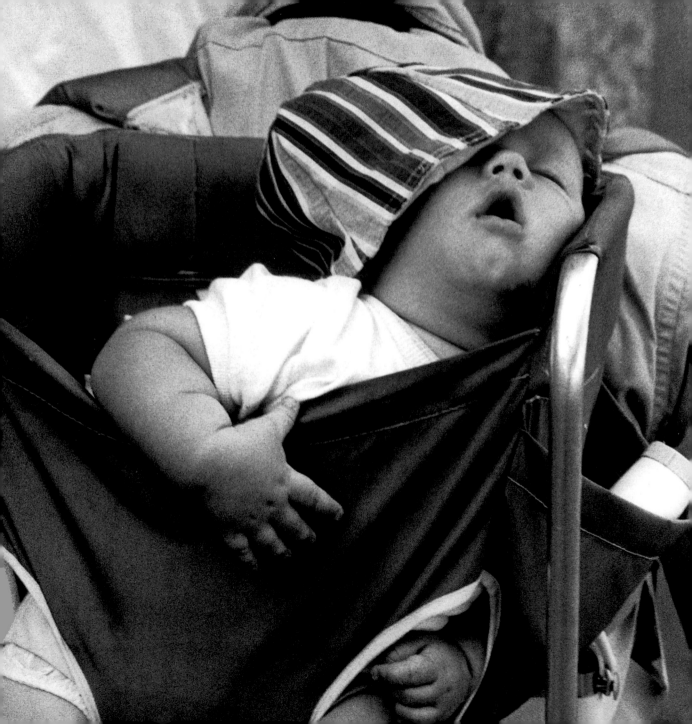

GOOD NIGHT AND GOOD LUCK

After the birth of my first child, it quickly came to my attention that I might never sleep again. Ever. For months our daughter passed out like a narcoleptic puppy during daylight hours, and then screeched like a rabid spider monkey all night long. So, we decided to "Ferberize" her—a euphemism, based on the work of Richard Ferber, for letting babies scream, shudder, thrash about in agony, shake crib bars, remove pajamas, and hurl pacifiers prior to falling asleep.

After reading all of the material on sleep training available, I've come to an important conclusion: All of these books could be condensed into one very slim pamphlet that says, "Put your kid in the crib and wait until s/he falls asleep."

Here's one thing those books don't tell you: to keep from going into baby's room during Ferberization, most couples pick fights with each other. What better time than the fifth straight hour of your child screaming at 4:30 A.M. on the Tuesday before a major early-morning presentation that will determine your future career path to bring up a bounced check, an empty milk carton left in the fridge, or cover hogging?

After two kids, all I can tell you is that sleep for families with young children is elusive and that anything goes—a little crying it out here, a little family bed there, plus a whole lot of bribing, coaxing, threatening, and praying in between. In the end, I think our old pal Edward R. Murrow said it best for parents of young children: "Good Night and Good Luck."

—HEATHER SWAIN
Writer

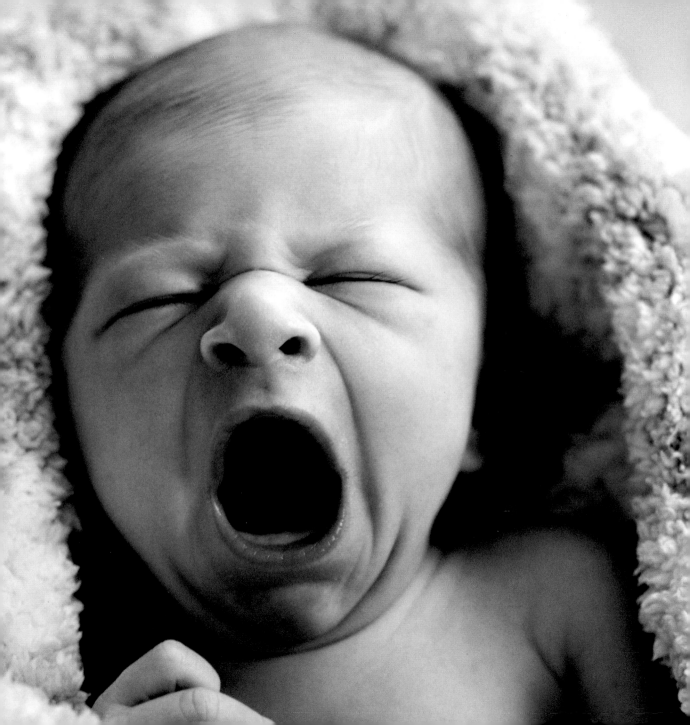

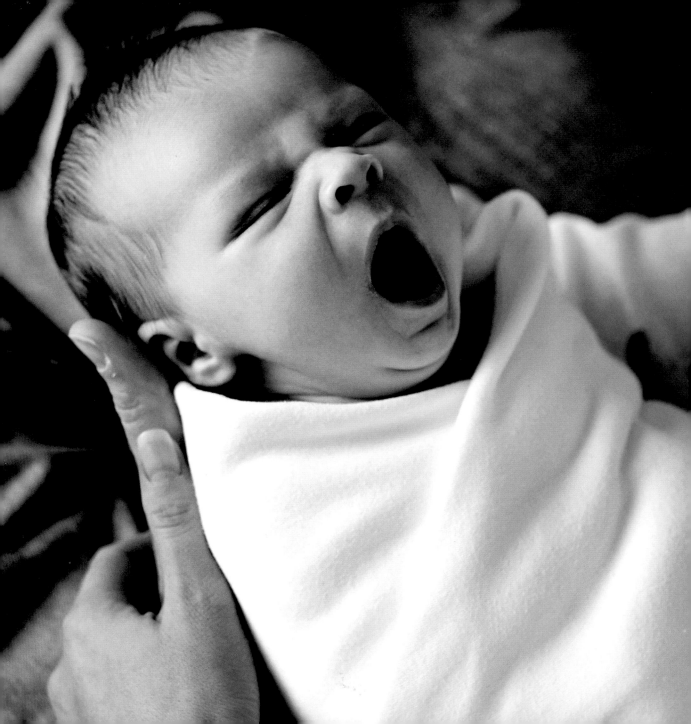

TIME

I remember my first baby and how her birth and every little stage of development were eagerly awaited. Chi Chi could not come or grow up fast enough. We were so curious and excited, waiting for her to smile, to crawl, to talk, to walk. Sylvia came along two years later and frankly it was hard with two little ones. Complete chaos. Those early years with them both seem to inch oh so slowly along. Yes, I remember how cute they were but I also remember feeling every day was an interminable blur of catering to their many needs. But they grew as kids do, and it was easier. Phoebe came along four years after Sylvia. My third baby was no problem and by that time, very little fazed me as a parent.

Time flies for a family of five with careers, school, and a juggle of events and activities. In fact, every year it feels as if time speeds up a little more. I am conscious of it all slipping by too quickly. I look at all my babies, eleven, nine, and five, what wonderful ages, what wonderful girls. My eldest, the image and the heart of the beautiful man I married, in the cusp of maturity; my second, my fascinating mini-me, blooming more each day; my youngest, a unique mixture of her parents, sisters, and grandparents, so determined and ambitious, but still so little and cuddly. I gather them up in my king bed, snuggle and hold them tight, and wish for time to simply stand still.

—ALICE WONG
Book Producer

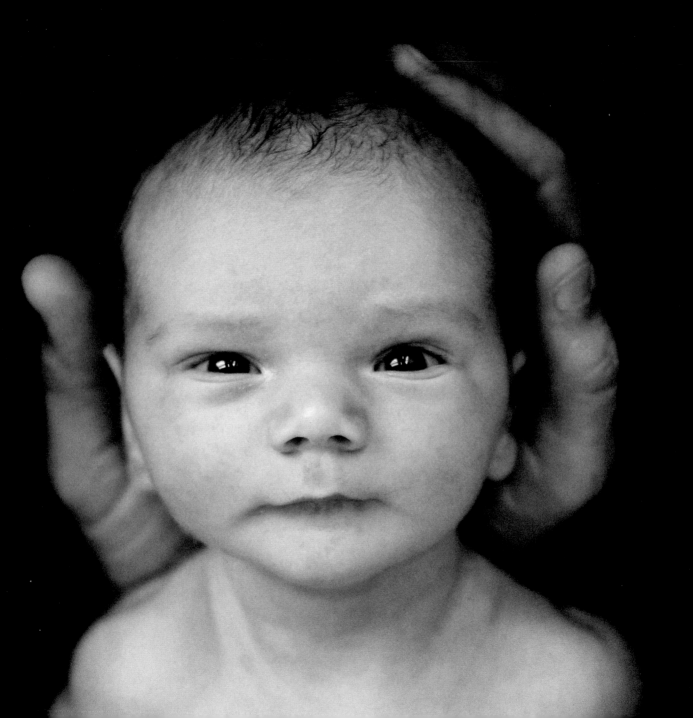

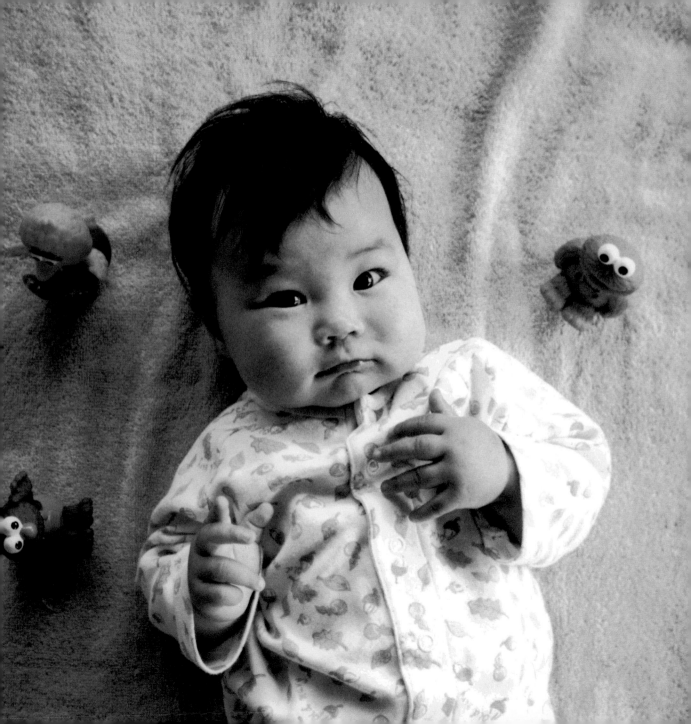

A child is a curly, dimpled lunatic.

—RALPH WALDO EMERSON

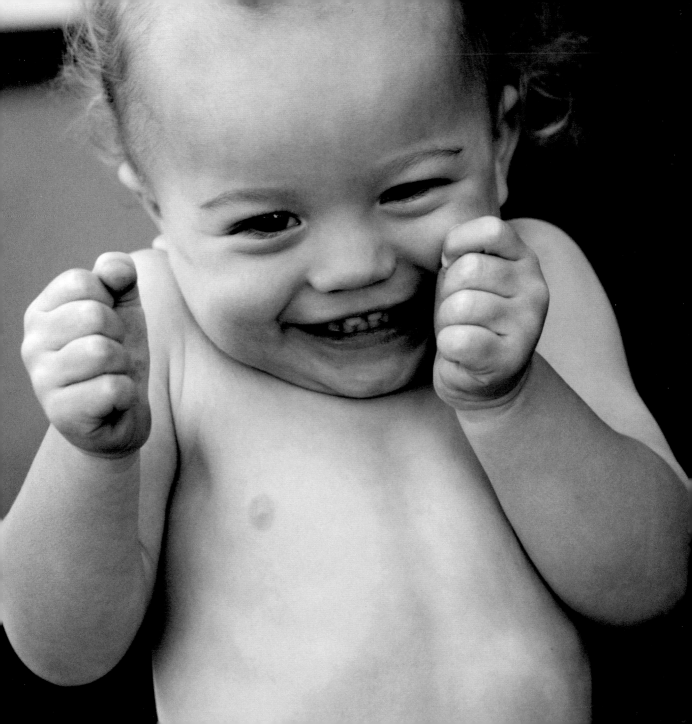

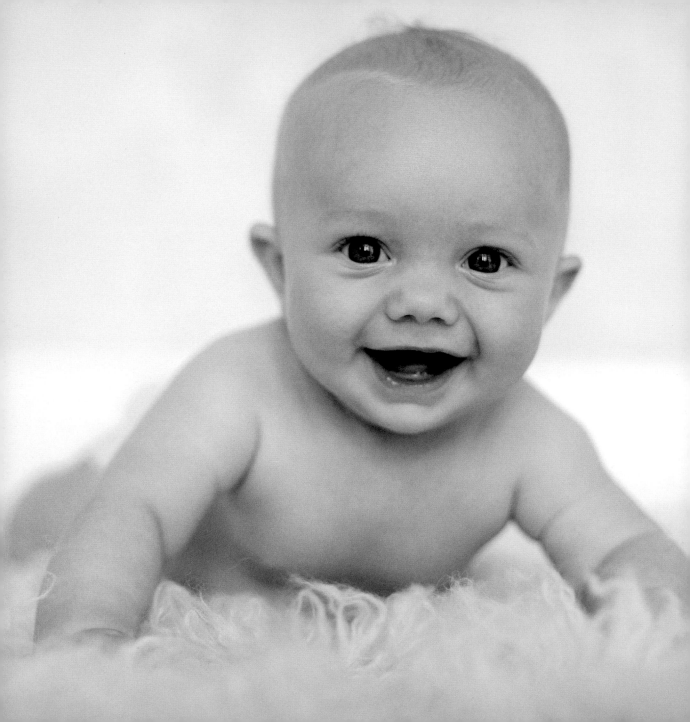

I think that I see something deeper, more infinite, more eternal than the ocean in the expression of the eyes of a little baby when it wakes in the morning and coos or laughs because it sees the sun shining on its cradle.

—VINCENT VAN GOGH

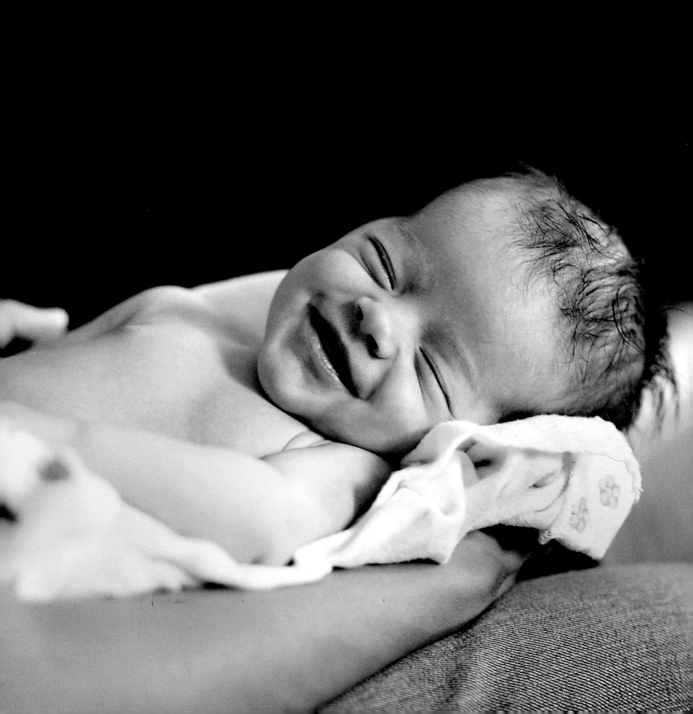

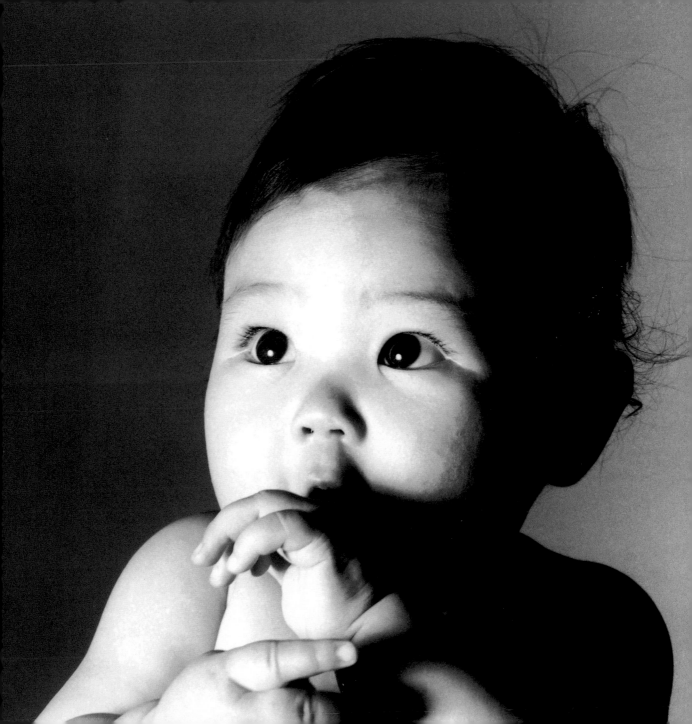

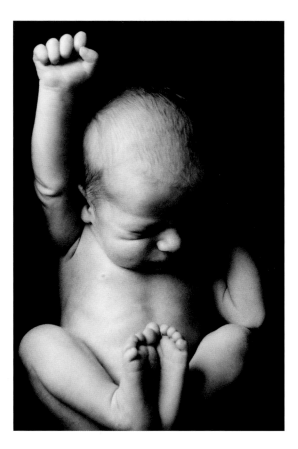

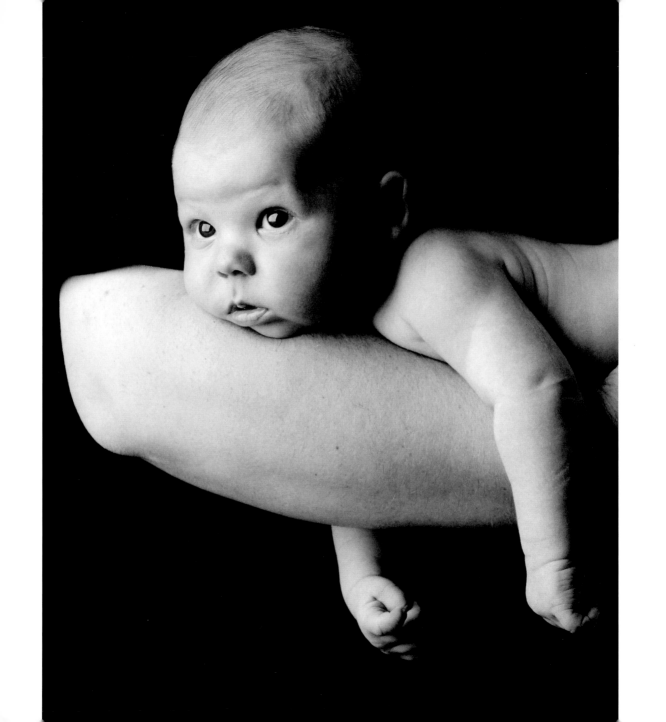

DARK AND LIGHT

When Bess was one week old, we rushed her to the pediatrician because the area around her mouth had turned a bit blue. Assuring us this was normal, the doctor asked, "Didn't you call us on Monday because her face had turned red?" We had. If Bess ever turns white, we realized, we'll just have to deal with it on our own.

We're much less anxious now that she's all of six months. In fact, I pride myself on being a relatively mellow mom. Any fear I have, really, is much deeper, less immediate; I walk around with the knowledge that I could lose her at any time. It's only a faint, faint hum, but it's there. Before we had Bess, and after a long fertility journey, we lost a perfectly healthy pregnancy to a prenatal test with a risk of less than 1 percent. Now, sometimes, when I look into Bess's eyes, I wonder about the face of our first. Now that I know what we have, I know even more what we lost. Our joy upon Bess's arrival was perhaps even greater than it might have been without what went before, but it by no means erased the grief. And I think it's important that people who've experienced miscarriage of any kind tell or at least allow themselves to feel the truth about that. Only then can we experience the full spectrum of emotions that surround parenting, in all their colors, dark and light.

—LYNN HARRIS ADELSON
Writer

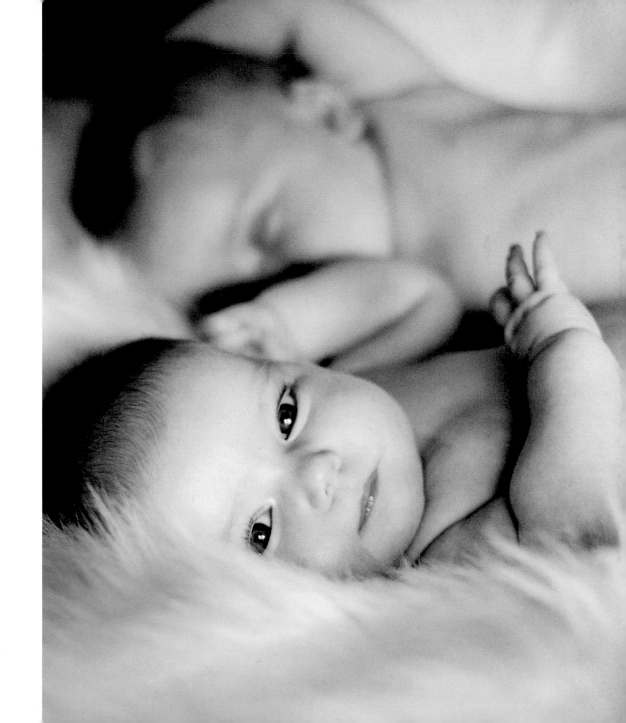

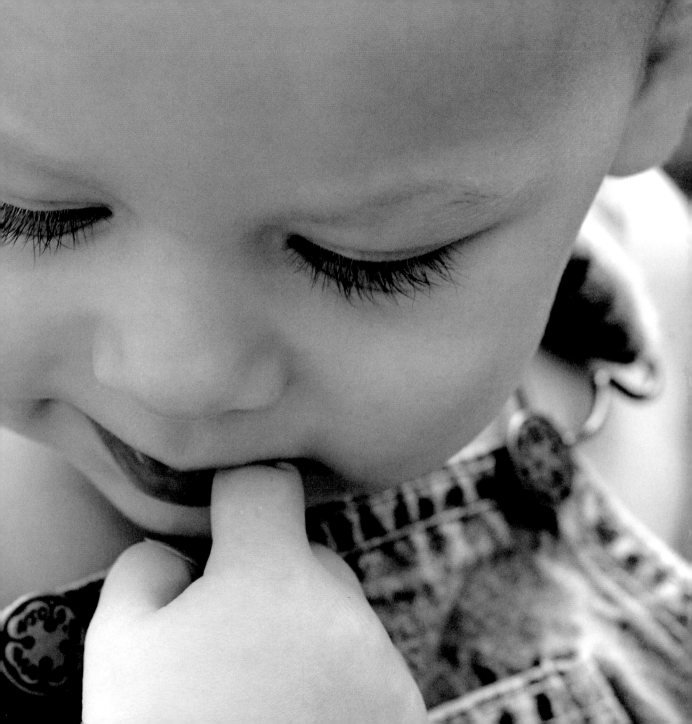

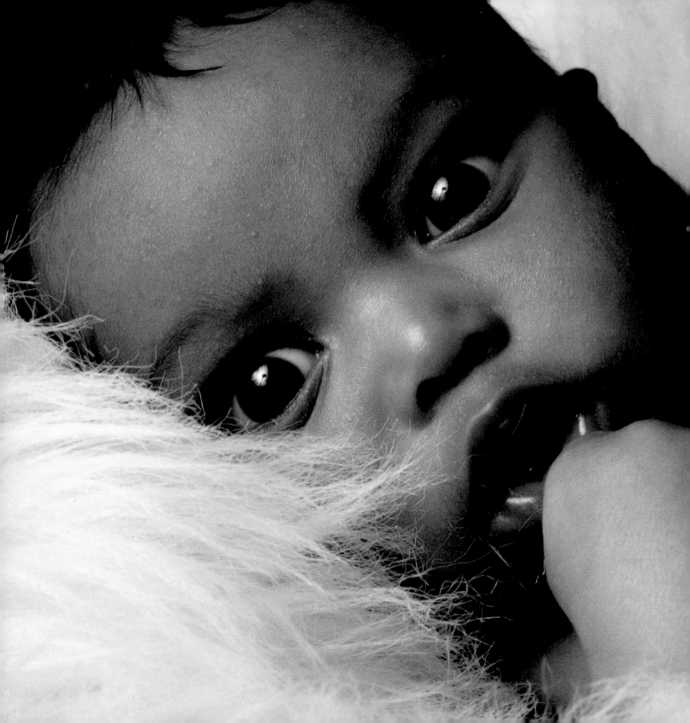

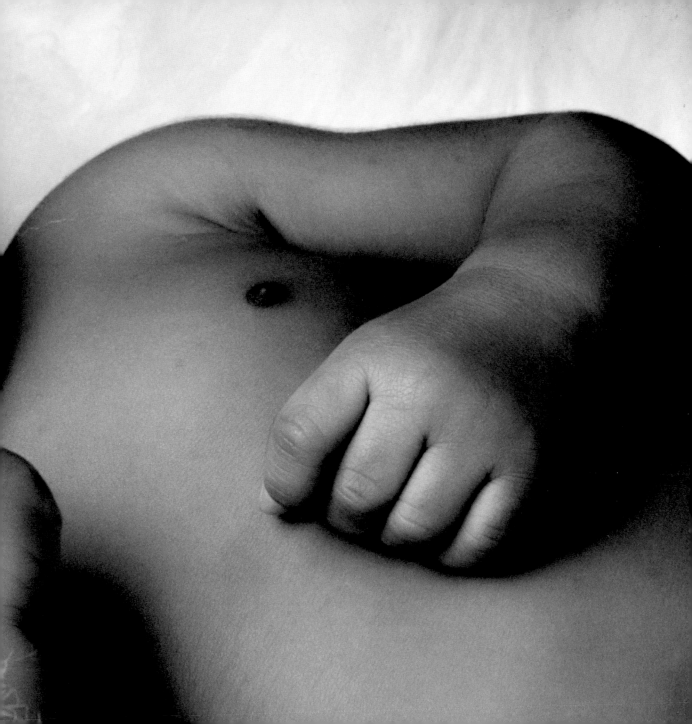

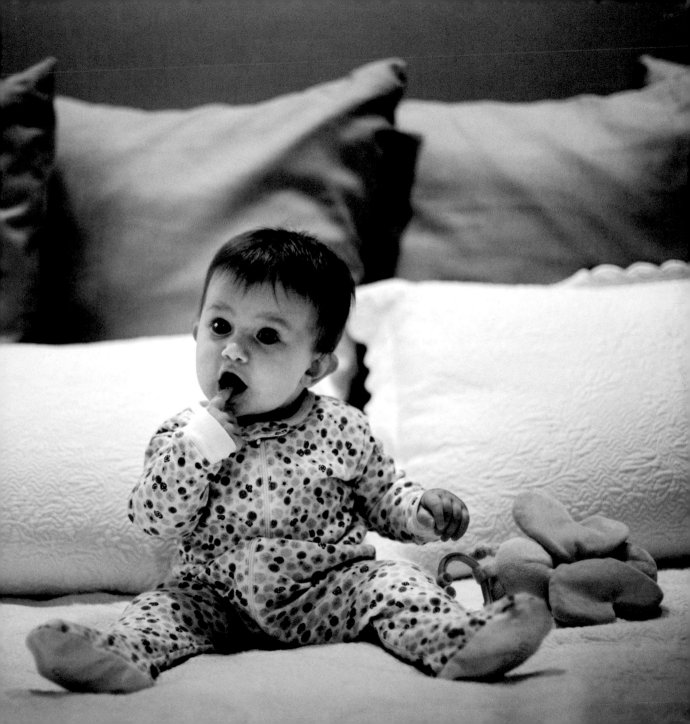

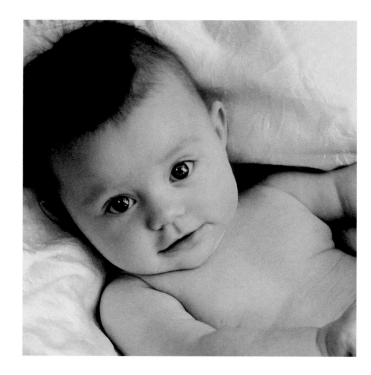

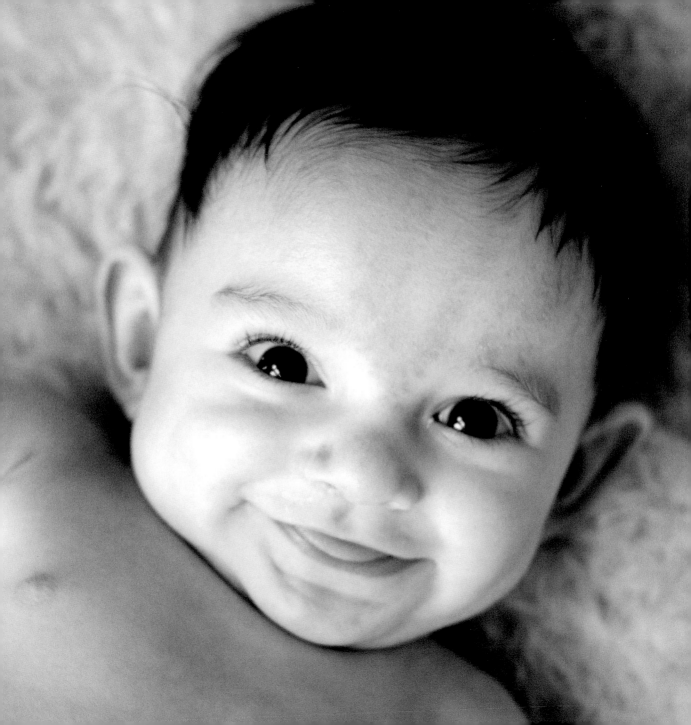

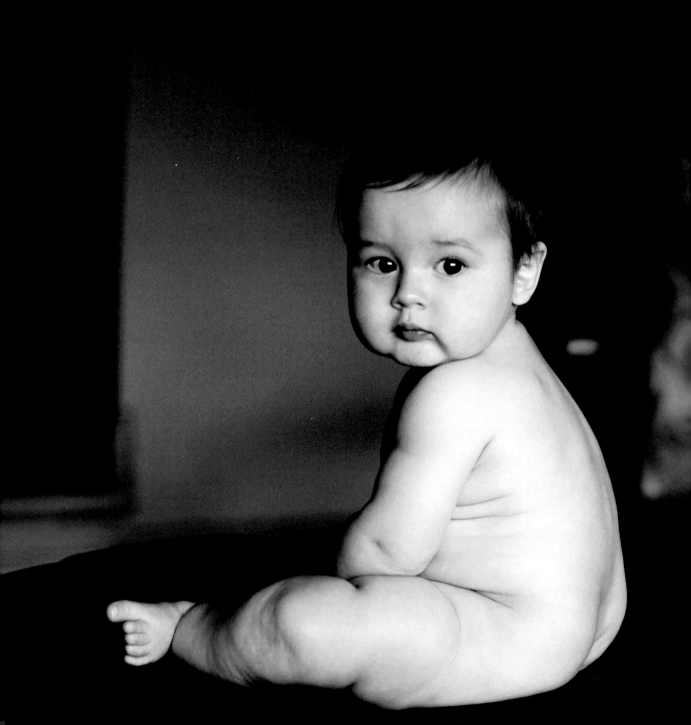

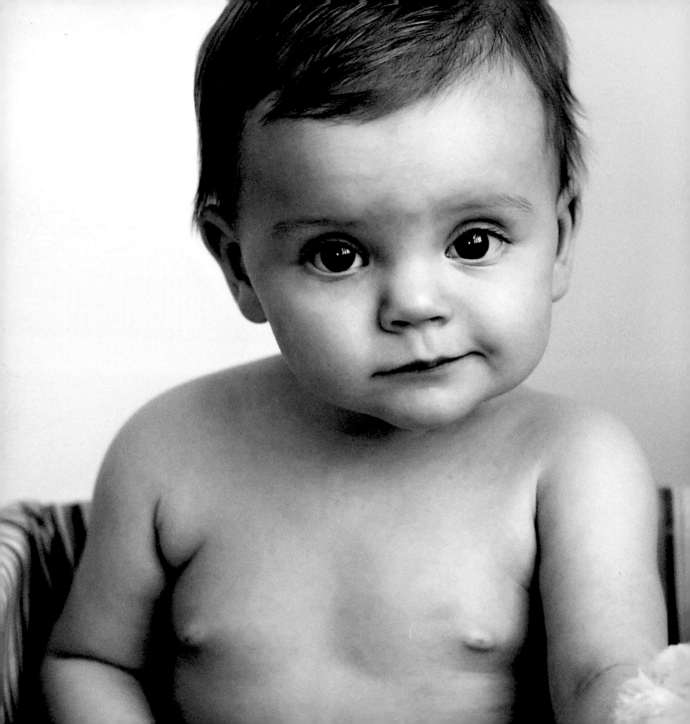

THE WONDERER

I wish that I could understand

The moving marvel of my Hand;

I watch my fingers turn and twist,

The supple bending of my wrist,

The dainty touch of my finger-tip,

The steel intensity of grip;

A tool of exquisite design,

With pride I think: "It's mine! It's mine!"

—ROBERT W. SERVICE

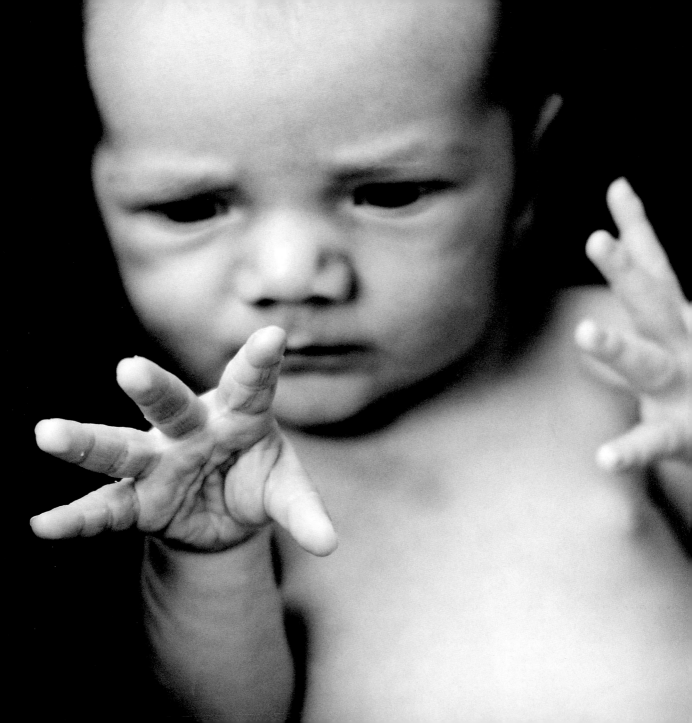

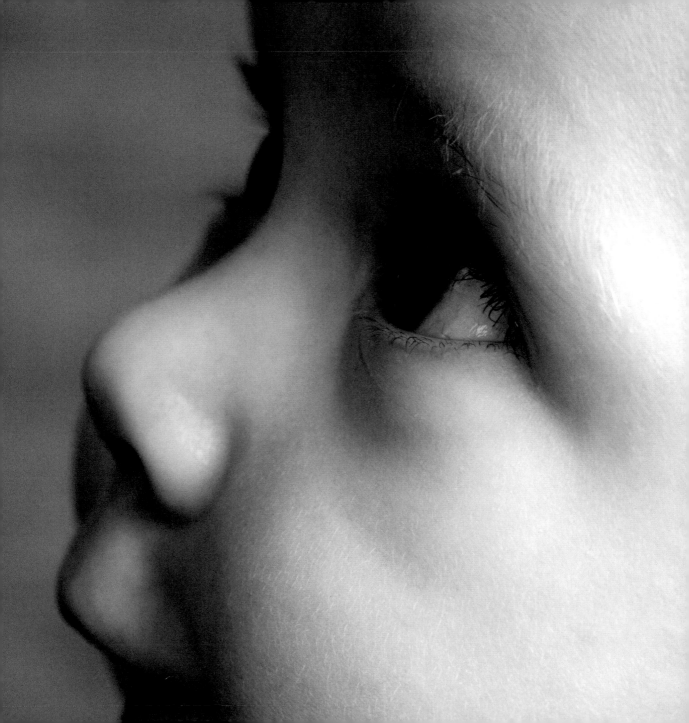

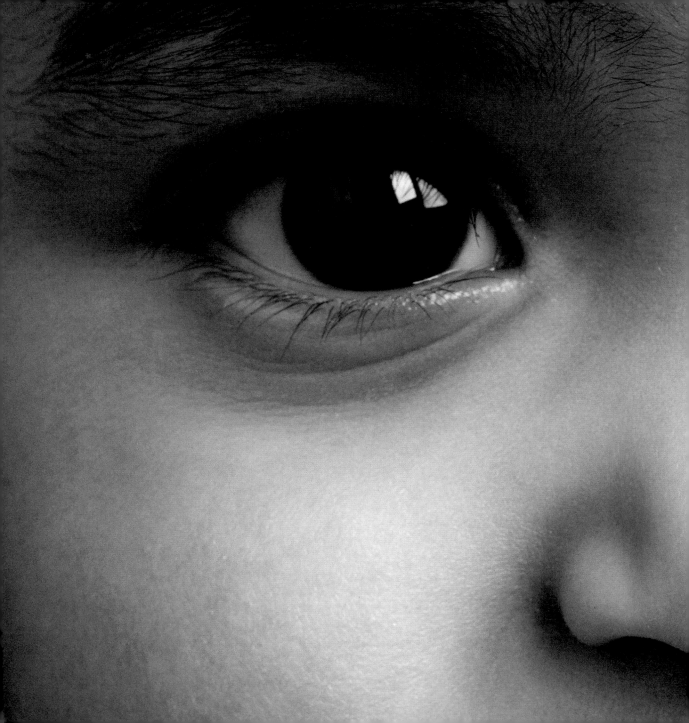

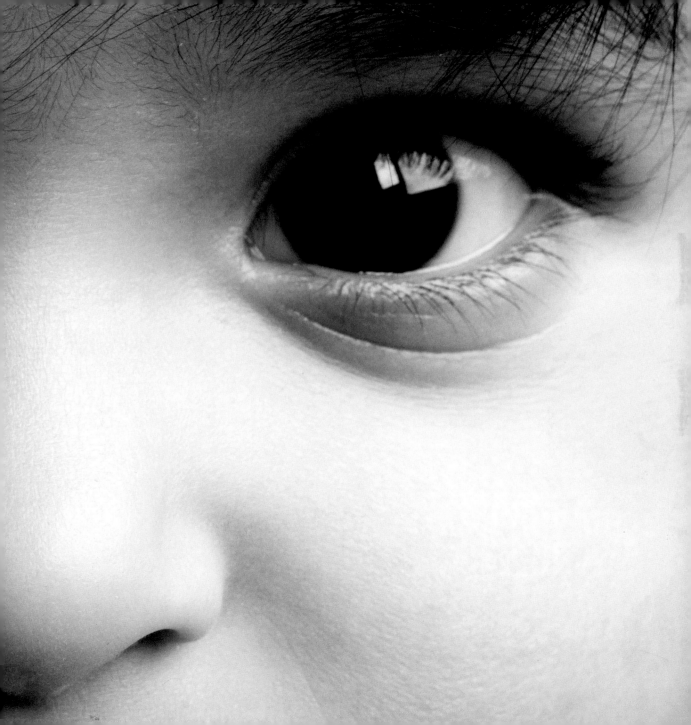

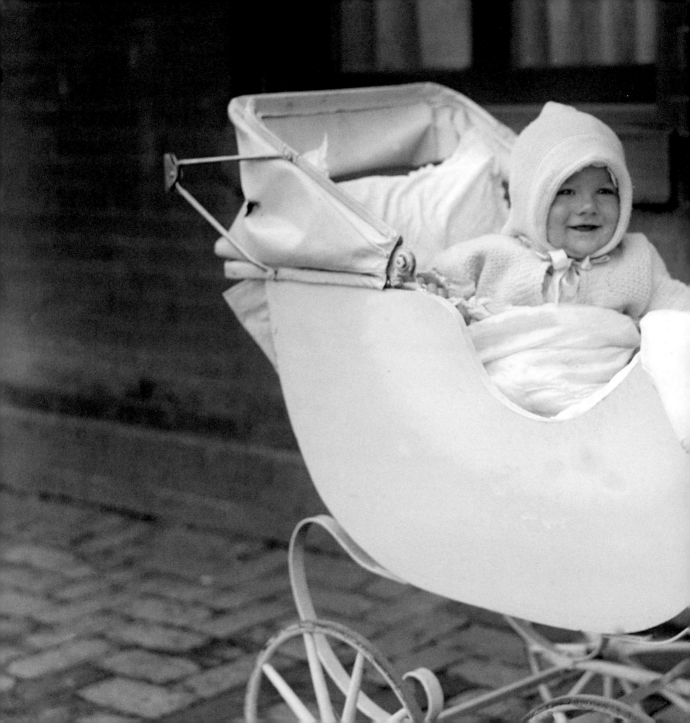

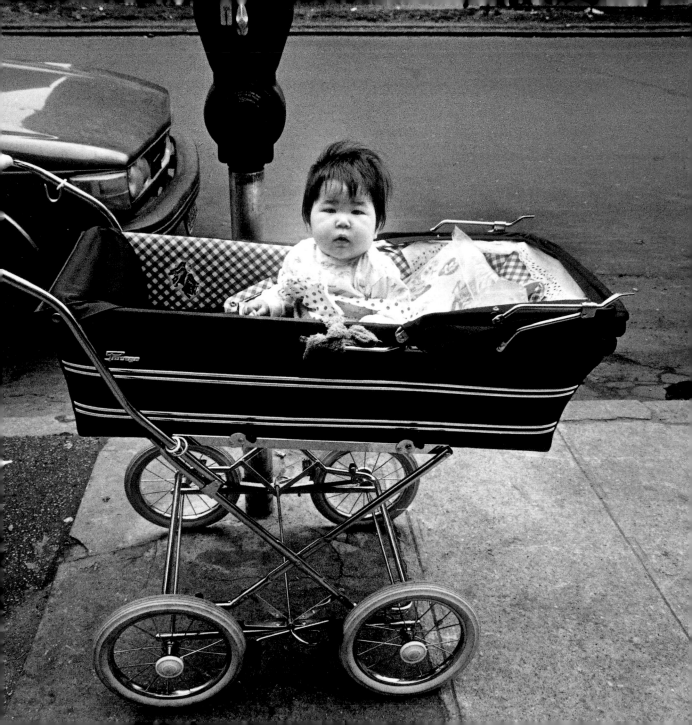

PHASE ME

It's ALL a phase: the adorable, the horrible, all of it.

Someone told me that when my daughter was about one year old and testing out her volume controls. (She would suddenly let out an ear-piercing shriek and then stop). I was told to either cherish the moment or grin and bear it, because either way, it would be over soon. Which is true for phases, most of the time.

Everyone tells you it all flies by. At a distance it does, but when you're in middle of it, it sure doesn't. For example, no one told me how very, very monotonous those early weeks are when babies don't do a thing but eat, sleep, and poop. Or they complain because they aren't eating, or sleeping, or pooping.

Now my daughter has reached the ripe old age of five. I've discovered a secret weapon that bails me out when I think I just can't take one more second of pretending to be the voice of a small, plastic purple pony: Time Travel.

I think about what I would give in ten years to come back and play Pony Beauty Pageant with my daughter again. I think about what I would give right now to sit again in a teeny little chair and accept pretend tea and plastic food from my earnest little two-year-old.

—CHERYL WILLEMS
Mother

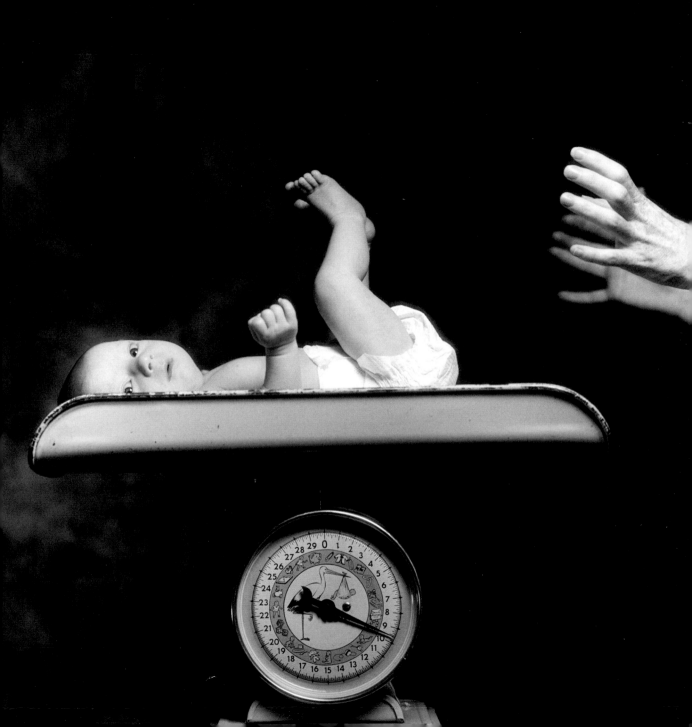

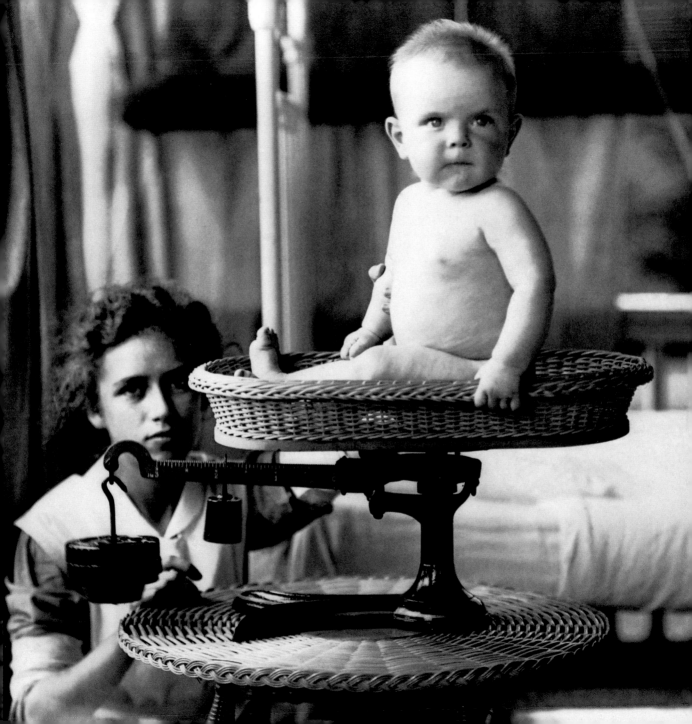

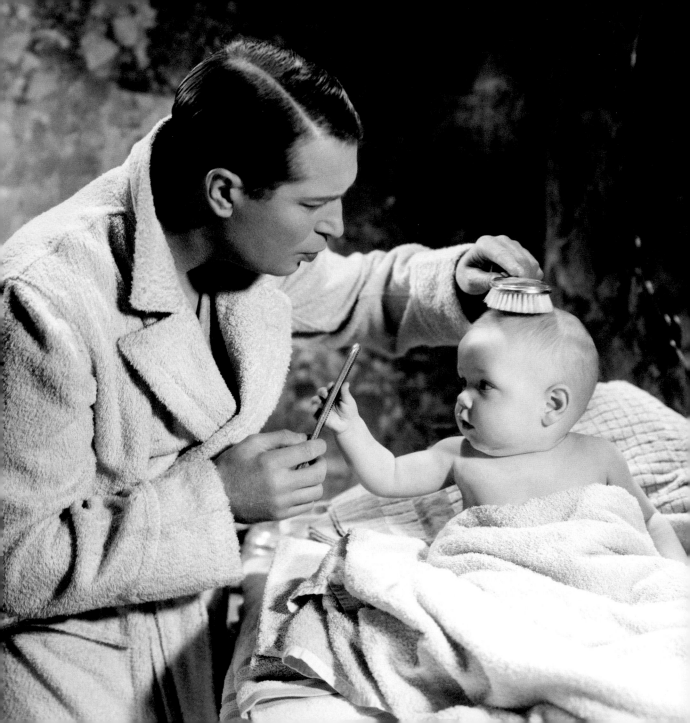

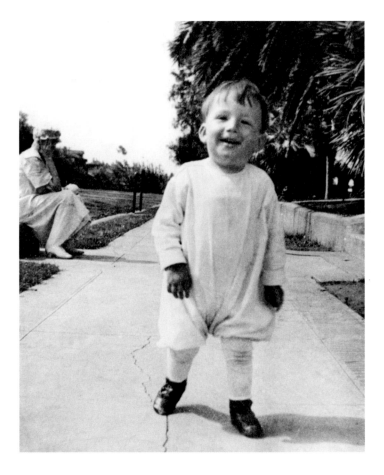

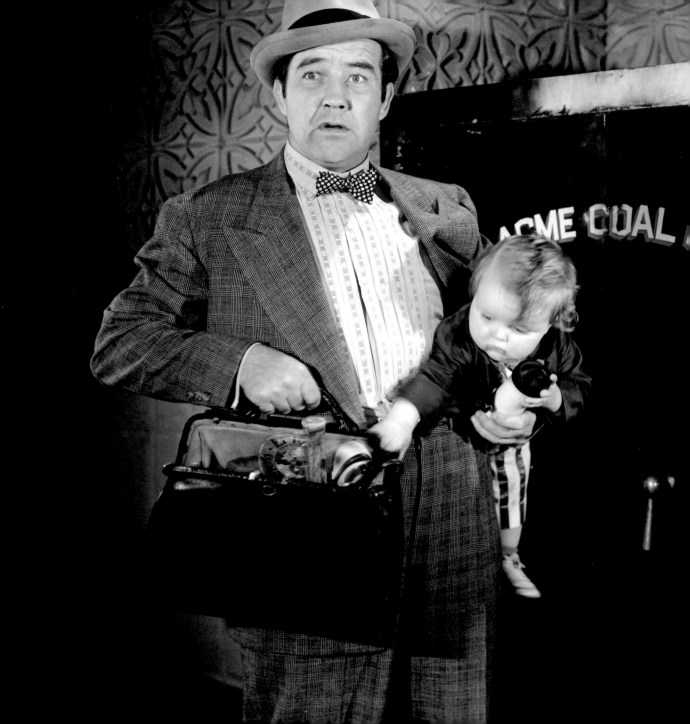

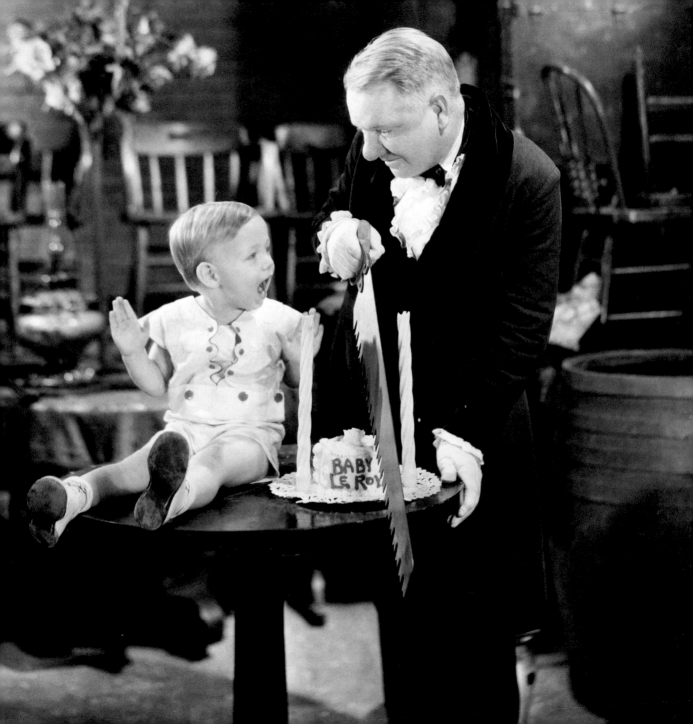

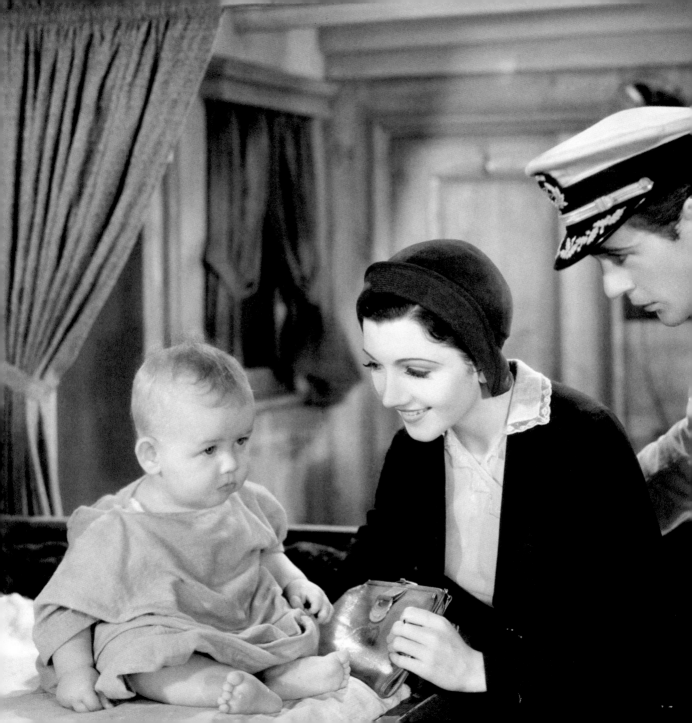

O wonderful son, that can so astonish a mother!

—WILLIAM SHAKESPEARE

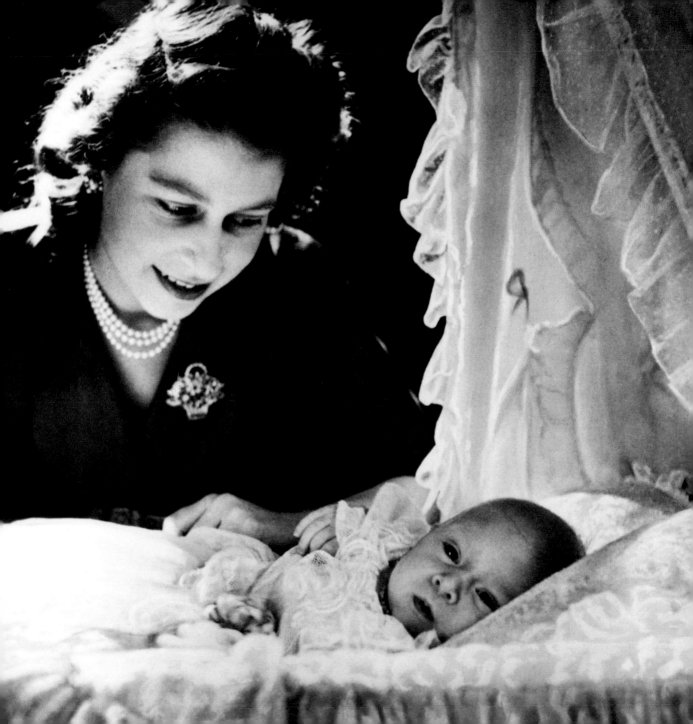

ROCKABYE

My wife, Jenny, and I are music lovers—rock-music lovers—and always have been. We both grew up listening to Alice Cooper, the Stones, and Jethro Tull. I still crank up the volume whenever Black Sabbath's "Paranoid" comes on the car radio.

We knew our kids would have to be music lovers too. The night my daughter was born, she cried nonstop. Jenny and I took turns singing to her. "Mairzy Doats" and "Down by the Station" soon gave way to the Pretenders' "Stop Your Sobbing" and Eurhythmics' "Sweet Dreams Are Made of This." I remember waking up on the hospital couch at 4 A.M. and hearing Jenny singing a lullaby version of "Rudy Can't Fail" by the Clash. Was this a good idea? This was the music we had used to rebel against our parents that we were now crooning into our infant's ear.

Ellie is eight now; her brother, James, is six—and there was no need for me to worry. Yes, they like rock. But they also like classical and bluegrass and zydeco. And at night, after we read them a chapter from *Charlotte's Web* or *Harry Potter*, they ask for a song. Nine times out of ten, it's "Mairzy Doats" or "Down by the Station." I'm happy to oblige. Soon they'll be cranking up their own radios, blasting whatever "noise" they've discovered to rebel against us. Plus, it won't be forever that they ask Mommy and Daddy to sing them to sleep, even if we are all music lovers.

—DAVID LOTT
Writer/Production Editor

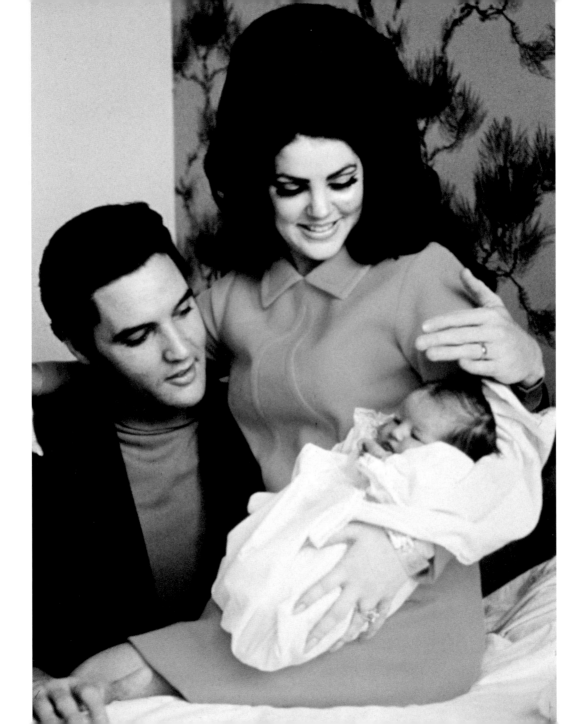

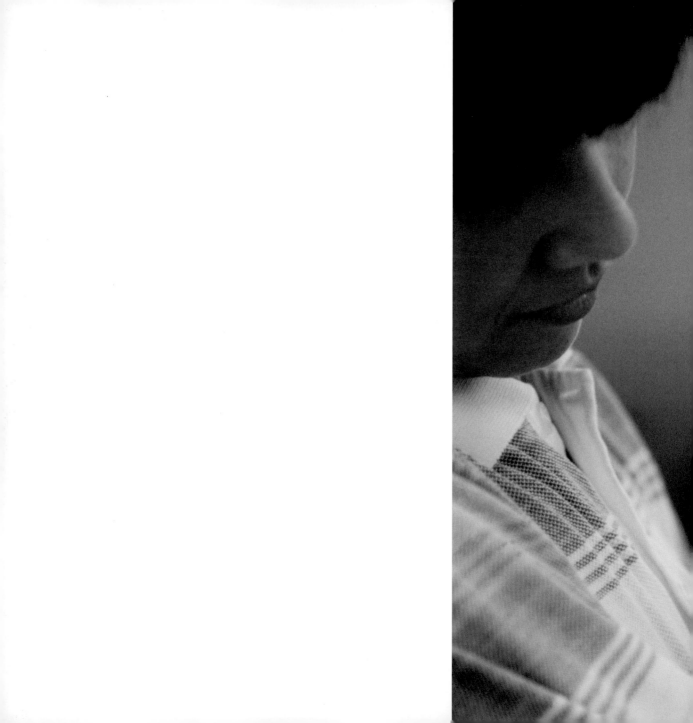

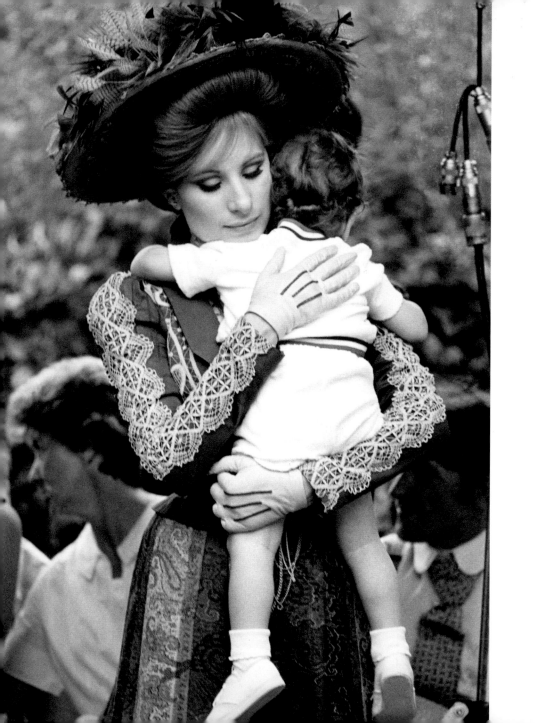

There is nothing more important in life than love.

—BARBRA STREISAND

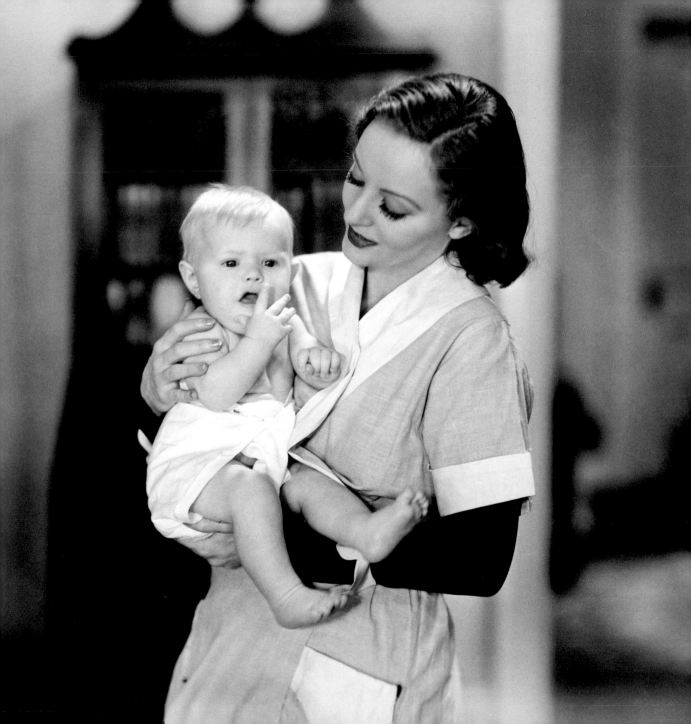

A baby is God's opinion that the world should go on.

—CARL SANDBURG

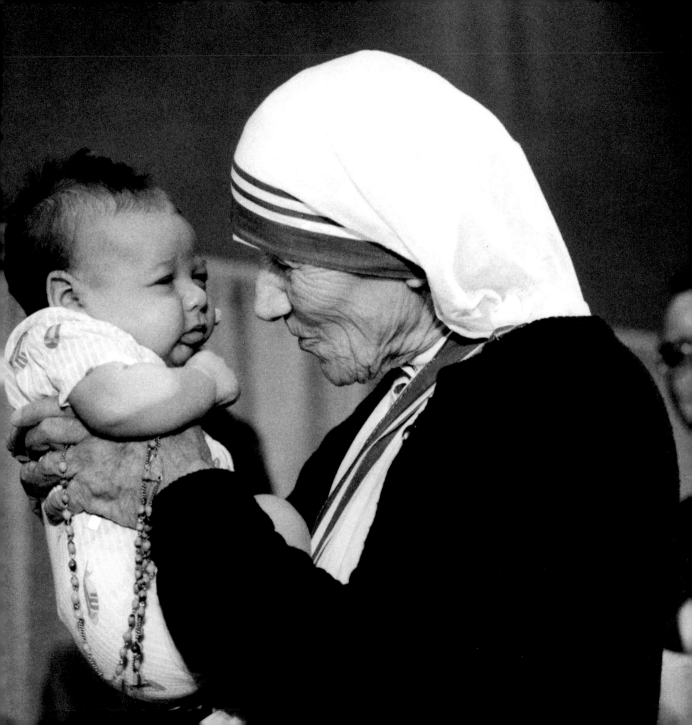

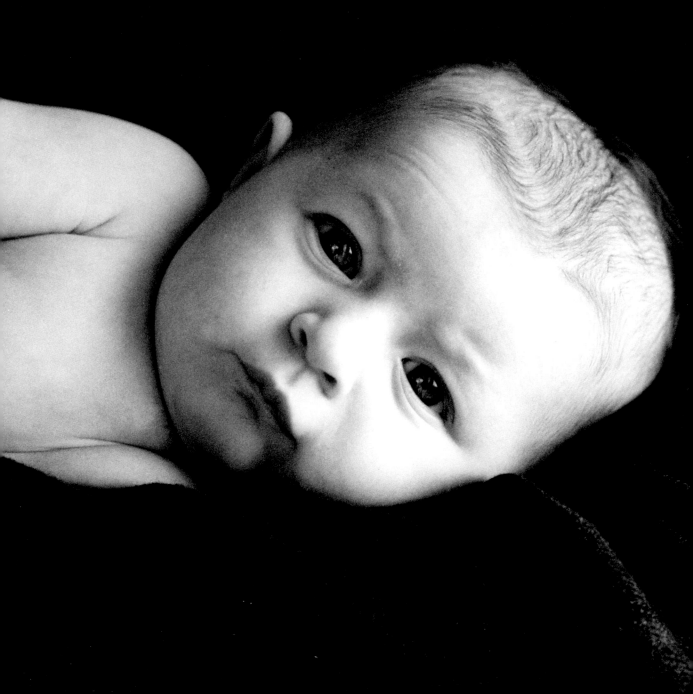

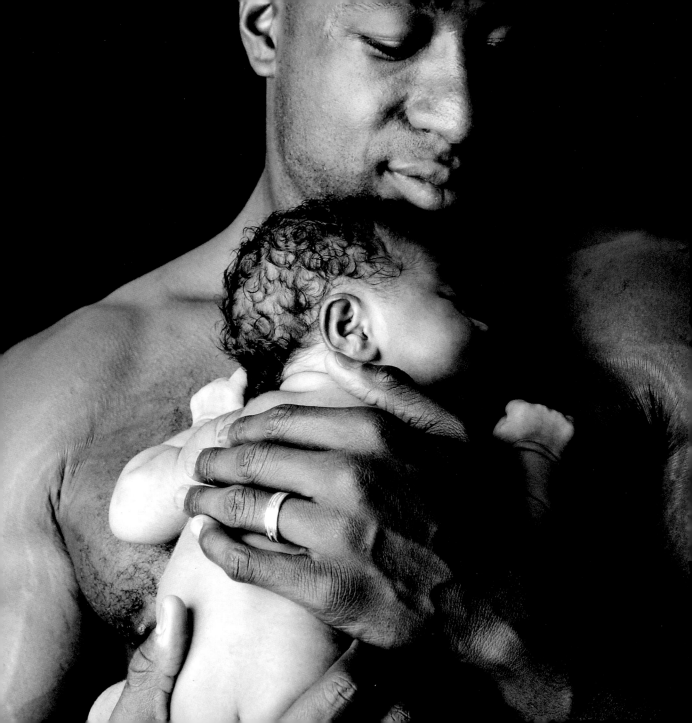

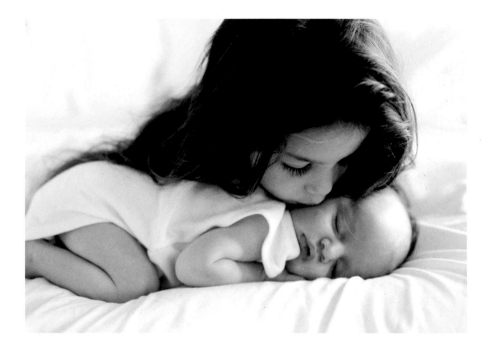

For all the moments of extreme joy I've experienced parenting an infant into early toddlerhood there is an equal number of frustrating and completely baffling incidents that have made me, if nothing else, a more patient person.

What parent can resist Baby's first smile? Finally, an outward hint of recognition! Or the first time he or she rolls over—at last, the beginnings of mobility. And, let's not forget sitting up—the world is suddenly a place to be seen and experienced on a whole new level, literally.

While I cheer the accomplishment, and carefully note the date in the baby book, these moments are tempered by the challenges and frustrations surrounding the early stages of verbal communication.

For me, nothing tops thirteen months. It seems to be the magical (unlucky!) number in my house where opinions are formed, but words are not. Everything is "Da!" and accompanied by a pointing finger and the expectation of possession. My very sanity seems to depend on my ability to guess the right item and hand it over in the shortest time possible.

Teaching sign language has helped a little. There seems to be a direct correlation between my son's enthusiasm for signing and his love of food. He uses the signs for "hungry," "more," and "all done" clear as day.

Now, if I could just figure out what he's pointing at on the bathroom counter.

—KAMA SIMONDS
Aviation Media Relations Director

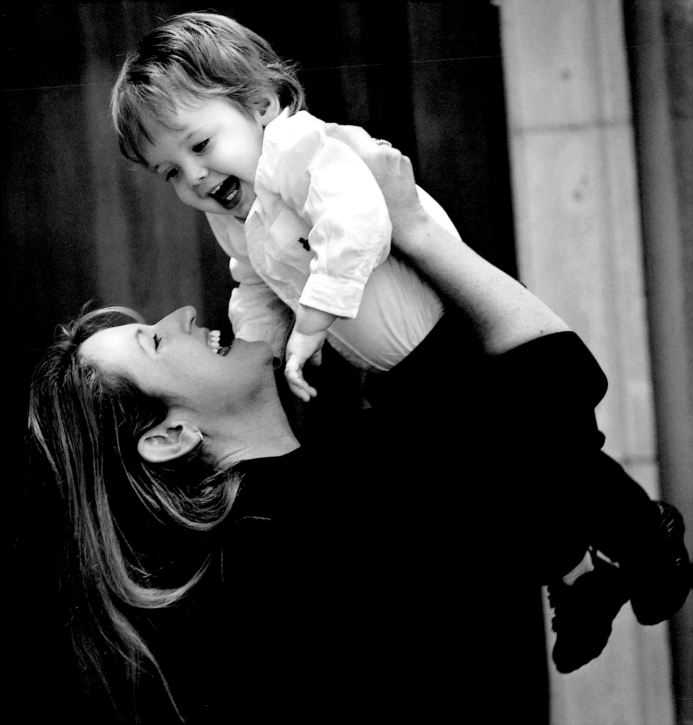

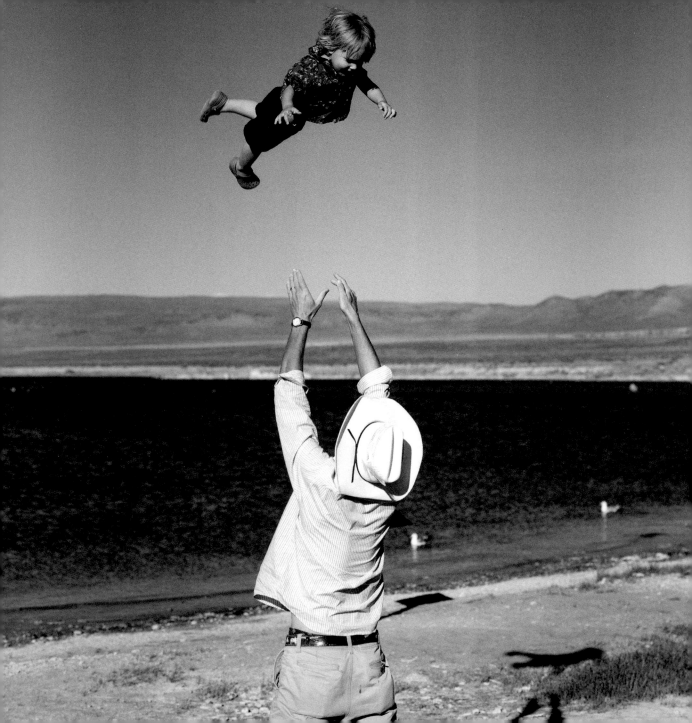

You are a human boy, my young friend,
A human boy.
O glorious to be a human boy!
O running stream of sparkling joy
To be a soaring human boy!

—CHARLES DICKENS

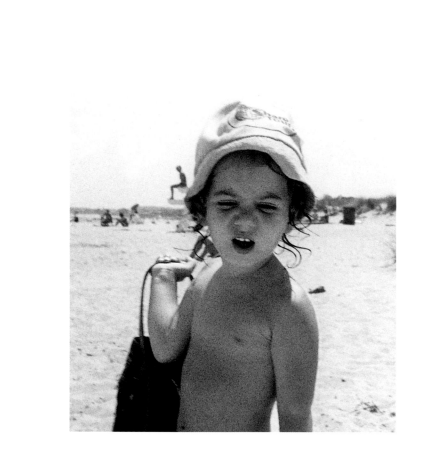

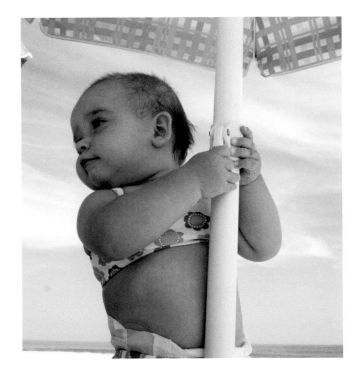

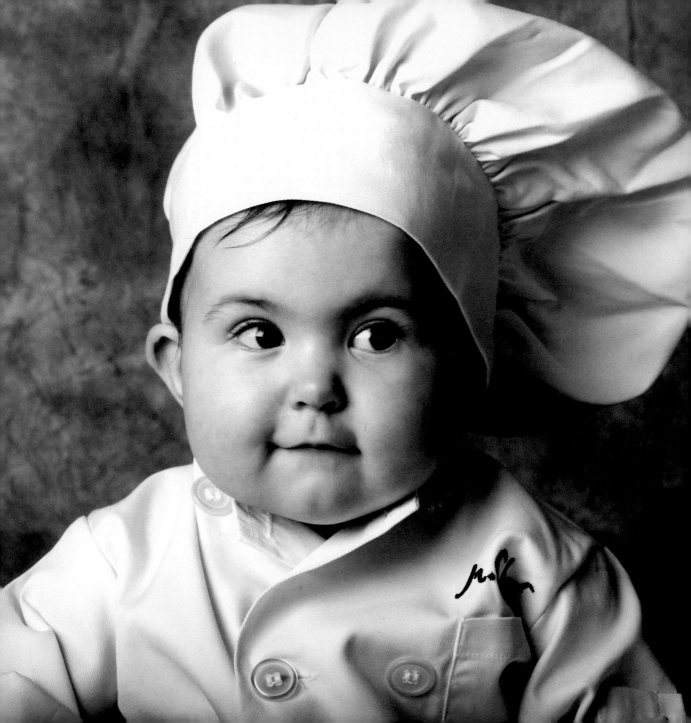

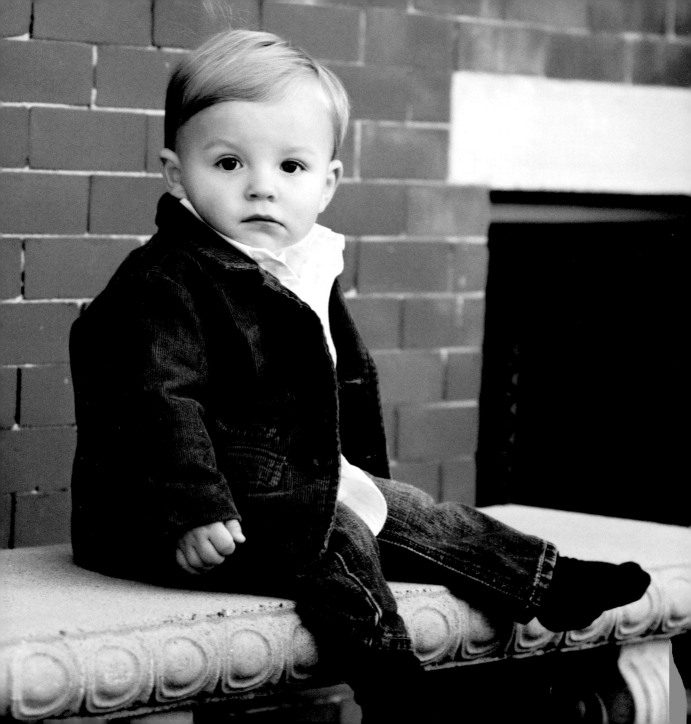

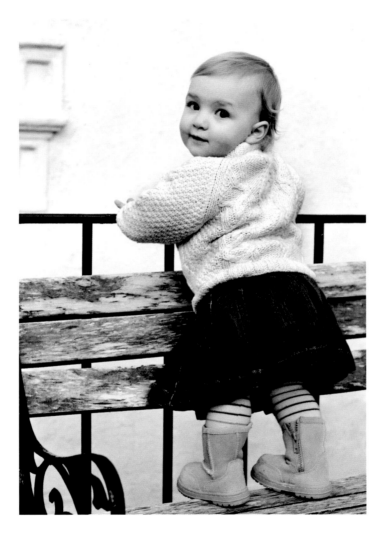

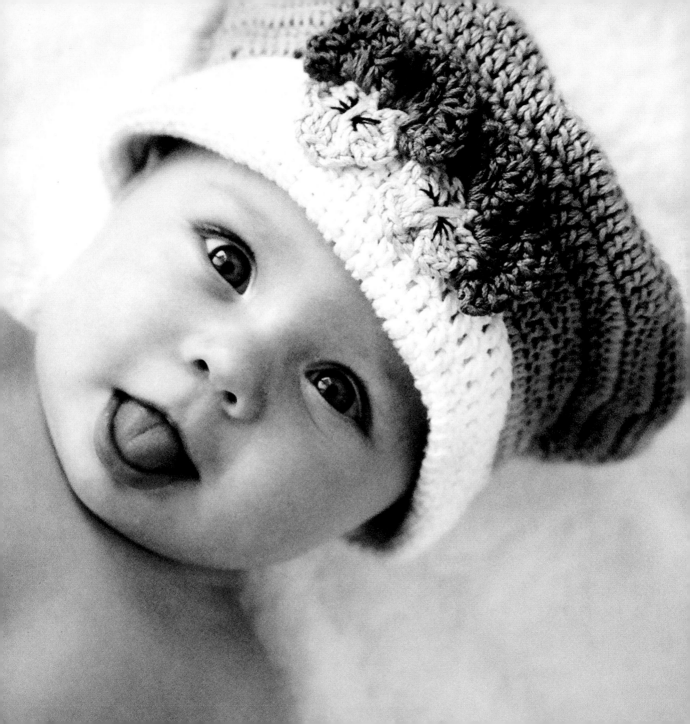

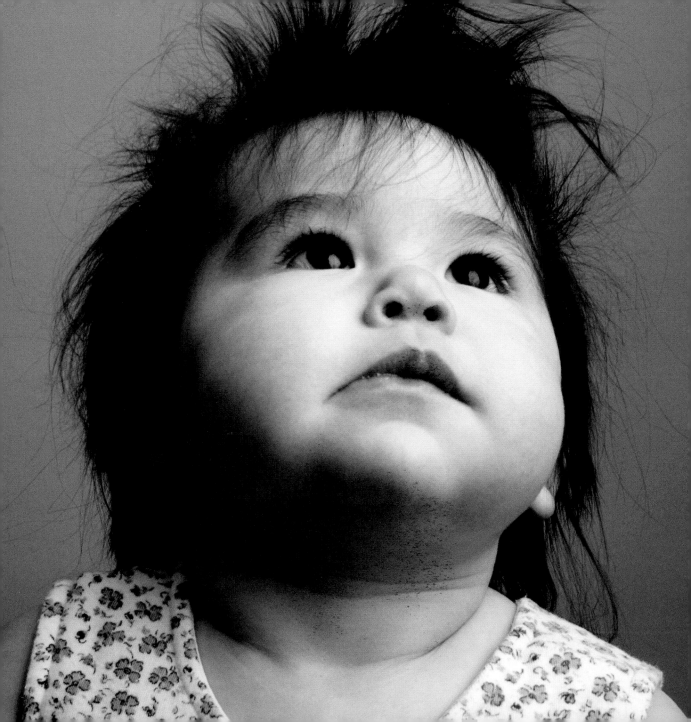

"The time has come," the Walrus said,
"to talk of many things:
Of shoes—and ships—and sealing wax—
Of cabbages—and kings . . ."

—LEWIS CARROLL

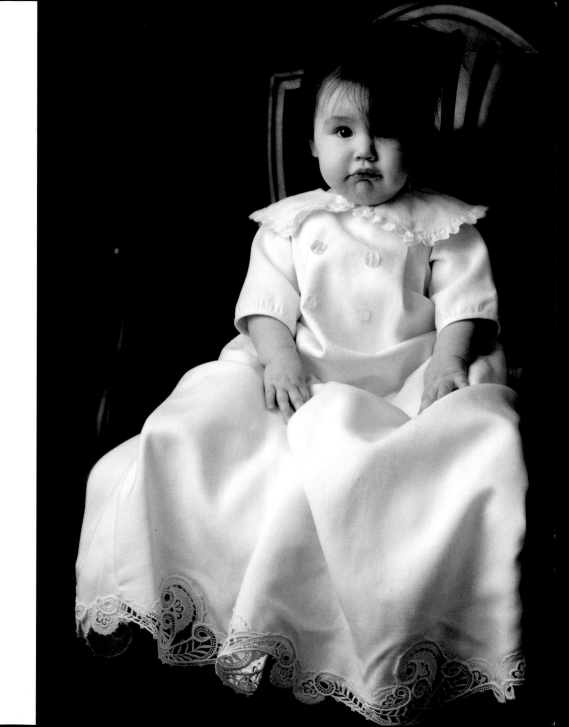

MISTAKEN IDENTITY

One snowy Chicago day, my baby and I had a serious case of cabin fever. No sooner had we ventured out than she was hungry. I ducked into a Starbucks, made myself comfortable, and she cozied up under my sweater. I closed my eyes and dreamed about the latté I would order when she was done.

"Excuse me."

I opened my eyes to a kindly face and, more importantly, a hot beverage. "I'm sorry to interrupt, but was wondering how you do that," she smiled.

"Well…" I said, a little confused, "we just kinda worked it out." As the words came from my mouth, I understood. "Oh," I continued. "You are not the first to wonder. She looks nothing like me, but she does look like my husband. He's of Chinese descent."

"I am so sorry," returned the now flush face. "You are so fair, I assumed you'd adopted her, and were fortunate enough to succeed at breastfeeding. I'm adopting a baby from China, and would love to do that."

In that moment I felt such compassion for this stranger. She wanted to do what generations of women take for granted—nourish her child from her own body. She, like me, would have a baby that has ancestors from a very different culture, a very different gene pool. And in the end it didn't matter, she just wanted to hold her child close and feed her.

I had read a lot about breastfeeding and knew a few contacts who might help. I invited her to join us but only if she was willing to order me that latté I had been dreaming about.

—LISA LIM
Writer

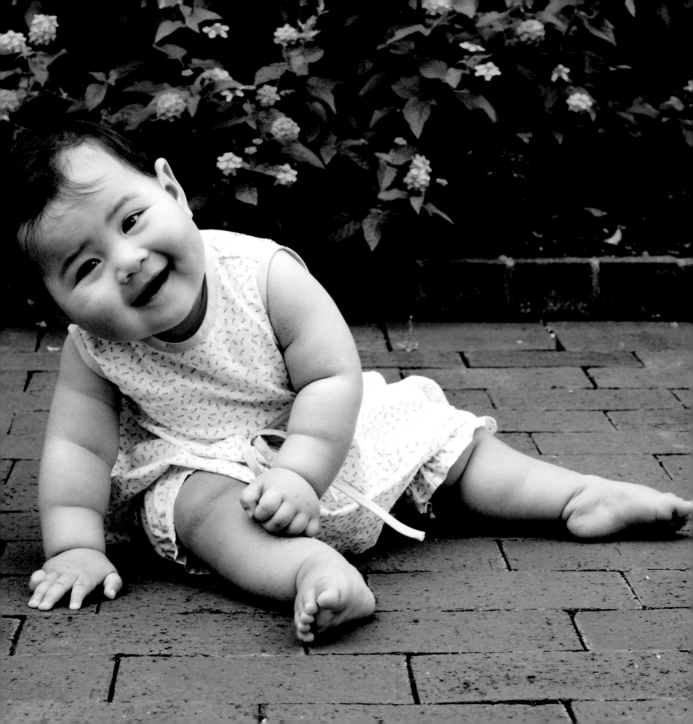

"Who in the world am I? Ah, that's the great puzzle."

—LEWIS CARROLL

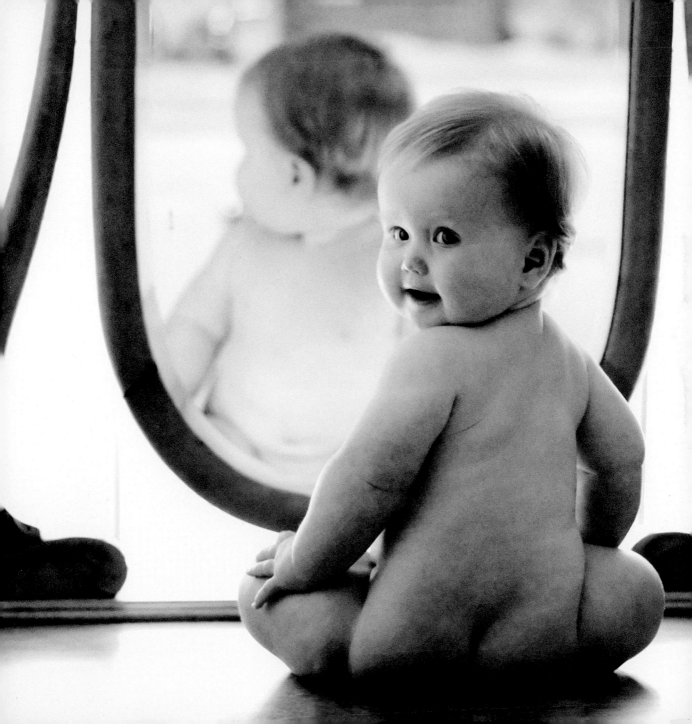

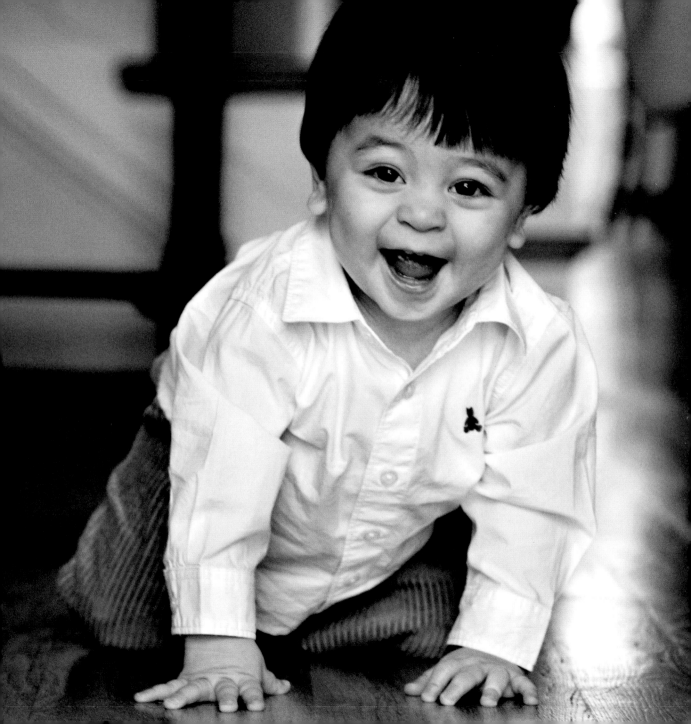

My mother loved children—
she would have given anything if I had been one.

—GROUCHO MARX

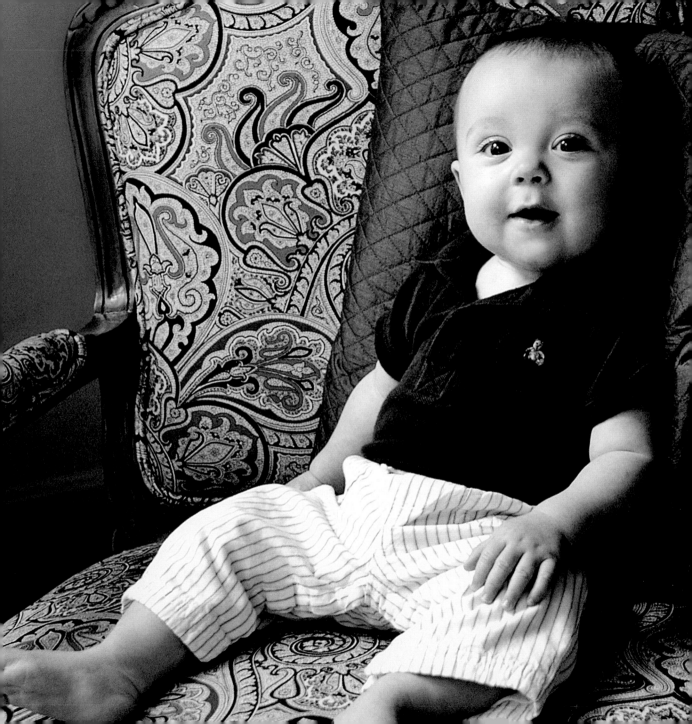

MIKO?

Someday, perhaps when my daughter has a child of her own, I will tell her about the countless nights her father and I spent before she arrived, poring over books filled with name after name, possibility after possibility. Paloma? Sophie? Stella? Too exotic. Too precious. Too connotative of beer. Wyatt? Oliver? Jack? Too country. Too popular. How could we possibly know the appropriate name before meeting him or her face to face?

And so, on the day of her birth we had not a single name but a list of names: eight if a boy, six if a girl and upon seeing her face and hearing her piercing cry, there was no need for discussion between her father and I. She was to be Neko: the name of our favorite alt-country chanteuse; "cat" in Japanese; the only one that felt right.

"Miko?" a nursed asked.
And another: "Is she Greek?"
"Big fan of the Velvet Underground?"
"Neko," we would reply. "N-E-K-O."

I had no sooner uttered these four letters than I realized that we had saddled our beloved with a name she would be spelling for the rest of her life. Which is why I plan to explain to her, my grown daughter Neko, that I am sorry for her moniker and any awkwardness or conversational labor it may have brought upon her over the years. But the thing is, I will say, we had no choice, really. Like you and I, some things just fit.

—ANGIE DAY
Writer/Television Producer

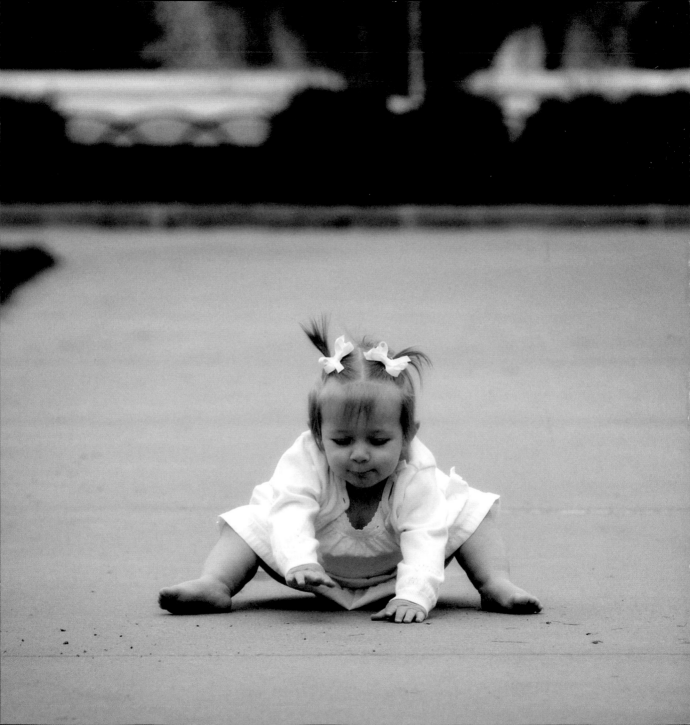

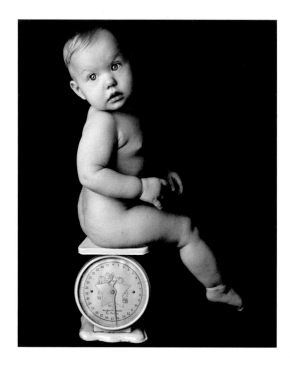

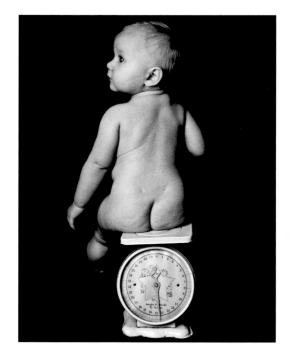

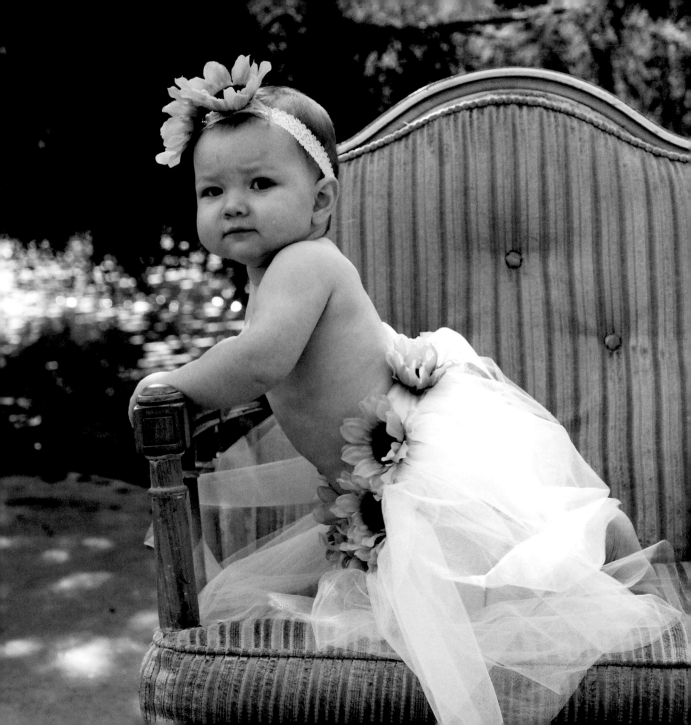

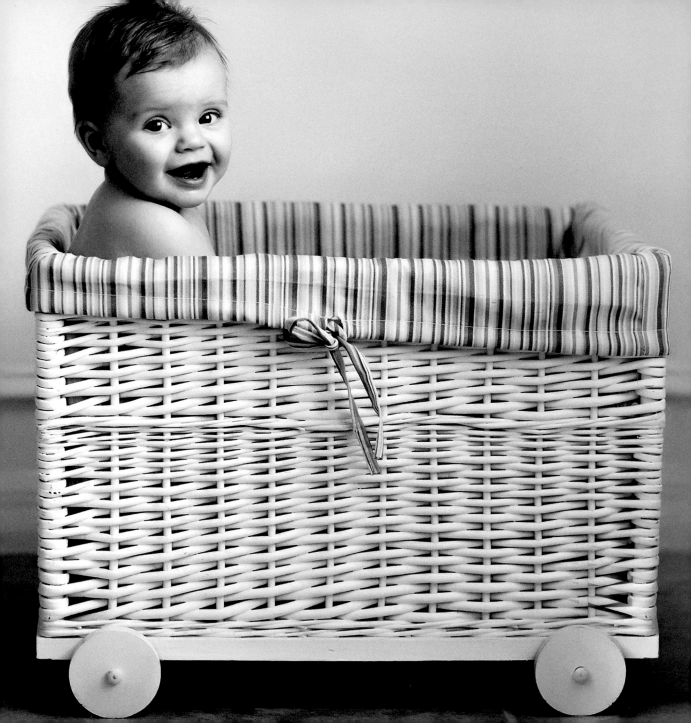

THE FACTS OF LIFE

They're practically old men now, but when one of our kids was two years old, one early cold winter, he climbed into our bed. I suppose he wanted to get warm. And he said, "How come I can't sleep in your bed all the time?" So Jan, my wife, explained to him that only married people slept in the same bed, and then to get him off the subject, she said, "Well, who are you going to marry when you grow up?" And he said, "Well you Mommy, but we're just going to have to get a much bigger bed."

—STAN BERENSTAIN
Children's Book Author

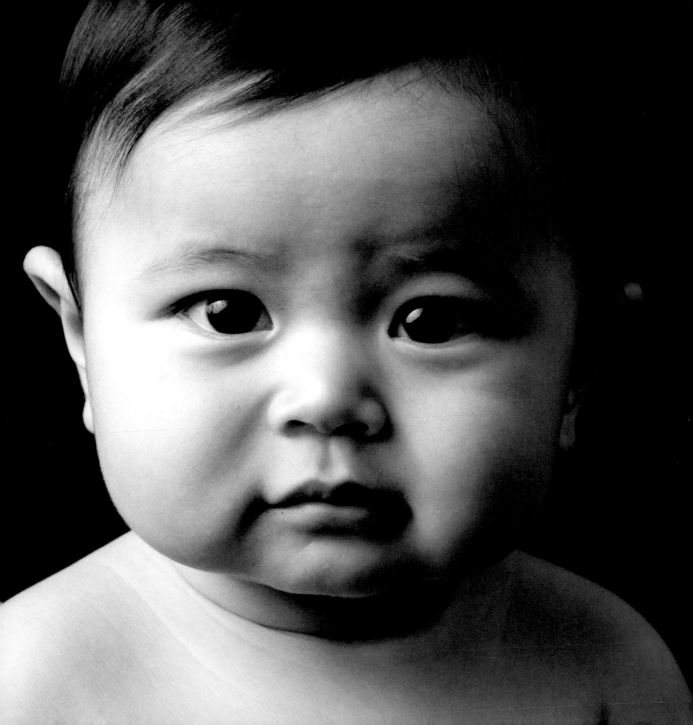

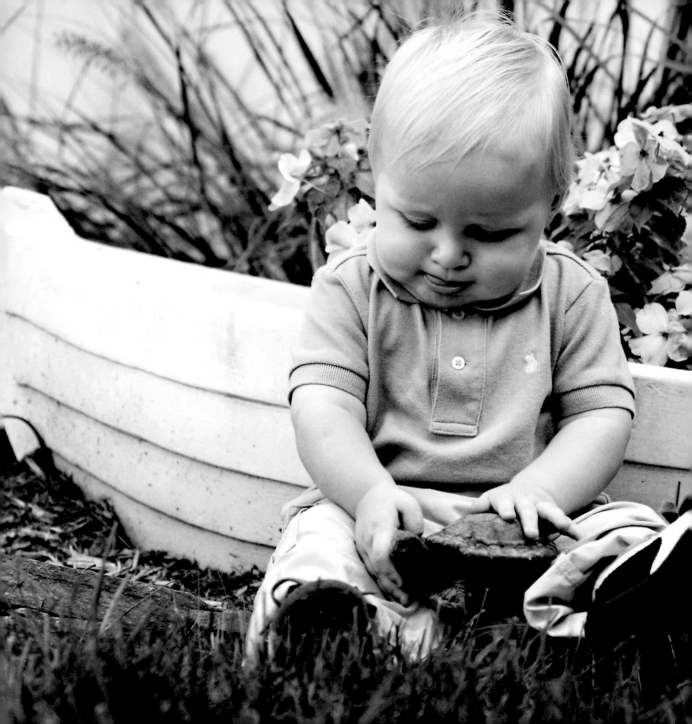

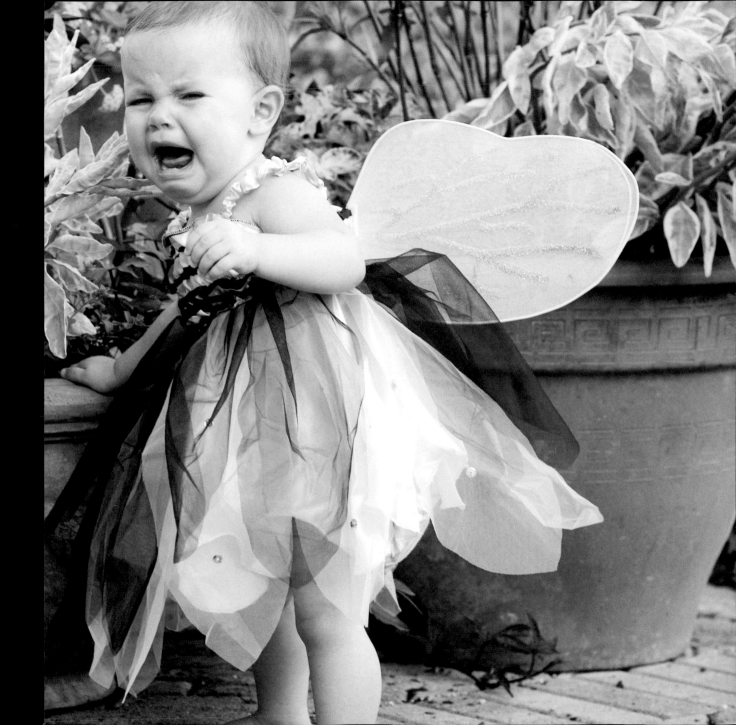

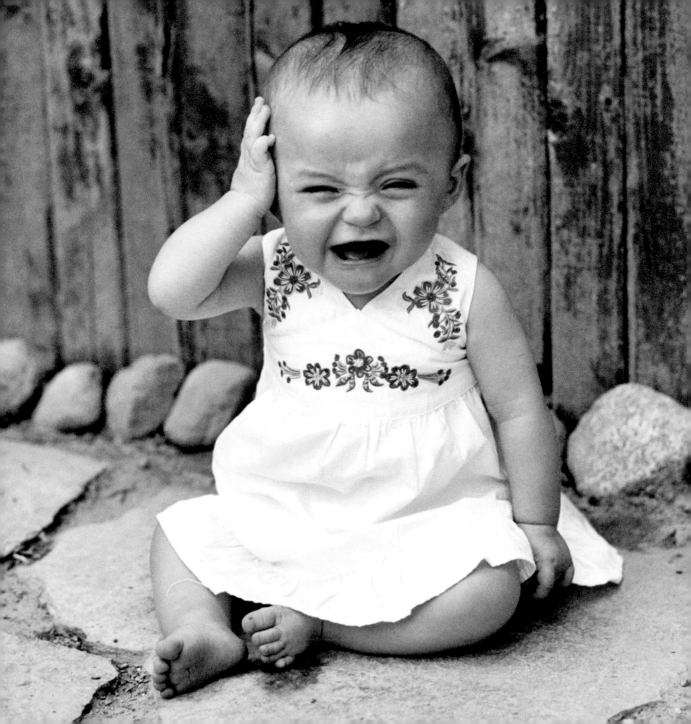

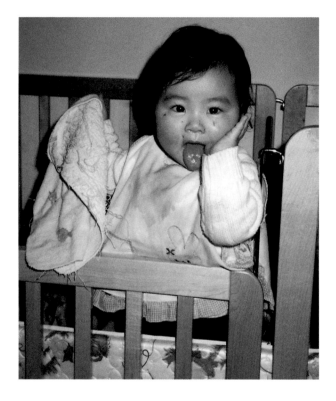

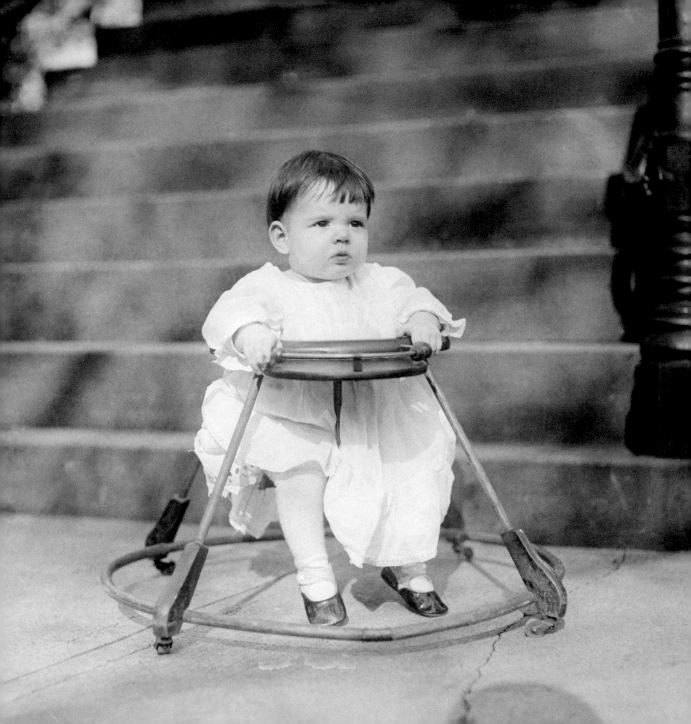

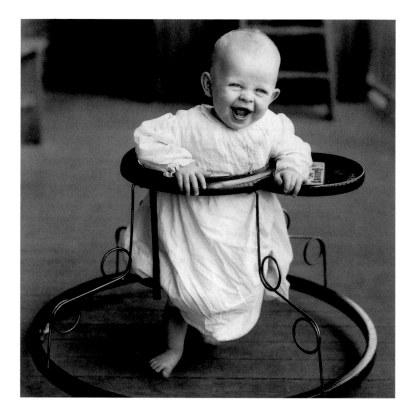

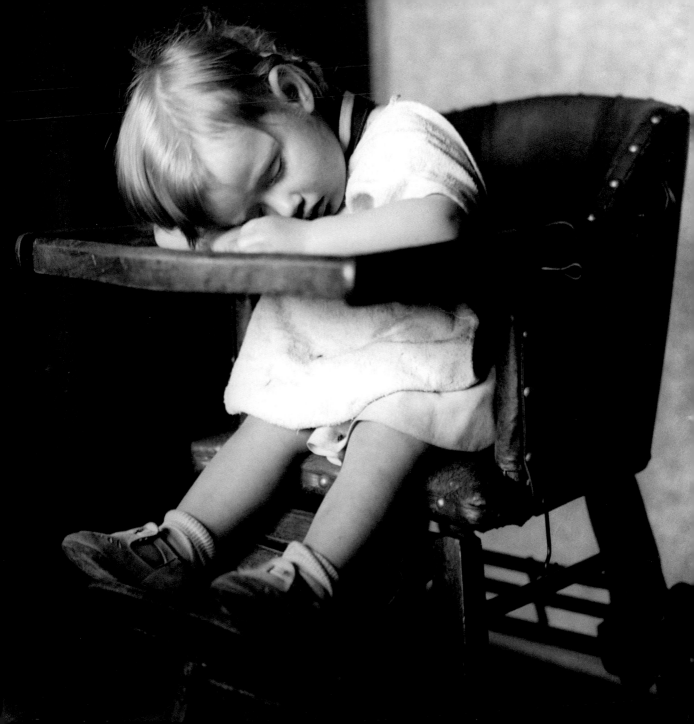

Every baby born into the world is a finer one than the last.

—CHARLES DICKENS

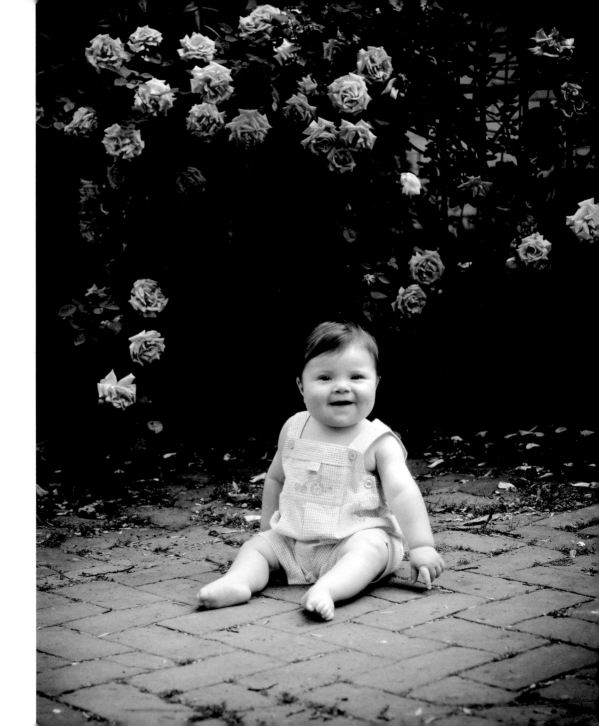

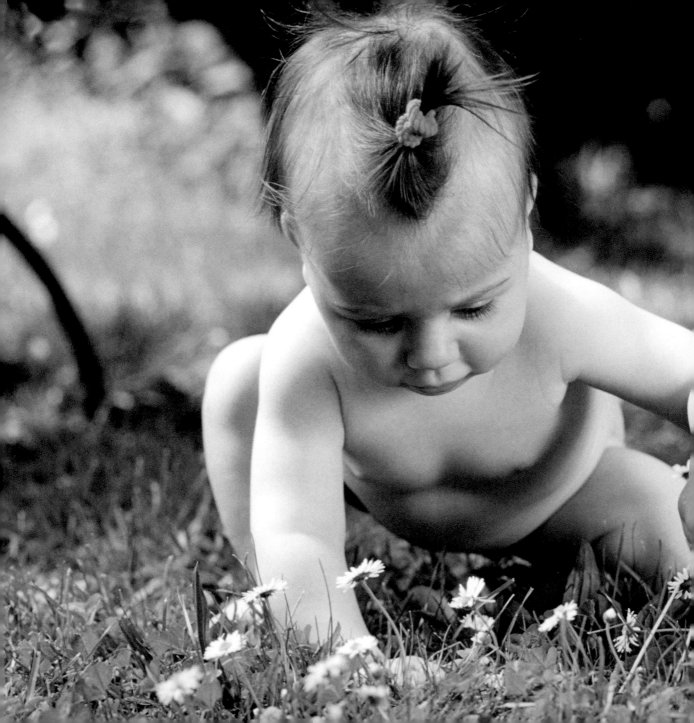

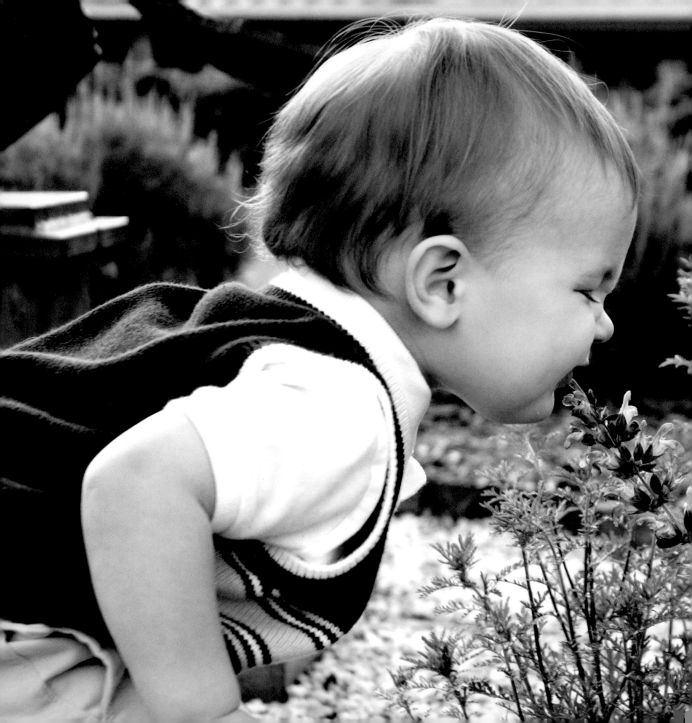

MEEE!

My friend is a new mom. She tells me about her baby, Sam, all the time. My favorite new development is that Sam, who is nine months old, is now talking. He has a vocabulary of about ten words that he uses constantly, but none of them are "Mama." Instead there's words like "Keekee" for kitty, "ba-bow" when he wants to be put in his bouncing wing, "na na na" for things he doesn't like, "Roe" for hello, "gokah" for going outside in the car, and "Meeee!" for himself.

—EVELYN MCDONNELL
Writer

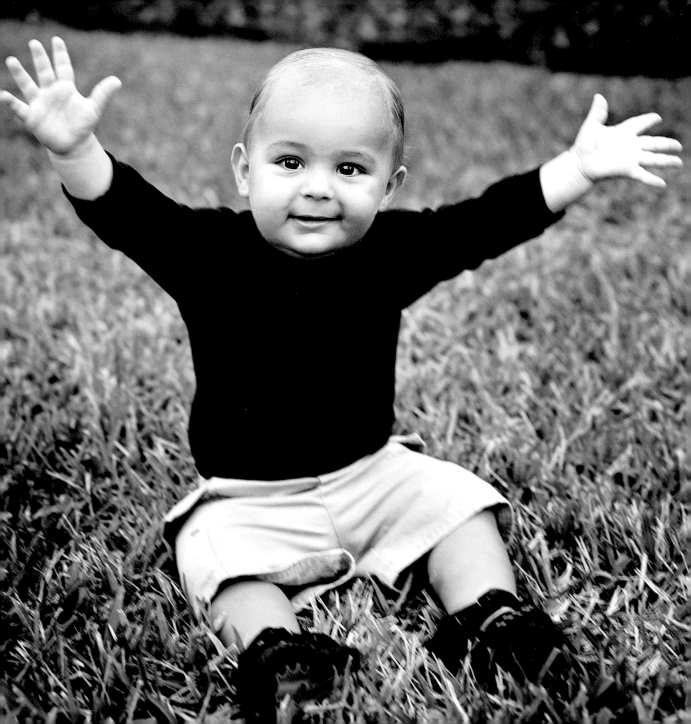

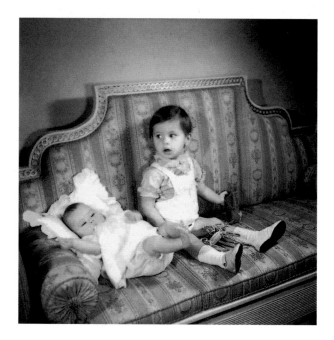

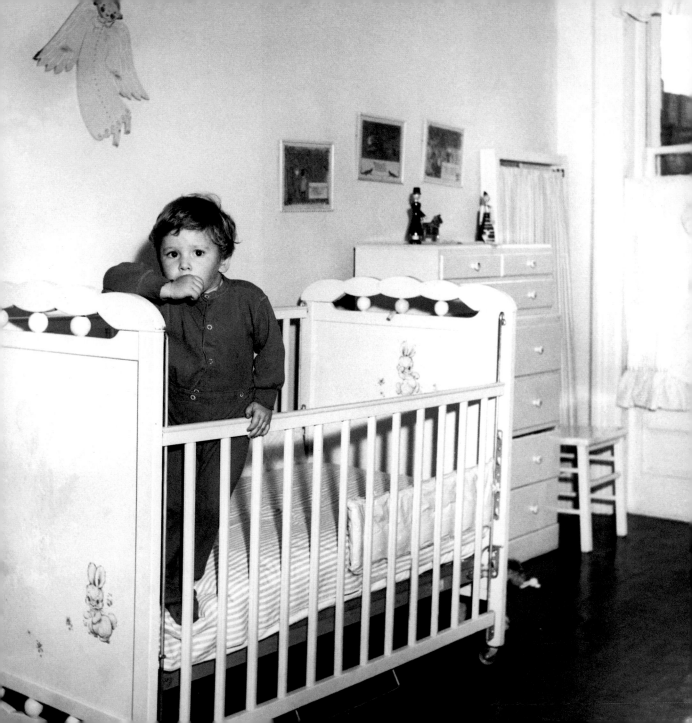

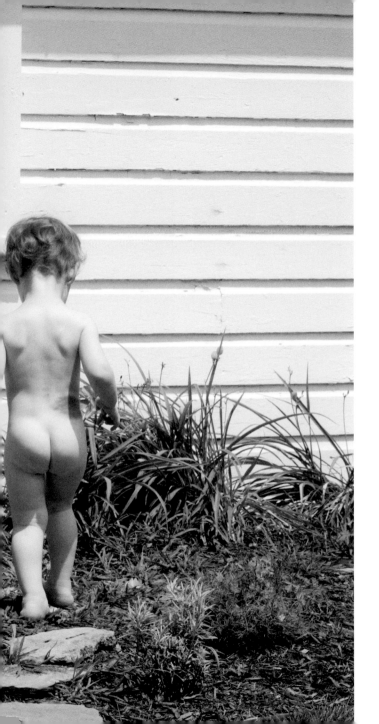

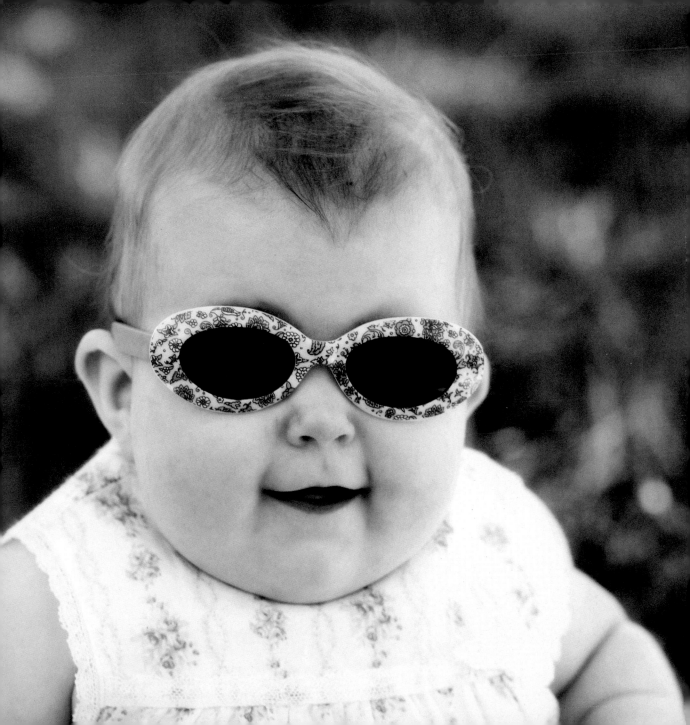

ZEN BABY

It was our routine. He would point, and Miwako or I would say the word, wondering when he would be able to say anything back. Today we were at the baby swing at the spitting seals park.

"Tree…trrrreeeeee…" I mouthed as he pointed at the towering oak over our head. He looked, made some indecipherable baby sound. Not that one.

He pointed at the blue expanse beyond the tree. "Sssskkyyy…"I explained. I demonstrated it several times, hoping. "Sssskyyy…" he mumbled.

What?!! Sky? He said it? He said it! "Sky?" I repeated. "Sssskkyy," he responded. Eureka!

Next he pointed at a billowy white cloud crossing the blue sky. "Clllouuddd," I mouthed. He looked at me, pointed again. One more time: "Clouuudd. . ." I said. "Cccclllowwwd," he offered. I was exploding with pride.

I grabbed him out of the swing, threw him in the stroller, and rushed home to Mama. She had to see this, she had to hear this.

Over and over I enticed him, "sky, sky, sky, cloud, cloud, cloud." Nothing. He just looked up at us with his soft trusting eyes and said nothing.

Not for months.

—JON GLICK
Book Designer

210

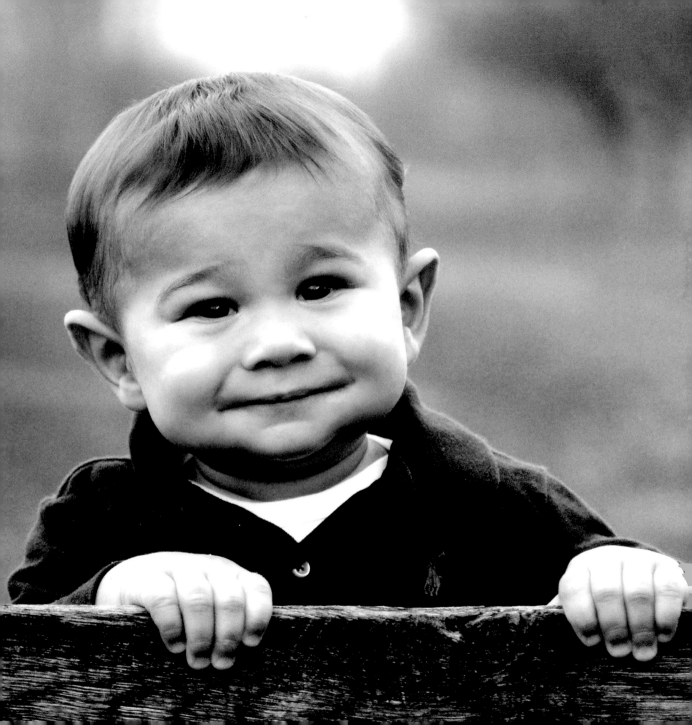

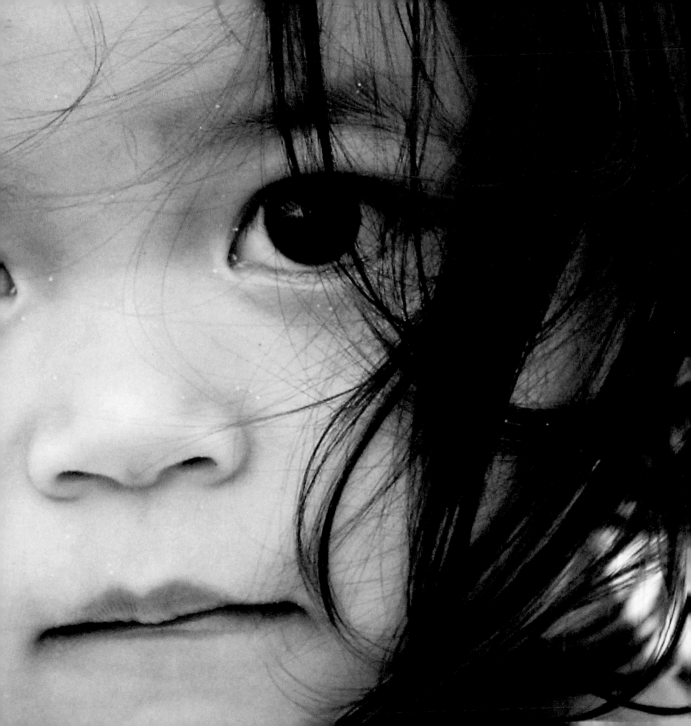

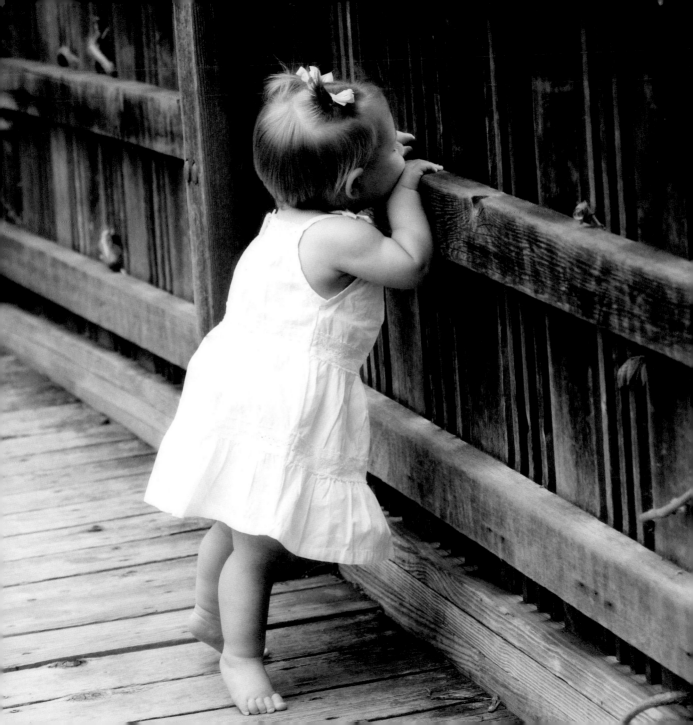

There was a little girl

Who had a little curl

Right in the middle of her forehead;

And when she was good

She was very, very good,

But when she was bad she was horrid.

—HENRY WADSWORTH LONGFELLOW

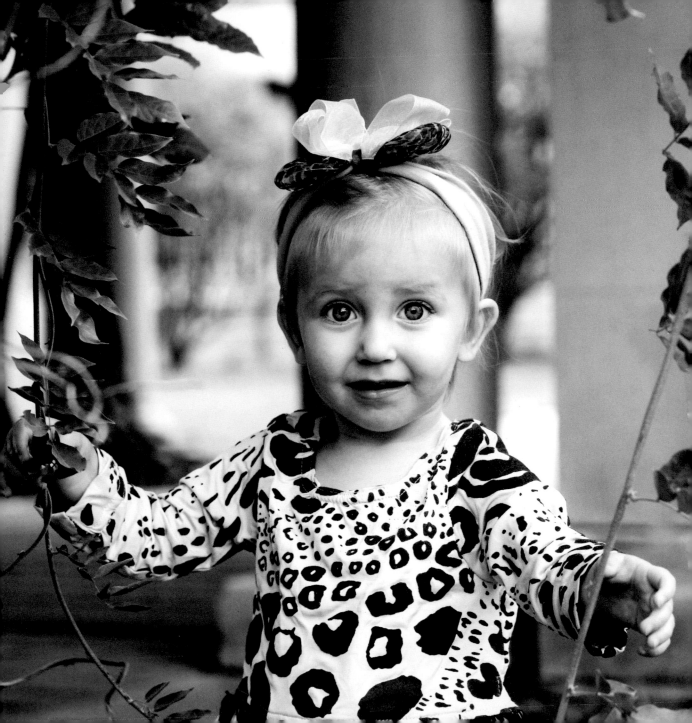

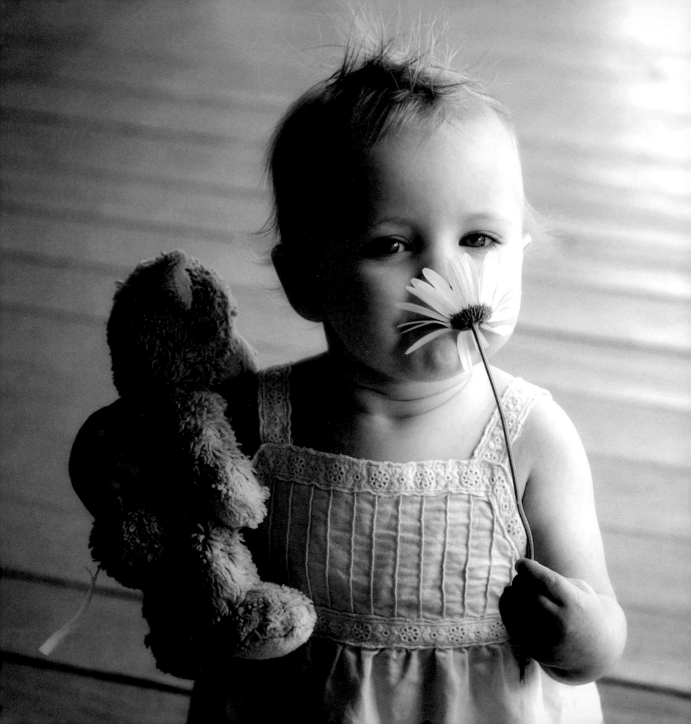

FORGET-ME-NOTS

Looking up from my book, I see Hazel toddle toward my seat in one of the tall windows overlooking President Street. The combined expanses of our long railroad-style front rooms present one yawning challenge to her little legs. Wearing an all-in-one suit in dark blue scattered with forget-me-nots, she is carrying a large board book to her reading nook in the window well adjacent to mine. Walking deliberately, stable on her solid bare feet, she comes to an abrupt halt. A frown worries her forehead behind her wispy golden curls. In one fluid movement, she squats. Heels and toes flat on the ground, knees bent, padded bottom suspended a few inches above the floor. She hovers there, her zigzagged body hanging. Carefully setting down her book, she smoothes out the kicked-up corner of the rug. Contented, she replaces the book under her arm and with one effortless, symmetrical elevation, she stands and continues on to her reading perch.

A teenager now, Hazel sits in the window of another apartment with a book on her knees, legs tucked sideways. Her bedroom is neat, pictures straight, bed made. That love of order has traveled with her through time. Her passion for reading has followed. But her perfect toddler squat is gone, forsaken with the onesies and the board books. I miss those abandoned toddler traits. But because of them, I cherish even more the loved ones who are with me still.

—SARAH BUTTERWORTH
Book Producer

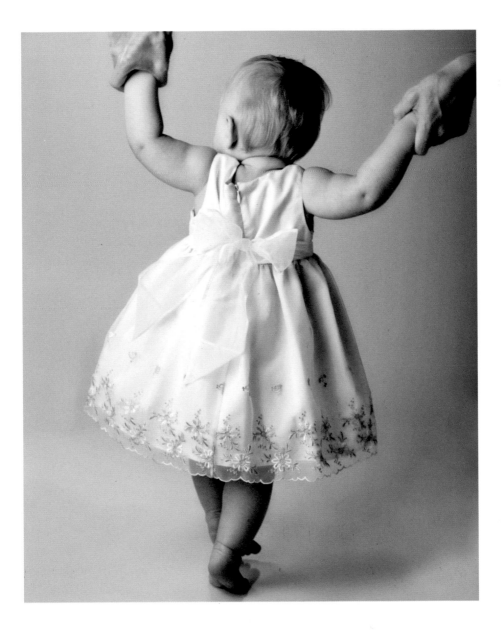

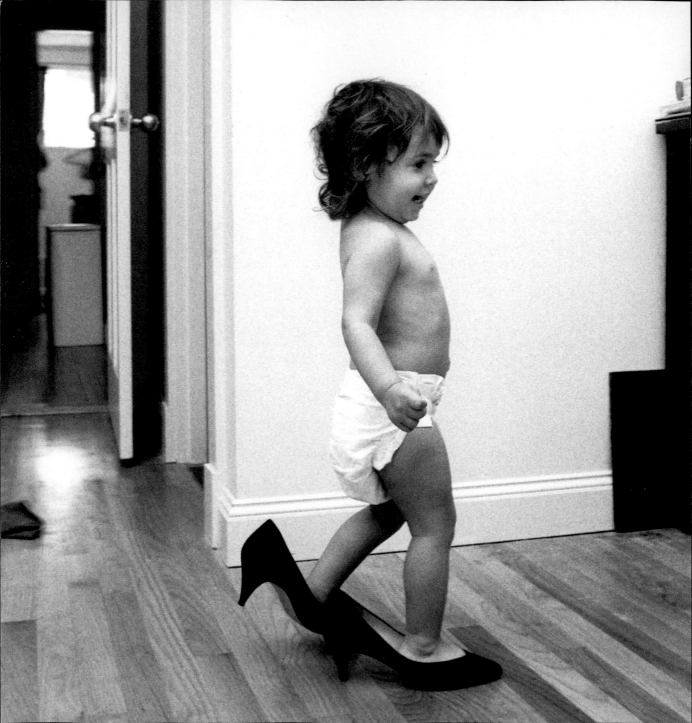

And whatsoever you do, do it heartily.

—COLOSSIANS 3:23

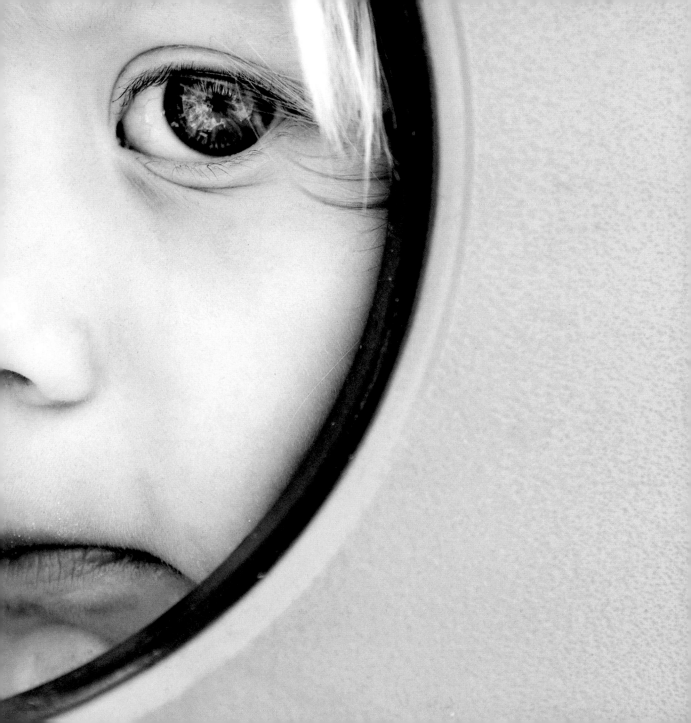

HEALTHY APPETITE

My daughter Nancy was what you'd call a busy baby. She was very strong, quick, and curious. So the house came under a state of siege. For instance, she enjoyed eating so much, she just wanted to eat anything she could. She ate foam rubber pads underneath our rugs, and the paper jackets on our books. She'd just crawl around, looking for things to eat. For safety's sake, I'd put little chains and locks on all the kitchen cabinets. So every time I went into the kitchen and opened them, she could hear the chains tinkling, and she'd rush into the kitchen after me knowing that for a moment, forbidden territory would be at her reach.

—MYRNA MARTIN
Artist

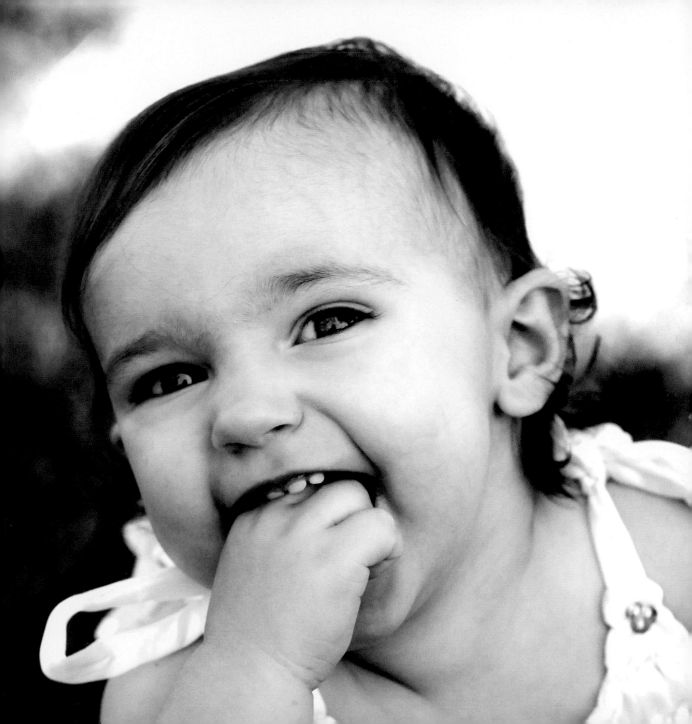

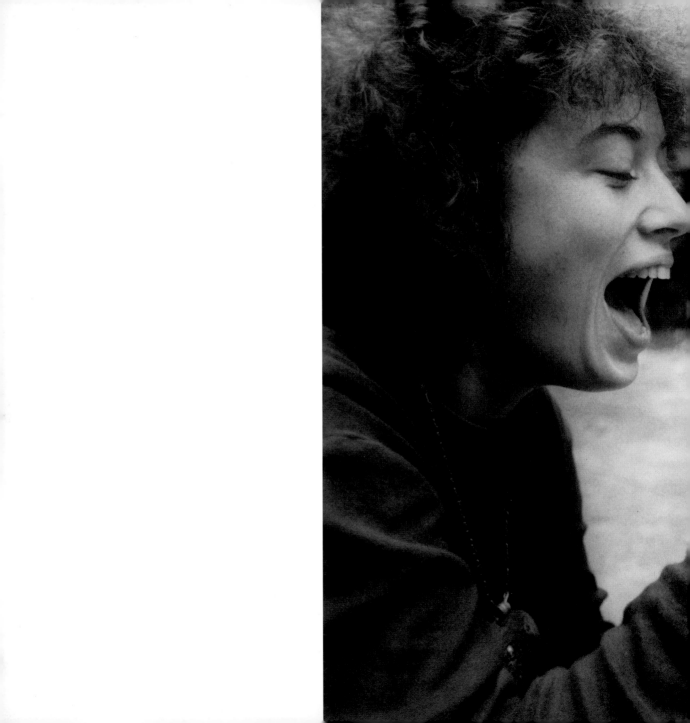

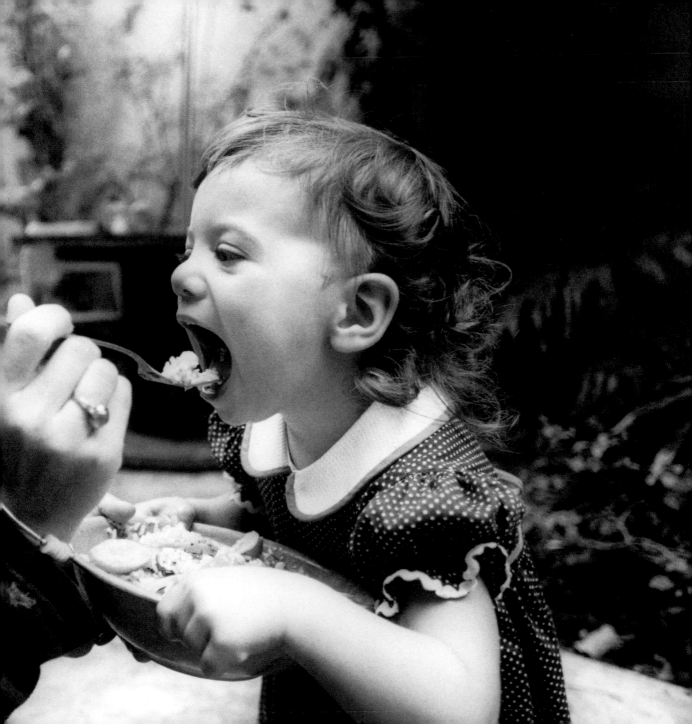

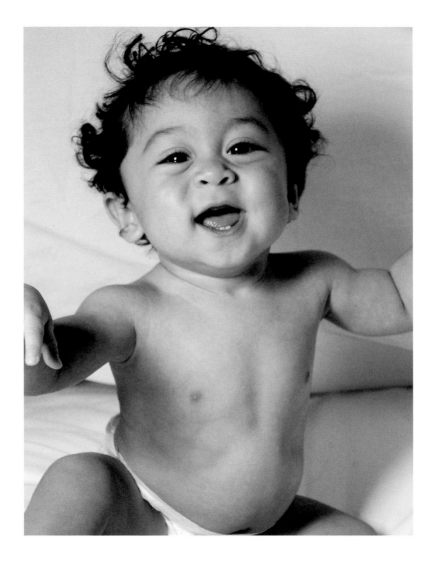

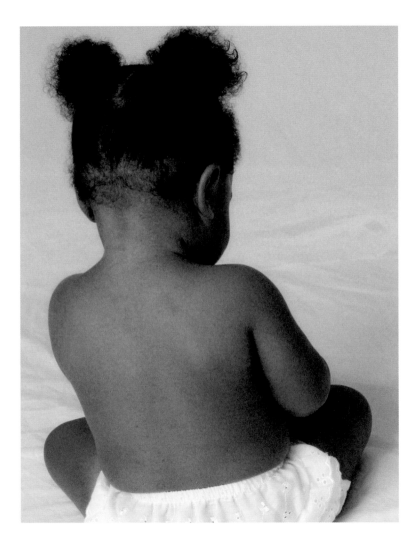

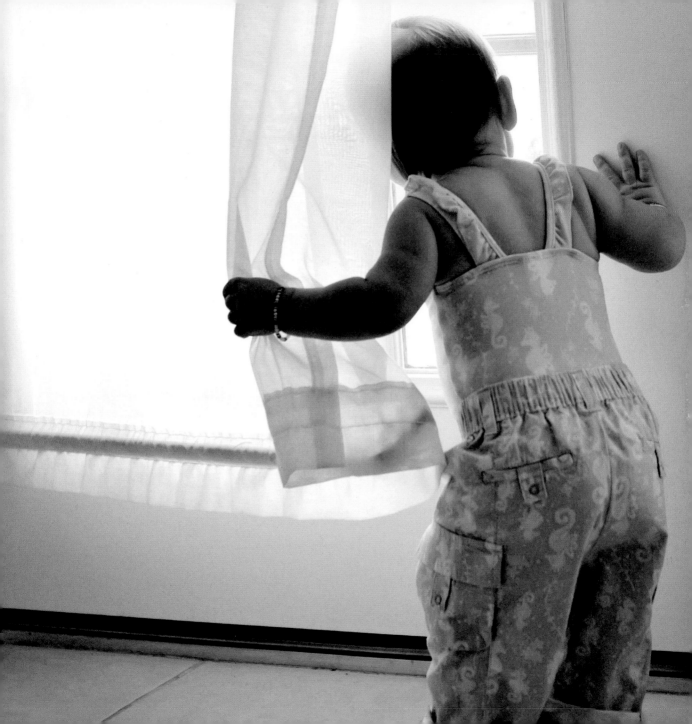

THE WHISPERING PINES

When Jasper was six weeks old it was not uncommon for him to wake up two or three times in the night and still be ready for action long before the rising of the sun. Then we took him camping. In a pack-n-play, zipped up in his own tent beneath the stars and the whispering pines, he slept twelve hours straight—without a peep.

I'd read a host of baby books on all sorts of subjects, but nowhere had I read of the simple mellowing powers of fresh air. I was tempted to sell our house in Los Angeles, to set up camp on a lake somewhere and never leave. That didn't happen. Still, it wasn't long before we figured out that when he got to that truly inconsolable place, the only way to calm the little dude was to take him outside.

Eventually, the fresh air in Los Angeles being what it is—i.e. exceedingly rare—we packed up our things and moved to the High Sierra, to Mammoth Lakes. By the time Jasper was 18 months old, the outdoors were no longer merely a sleep agent, they were his whole world. His first words: pinecone, moon, rock, bluejay, bear… "Bear!" he shouted gleefully while tearing across the playground toward a full-grown female black bear. She, in turn, chose to amble off in the direction of a dumpster. Jasper's first favorite pastime: "baseball" (hitting a pine cone with a stick). His second and third: skiing and snowboarding.

I grew up in New York City. The out-of-doors is not foreign to me but it is also not home. For Jasper it clearly is. Now he is two. Does he sleep through the night? Sometimes.

—ALLISON MCDONELL
Actress/Writer

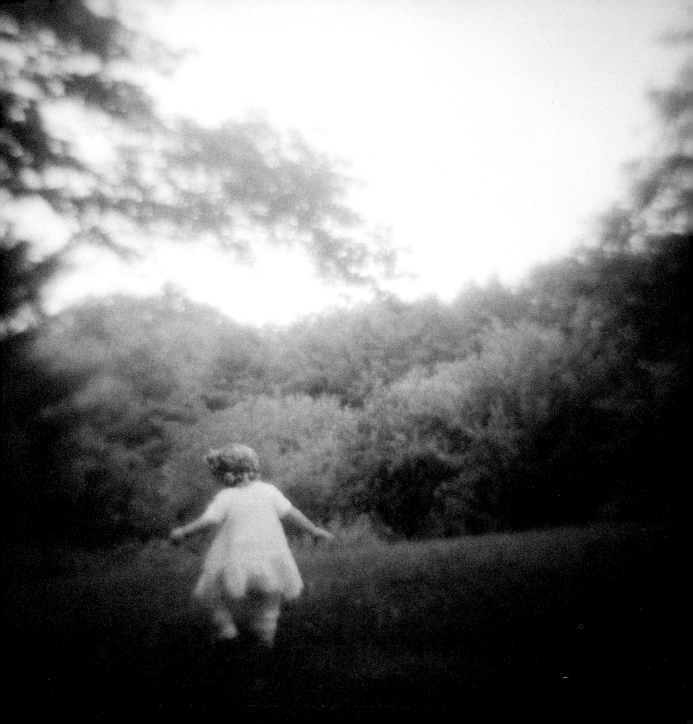

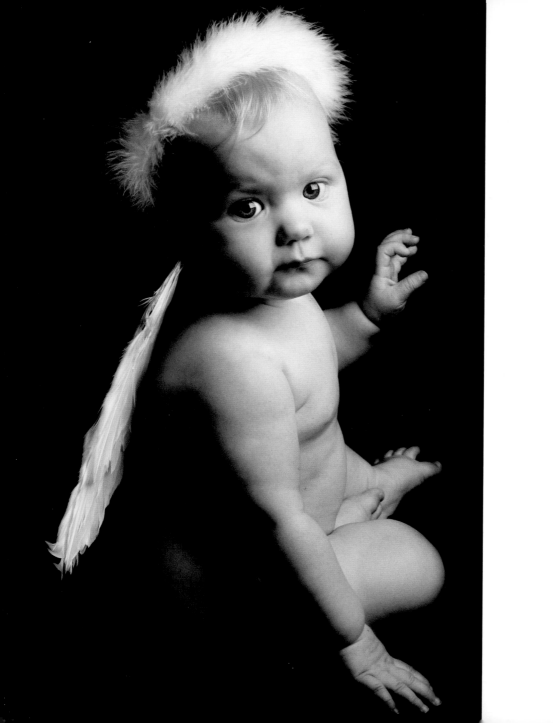

A CHILD'S THOUGHT

At seven, when I go to bed,

I find such pictures in my head:

Castles with dragons prowling around,

Gardens where magic fruits are found;

Fair ladies prisoned in a tower,

Or lost in an enchanted bower;

While gallant horsemen ride by streams

That border all this land of dreams

I find, so clearly in my head

At seven, when I go to bed.

—ROBERT LOUIS STEVENSON

BUNNY BAGS

We sing to our children every night at bedtime. My husband, Tyler, sings boisterous songs like "John Jacob Jingleheimer Schmidt" and "On Top of Spaghetti," and I sing slower, mournful ones. And I never sing "Loch Lomond" without telling them the story that goes with it.

I am pregnant with our second child, slightly nauseous, doing the dishes. Tyler comes whipping down the stairs into the kitchen. He's been putting Calla, who is a little more than a year old, to bed.

"Where are the bunny bags?" he says.

I shut off the faucet and hear Calla crying in her crib.

"What?"

"Where are the bunny bags? She's screaming for the bunny bags!" He comes in and rakes his eyes around the kitchen as if I've stuffed bunny bags in one of the drawers.

Aware of the wailing above, my mind flips at lightning speed through images of all our bags: the black diaper bag, the striped toy bag, the two backpacks, the duffels, my green purse. Not a bunny on or in any of them. No bunny bags. And then I get it, and start to laugh.

"What?" he says, somewhere between chuckling and whimpering.

I sing: "By yon bonnie banks and by yon bonnie braes

 Where the sun shines bright on Loch Lomon'."

But he's gone by the third word.

I stand at the foot of the stairs, listening. A few louder, outraged bleats from Calla upon his return, and then silence as my husband hits the first note.

—LILY KING
Writer

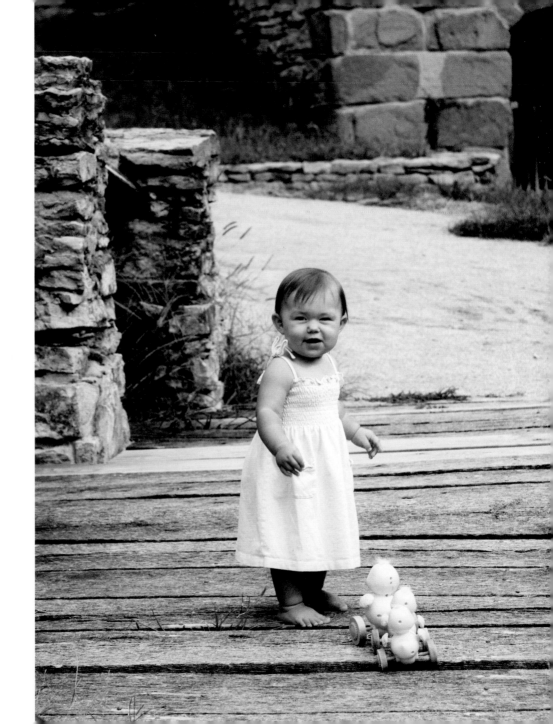

Every day I count wasted in which there has been no dancing.

—FREDERICH NIETSZCHE

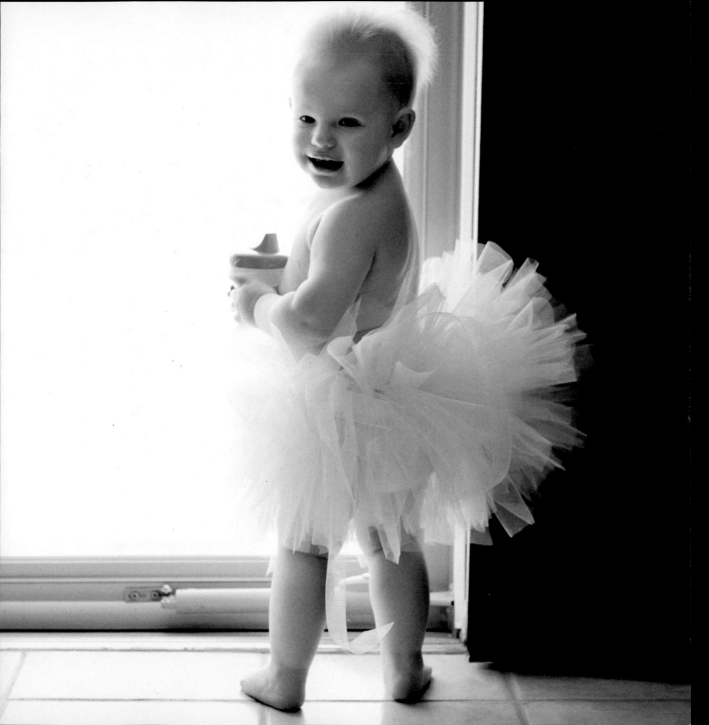

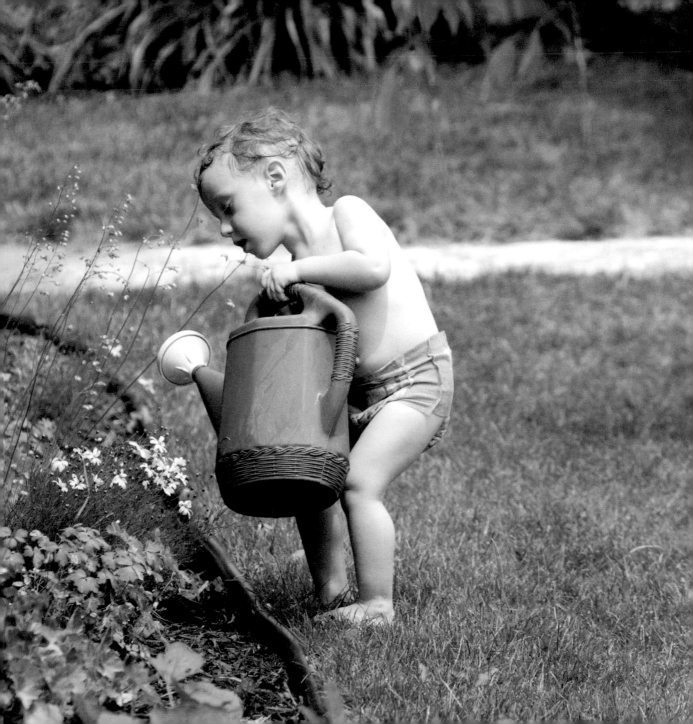

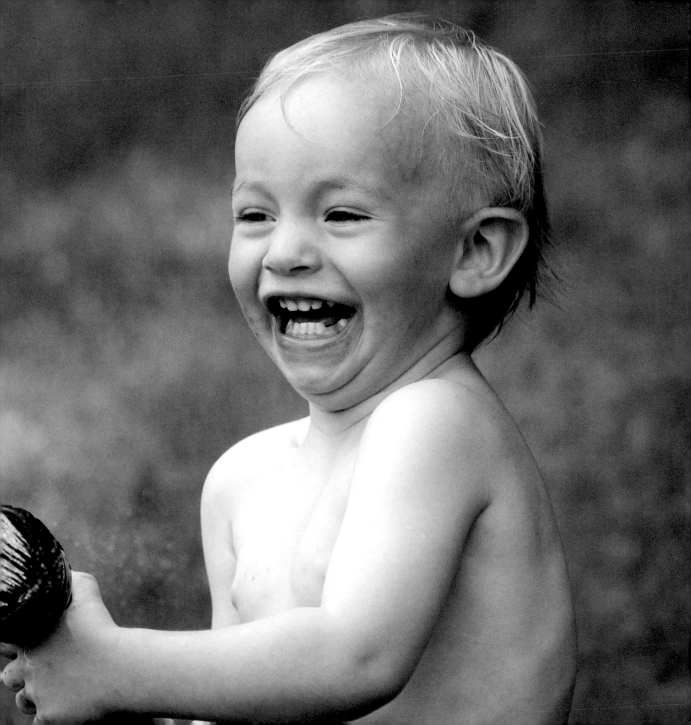

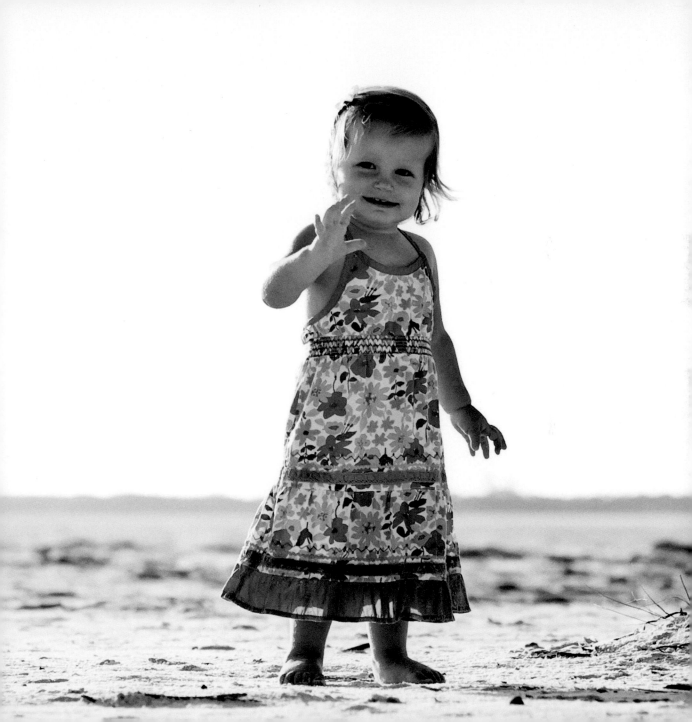

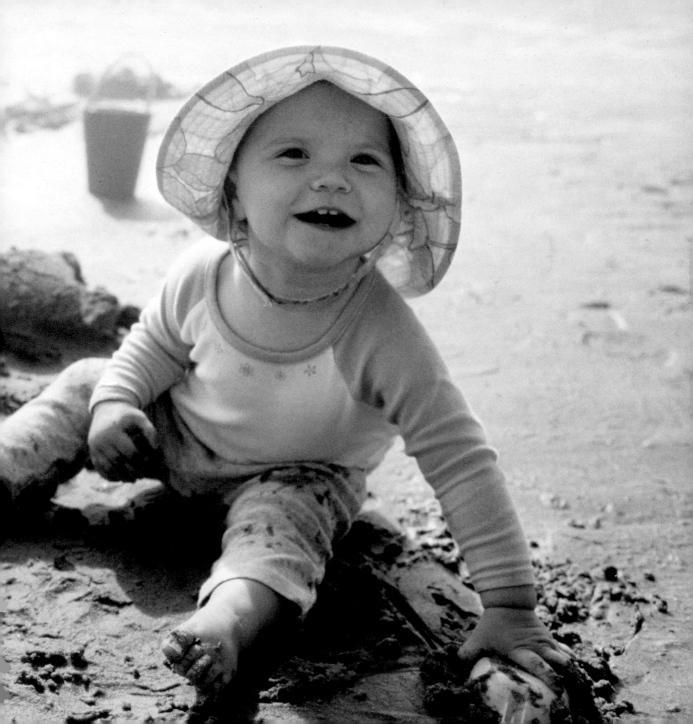

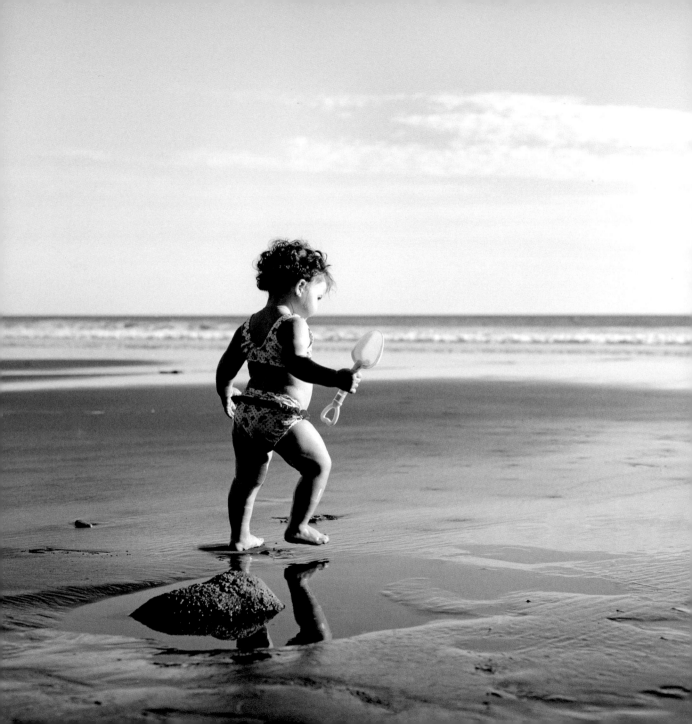

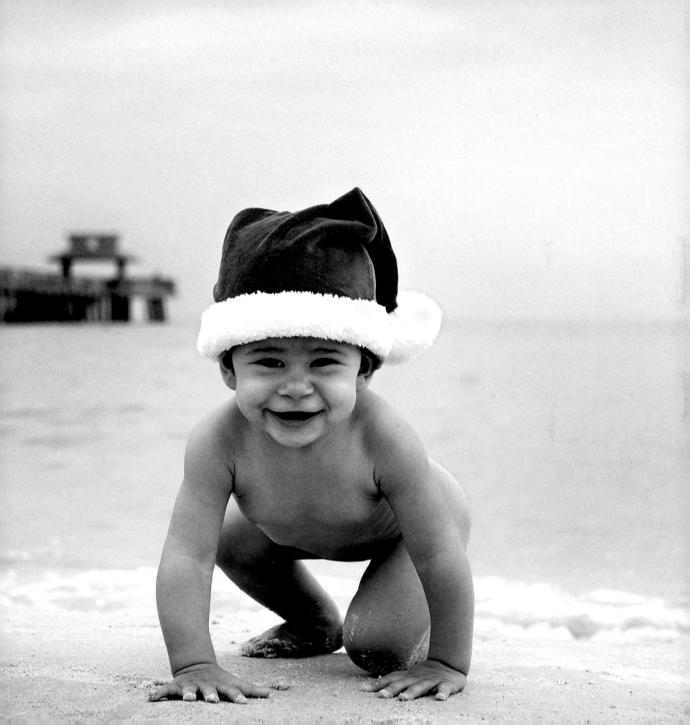

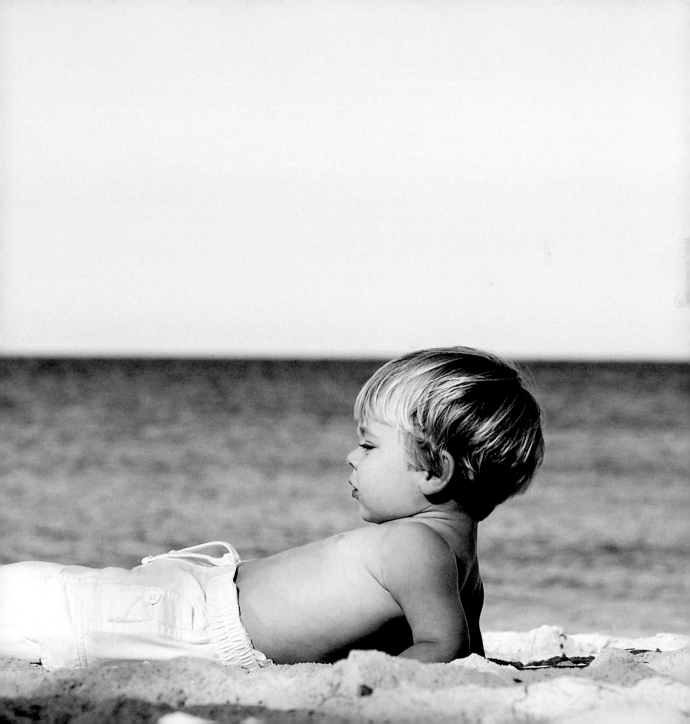

I MET MY DAUGHTER

I met my eleven-month-old daughter, Jaden, on a sweltering August day in Southern China in a wood-paneled meeting room along with two dozen other Caucasian Americans who were meeting their babies too. The infants cried and the new parents suppressed sobs while attempting to videotape their first moments together. Our daughter had never seen a non-Chinese face before, and the shock of being placed in my husband's pale arms made her reach for her dark-haired Chinese nanny. Then we gathered around—our blonde four-year-old son, my blue-eyed mother, and myself—and caused her to cry so hard that she became feverish and the back of her light brown head dripped with sweat.

Later, as I carried her through the halls of our hotel watching as she reached out desperately to any Chinese person—man or woman—who passed by, I worried that she might never feel at home with people who look so different. She refused food and drank nothing for the first twenty-four hours. Her hesitation and fear continued for three days. On day four, our son began playing with a red plastic ball that had a simple smiley face painted in black on one side. He bounced the ball close to Jaden's face, and suddenly, despite her unease, she reached for the ball and giggled. Tears sprang to my eyes and my husband reached for the camera. Every face in the room was smiling—four eager white ones, her toothless brown one, and the smiling red face on a little plastic ball.

—LAURA KRISKA
Writer/Intercultural Business Consultant

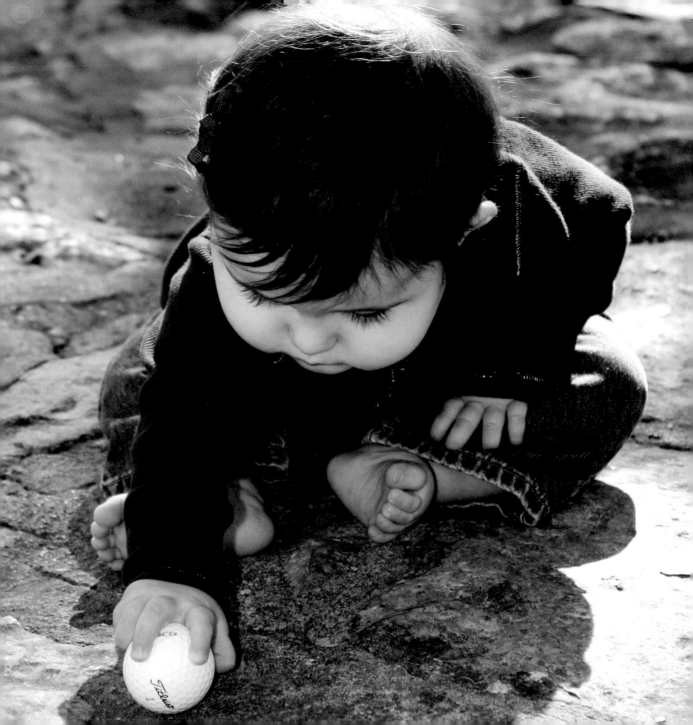

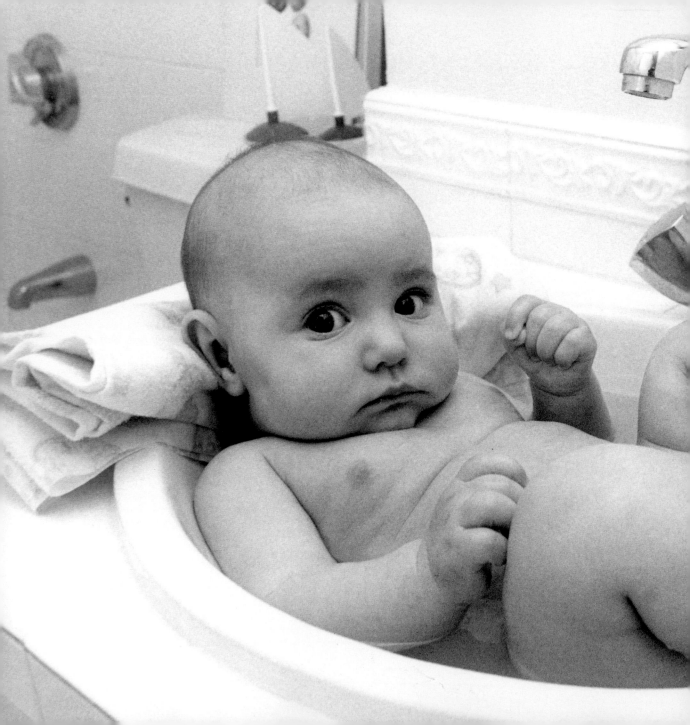

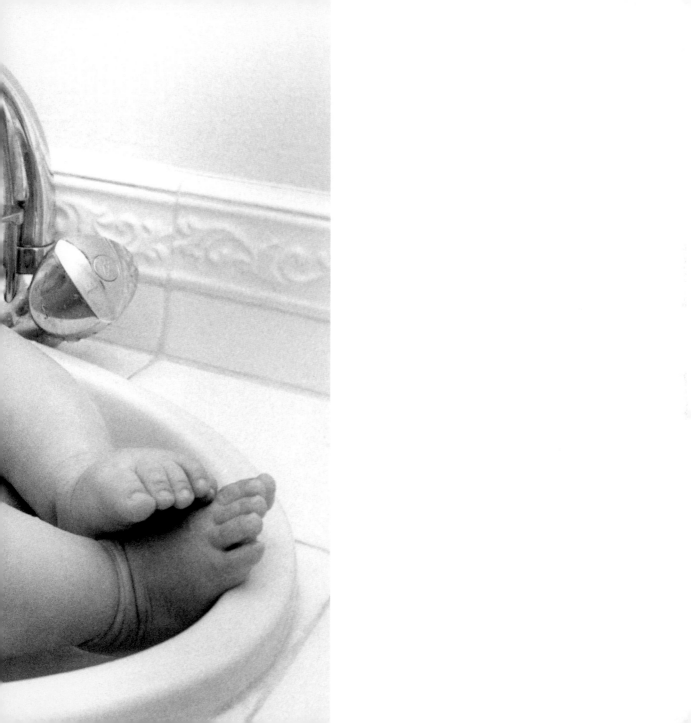

Piglet sidled up to Pooh from behind.
"Pooh!" he whispered.
"Yes, Piglet?"
"Nothing," said Piglet, taking Pooh's paw.
"I just wanted to be sure of you."

—A. A. MILNE

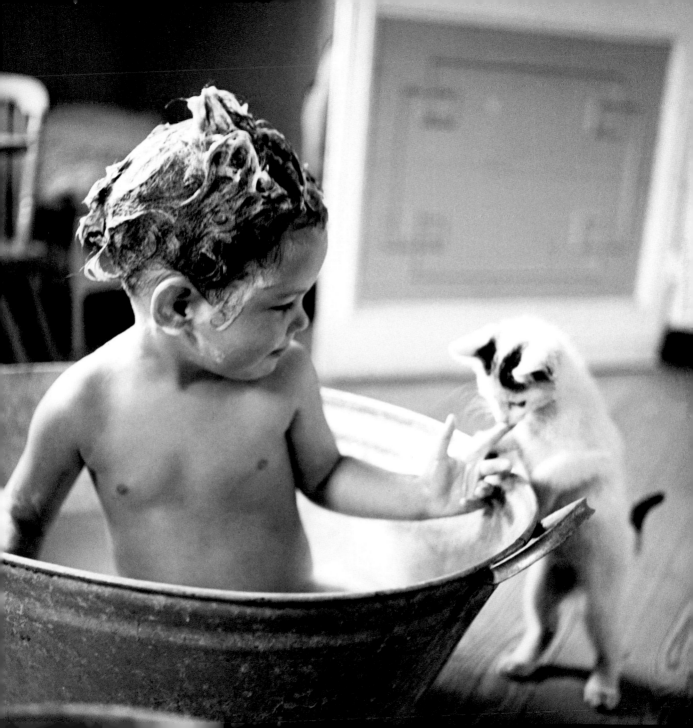

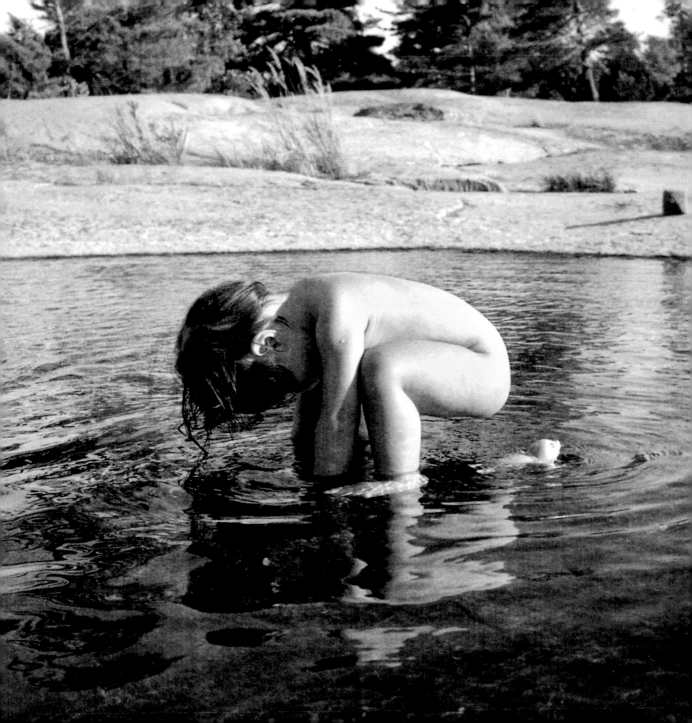

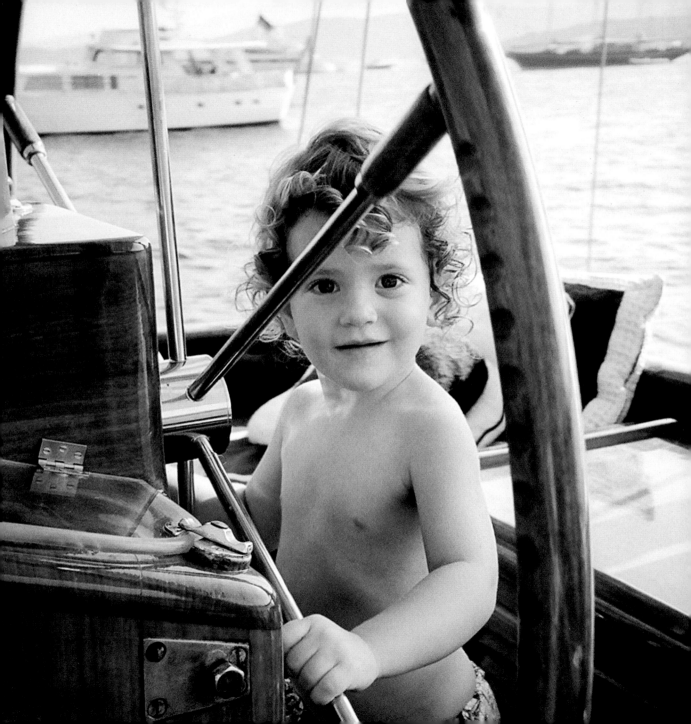

Life loves to be taken by the lapel and told:
"I'm with you kid. Let's go."

—MAYA ANGELOU

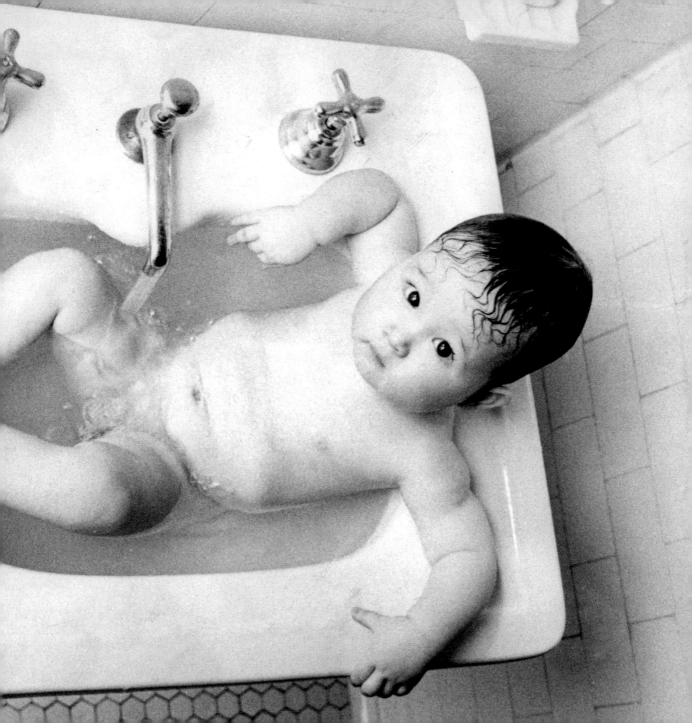

I'M THE BIG SISTER

Normally I help my Papa give my little sister a bath. We wash her hair carefully and lean her head way back so she doesn't get soap in her eyes. I like the way her hair gets flat on her head, like mine when it's wet. Sometimes I imagine what it's going to be like when she is older and has a lot of hair like me. I think about what kind of hair I'd like for her, and I think I'd like it to be my color, but a little darker, and my length, but a little shorter. Sometimes after the bath, I put cream on her head and make it like she has a hairstyle.

But it's more fun for me to get in the tub with her. My sister loves being in the water and goes "splash splash splash" with her hands. She laughs in the bath and makes funny faces. I like her little teeth. They're very small and very white, like little eggs. Sometimes she tries to eat the water. I lift her up so she doesn't drink it.

We're a lot alike, my little sister and me. Even though she wears socks, sometimes her feet smell really bad. Except she likes to crawl, and I never did.

—SOFIA BERG, AGE 7
Big Sister

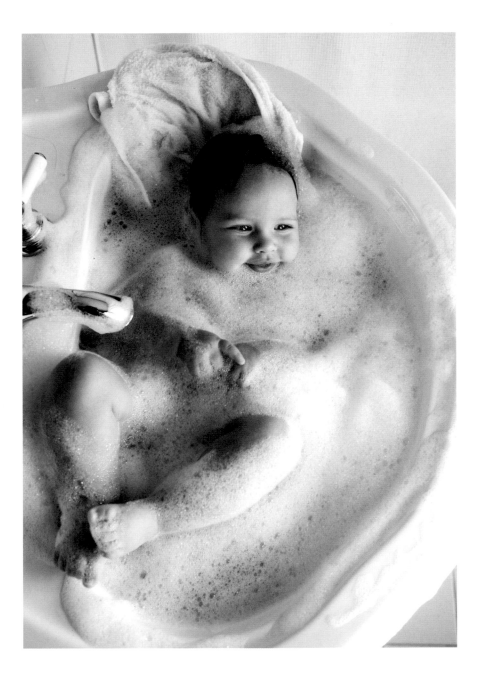

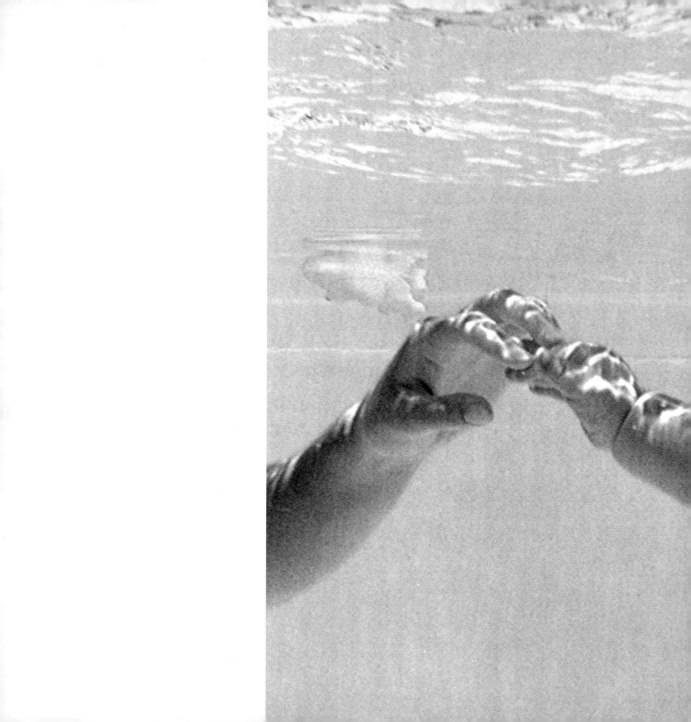

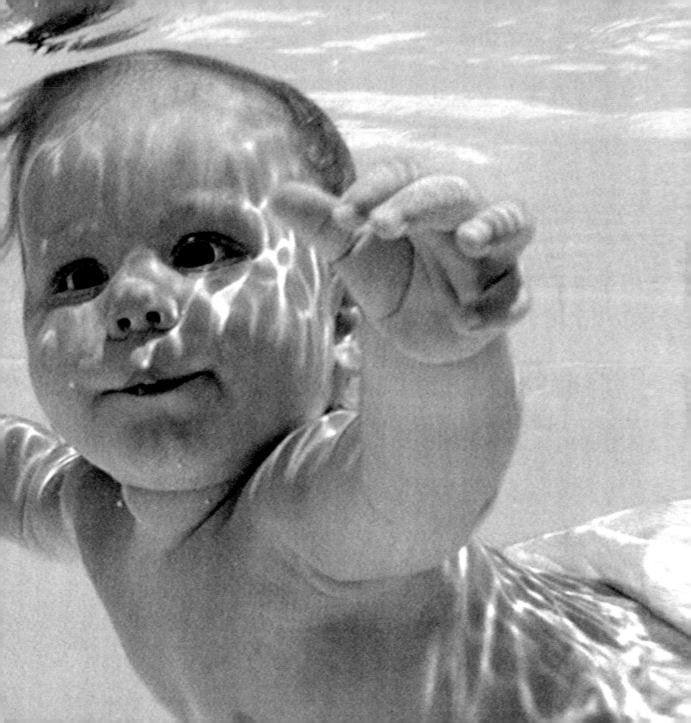

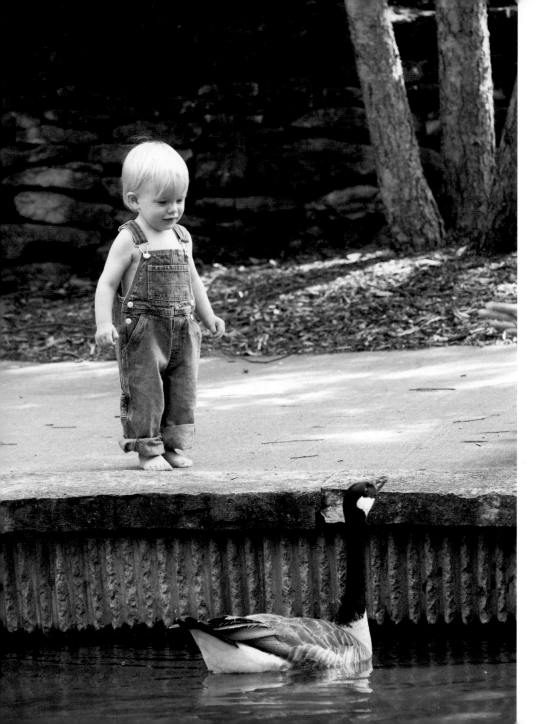

Ah!
happy years!
once more who would not be a boy?

—LORD BYRON

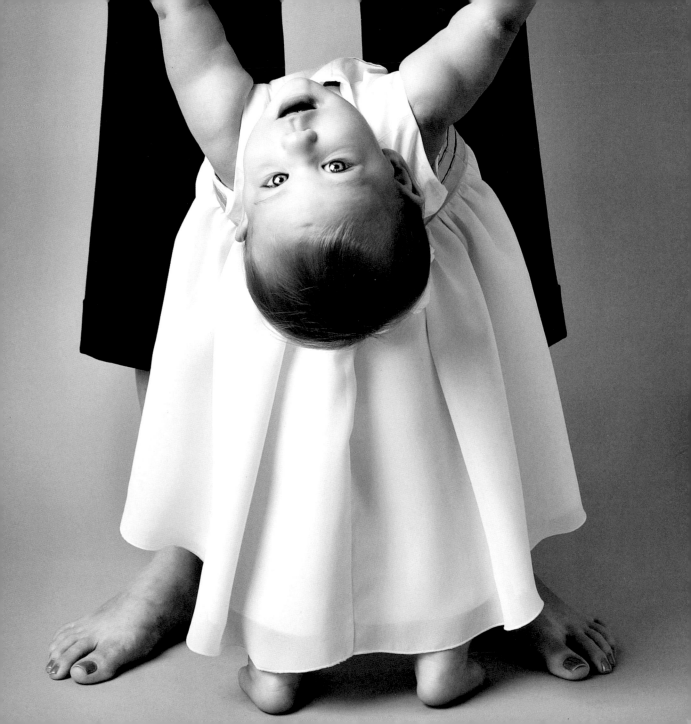

TIME OUT

My introduction to our local fire department, Ladder Company 122, came in the spring of 2005. One sunny afternoon, as my four-month-old napped in his crib and my husband and three-year-old headed up to the park for a stroller ride/run, I decided to take the rare moment of quiet to sweep our entry stairs and foyer. Exciting stuff, I know! As I emptied my dustpan into a planter out front, a gust of wind caught our entry door, and—SLAM!—I was stuck outside, barefoot, without keys.

Dumbstruck, I stood frozen for what seemed like several minutes. My husband had not taken a set of keys with him, and our neighbor had just returned our only spare set and moved across the country. After finally coming to my senses, I ran up the street in search of a phone. I entered the nearest business—Sisters Nail Salon—and in my broken Spanish, explained that mi bebé was cerrado en casa. Juanita handed me the phone and a pair of flip-flops. "Gracias," I whispered as I waited for the 911 dispatcher to come on the line.

By the time Engine 220 rolled down my block, my husband and son were rounding the corner. (All my heroes had arrived!) When I saw their faces, I burst into tears. "I locked myself out, and Oliver's inside!" I sobbed.

"Is he in a time out?" asked my eldest.

"No, Honey," I managed. "Mommy is!"

—SARA BAYSINGER
Editor

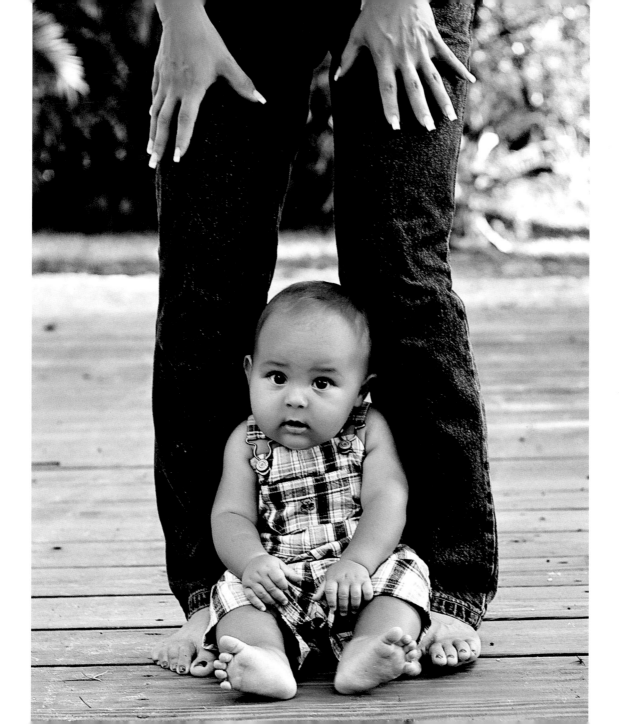

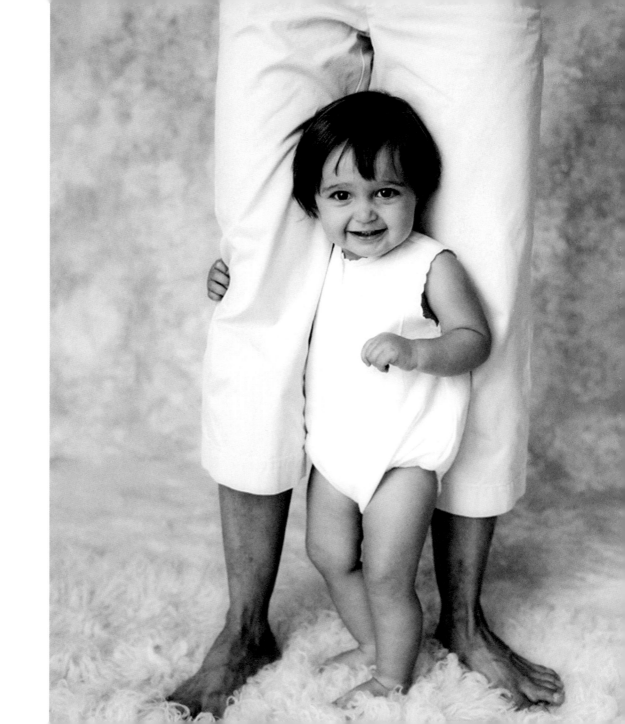

TWIN GIFT

Twins offer overwhelmed new parents a secret gift: in one key respect they are miraculously easier than having a single baby. I experienced this the evening I gave them their first real bath.

The moment Olivia's toes touched the water, she shrieked in terror. Olivia's stiffened body, rigid with protest and fury, mirrored my own, frozen with insecurity and anxiety. Sweaty and shaking, I toweled her off, set her down, and prepared for round two.

I placed her twin sister's silky little body into the tub and braced myself. Zoe began to coo, her first little gurgle of delight. She wiggled her fingers and toes, chirping like a little bird as the warm waves of water surrounded her shoulders like a liquid blanket.

If I had been a mother to only Olivia, I would have remained convinced her bath-time misery was my fault. But Zoe showed me that was impossible.

Later that evening, I lay on my bed, exhausted, with my two clean cherubs. Olivia cuddled close, breathing deeply in pure contentment. Zoe was like a grumpy porcupine, tossing and turning and grunting. Olivia was a snuggler. Zoe was a spa girl. They are who they are.

Twins taught me that a baby's emotions are not necessarily a reaction to us, but often just an expression of who they are. We found this lesson so life-affirming that, three years later, my husband and I had another set of twins.

—ALISON HOCKENBERRY
Television News Producer

280

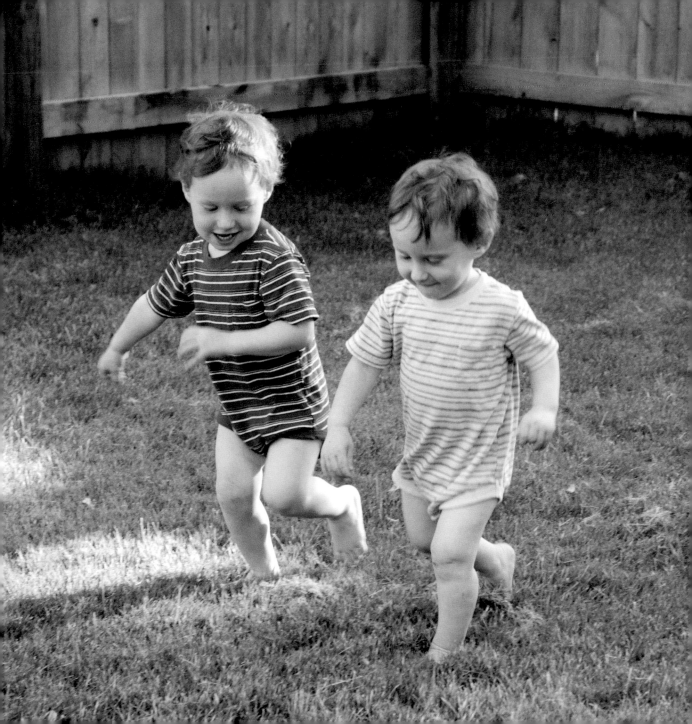

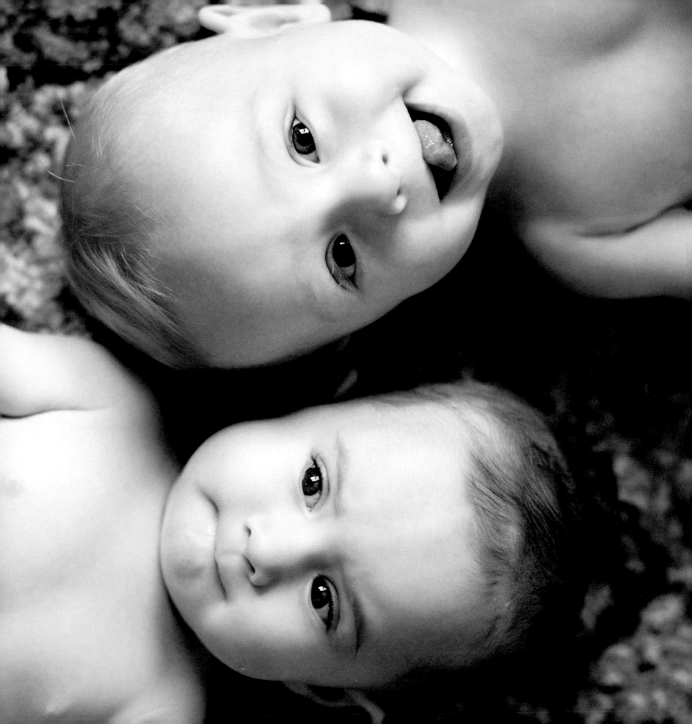

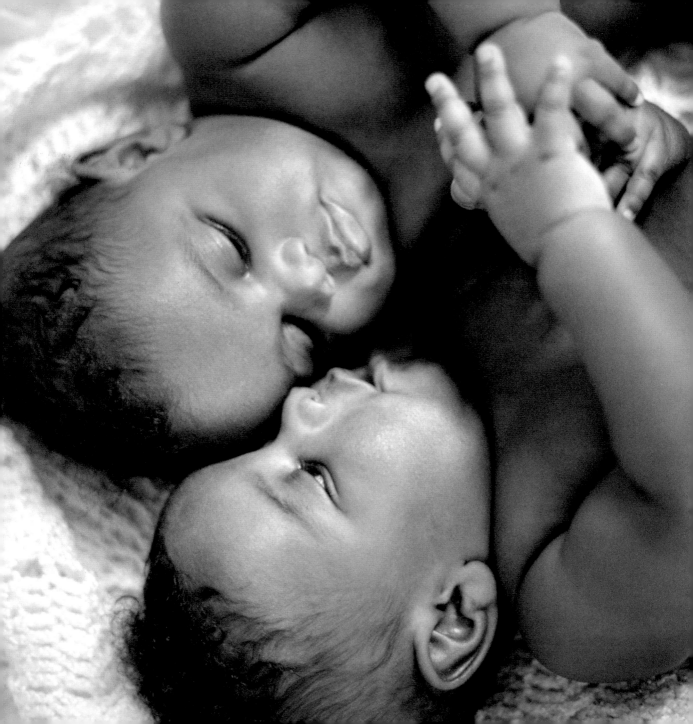

If the greatest gift of all is life
then the second must be that no two are alike.

—ANONYMOUS

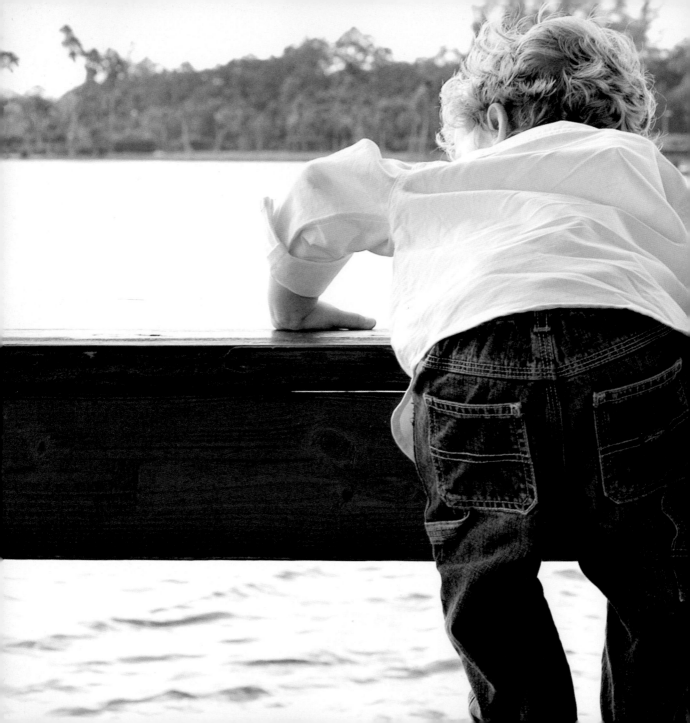

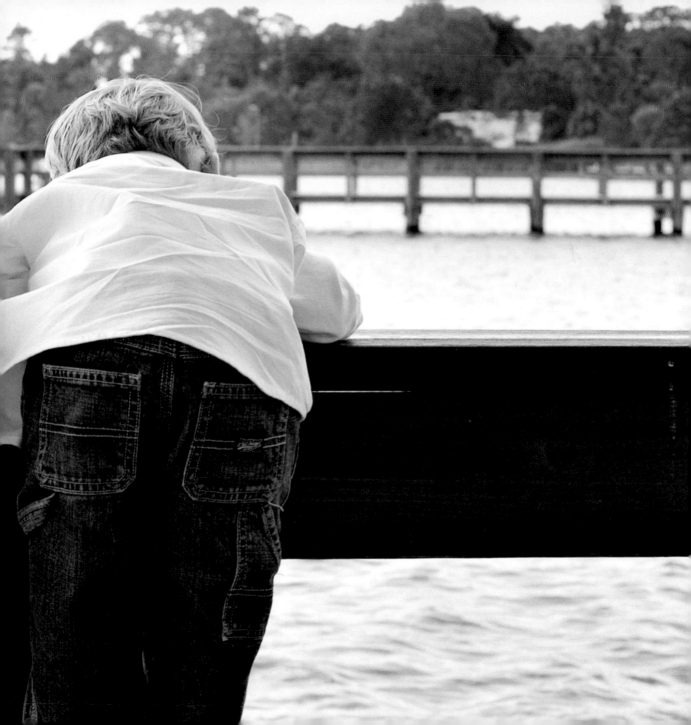

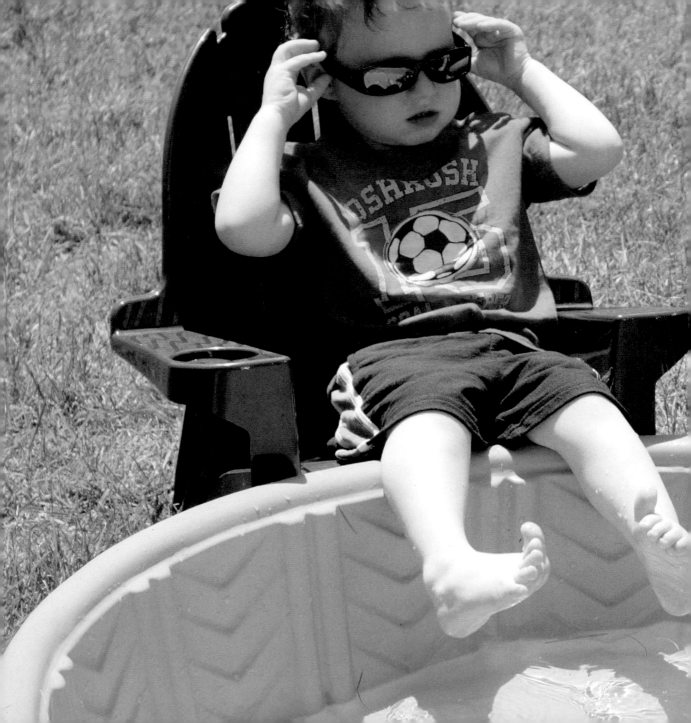

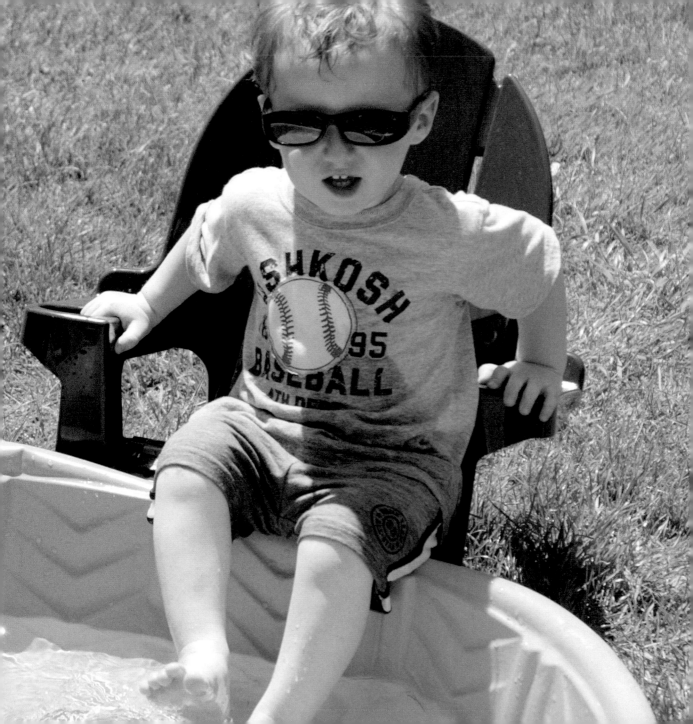

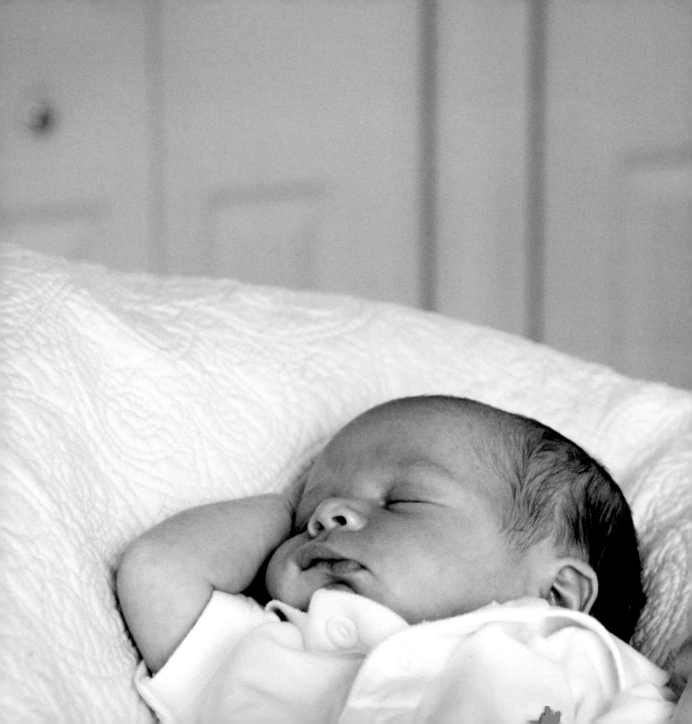

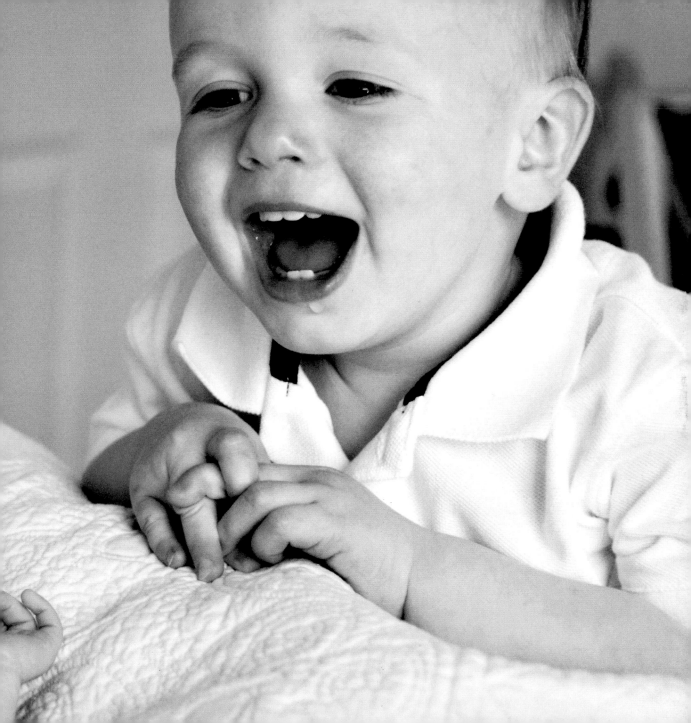

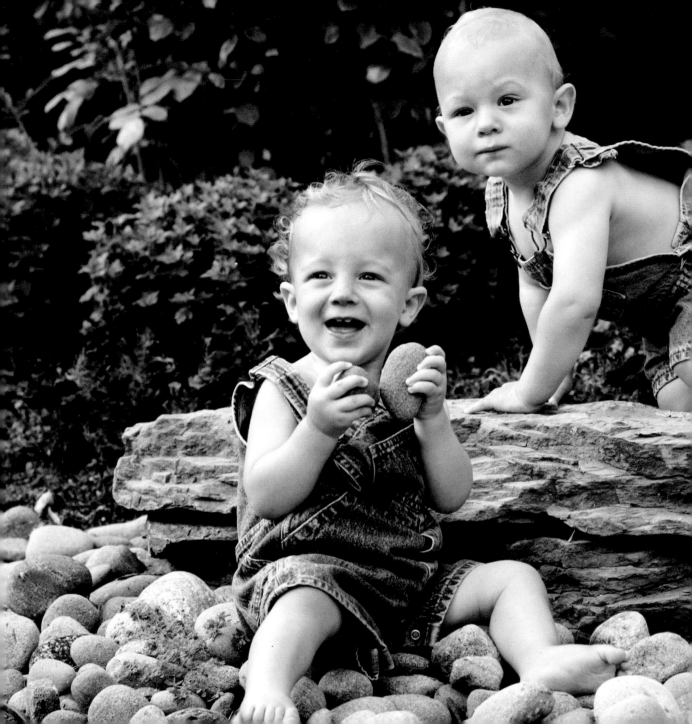

THE TRUTH

When my first child was born, I held her perfect body and prayed that I would be the mother she deserved. I asked the universe for the divine wisdom to help her not only to survive in this life, but to thrive in it as well.

When my second child was born and I held him and marveled at how beautiful he was, I took the time to do a bit of reflecting. Parenthood had not been as easy or as straightforward as I had expected. I had been forced to admit weaknesses within myself that had caused me to really stumble in certain areas of child rearing. I vowed to learn from my mistakes with the first child and do better, much better, with the second.

When my third child was born, he was round, sweet, and cuddly. As he was my second boy, I knew what to expect with him. This time I was finally going to get it right. I knew how to deal with sibling rivalry, temper tantrums in public, and diaper blowouts at weddings. Maybe I hadn't been the most patient, roll-in-the-mud-if-it-makes-you-happy, let's-make-a-volcano-in-the-kitchen-for-laughs mom up until this point. But life was about learning lessons, and I had been enrolled in this school of parenting for a good number of years now. I looked at my baby's precious face and whispered that he was lucky to be the third.

When my fourth child was born, I held her tight, kissed her angelic little face, and told her to hold on, because it was going to be a bumpy ride.

—BEVANN SCHULTZ
Mother

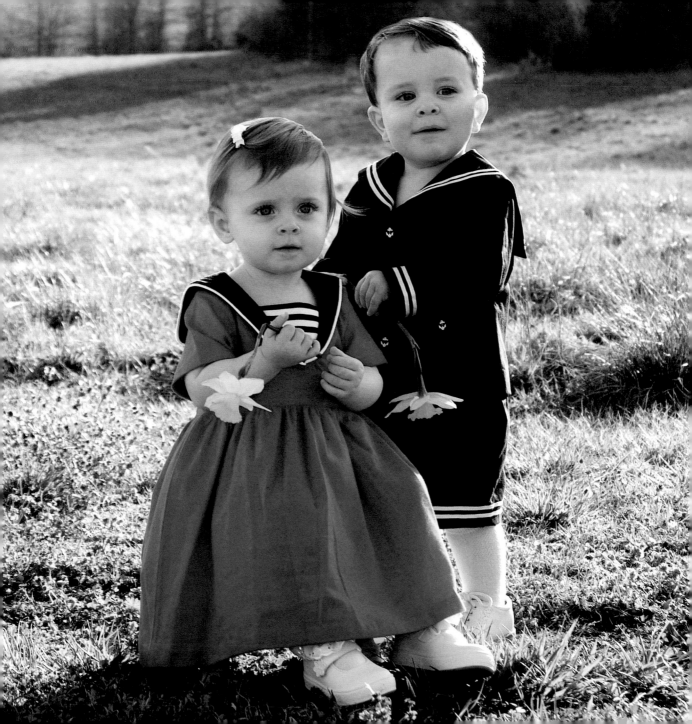

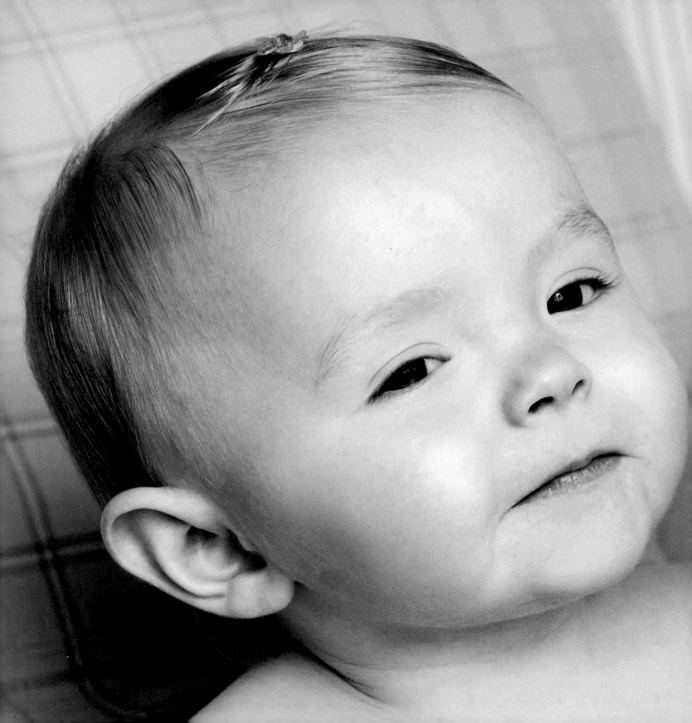

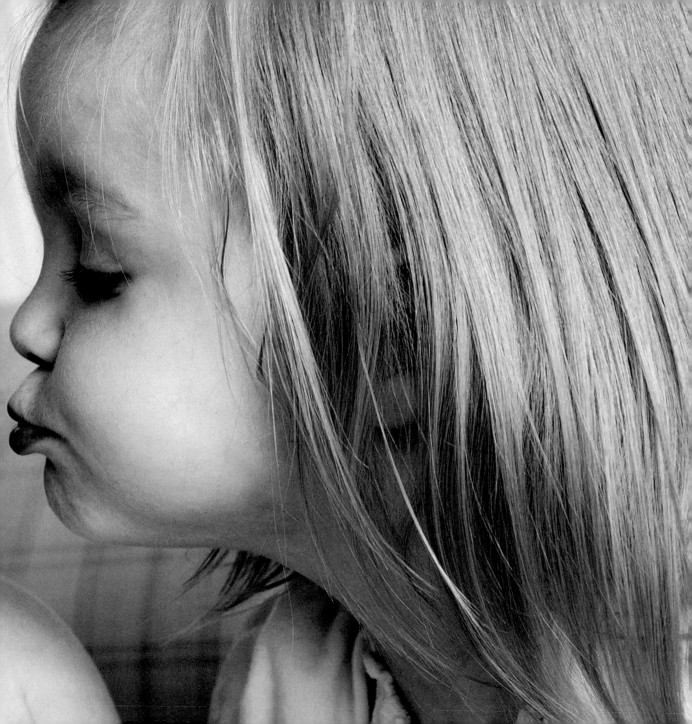

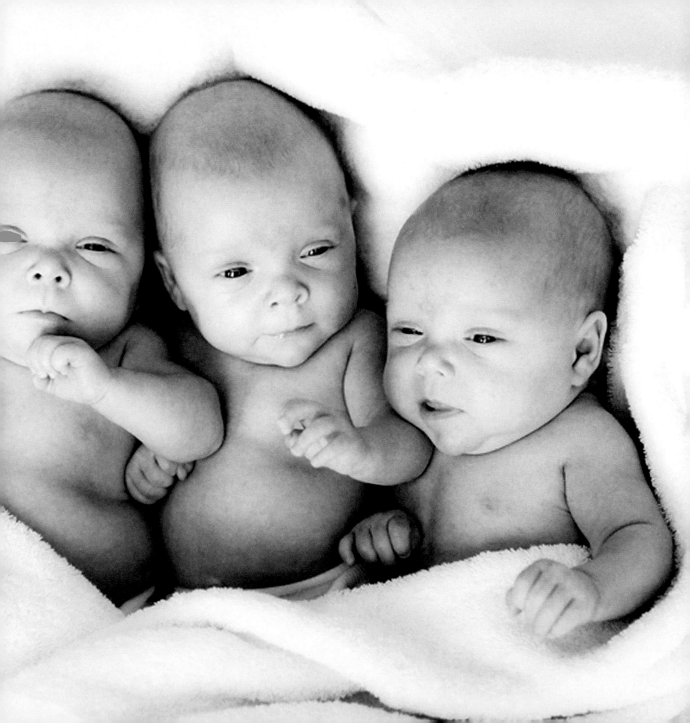

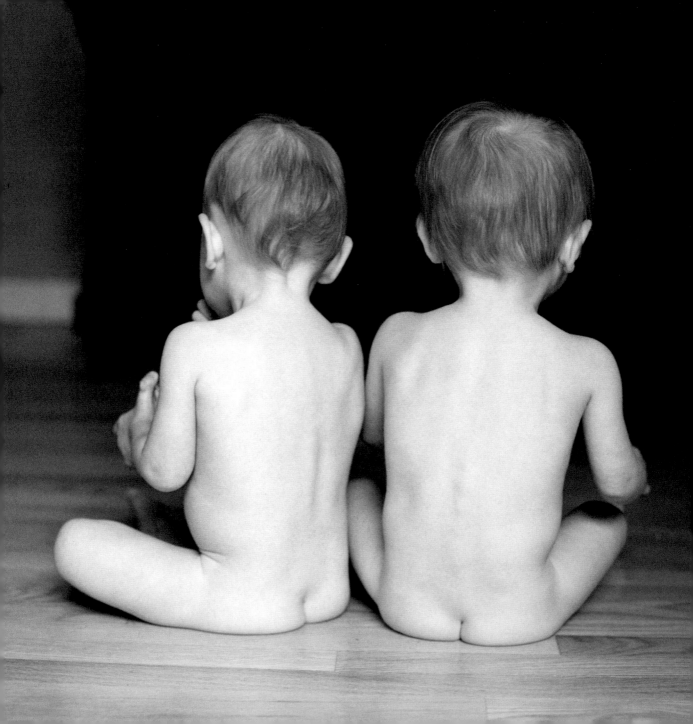

IN AND OUT

I put a lot of thought into what my son's first solid food would be. I pestered the pediatrician, thumbed through the baby books, canvassed countless parenting Web sites, and asked my mom.

Bananas, one source claimed, are the perfect first food. Stick with avocados–they're nutritious and rarely trigger allergies, argued another. Start with vegetables, proclaimed yet another, so that Baby doesn't get too used to sugary fruits. My mom weighed in: "Rice cereal. That's what I gave you."

And when's the optimum time to start solids? At four months? Six months? Sometime after the baby starts showing an interest in food, but before he's resorted to making desperate grabs for your burrito?

In the midst of all of this thoughtful and well-reasoned advice, there's one thing that no one tells you: the poop of a baby on a liquid diet is dramatically less unpleasant than that of a baby who has started solid food.

My husband and I stared down at our son's first solid-food diaper with no small amount of alarm.

"Yuck," I said, leaning back. "This one is definitely a Code Brown."

"If you change it, I'll get the next one," my husband offered.

"Coward," I said. "Pass the wipes."

My husband handed me a single wipe. From a distance.

"Yeah. I'm going to need about a dozen more of those," I said, "and maybe a HAZMAT team."

—WHITNEY GASKELL
Writer

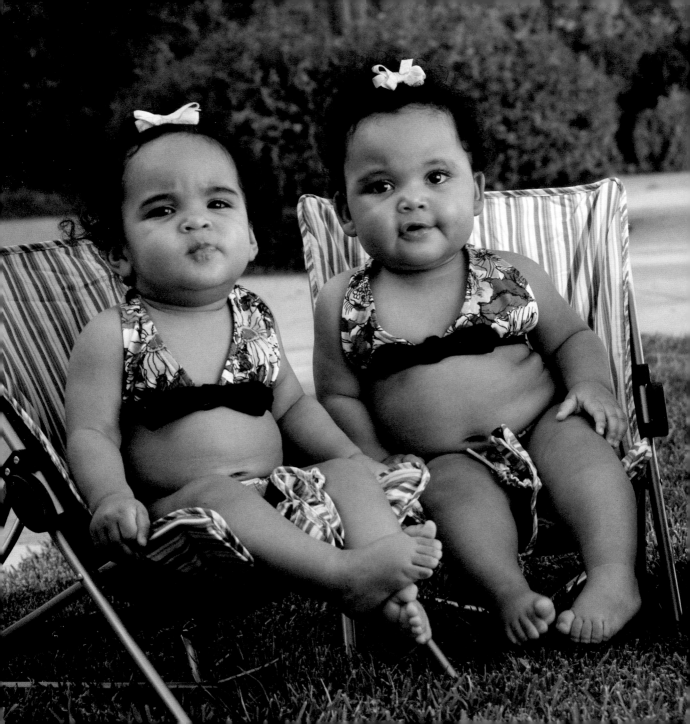

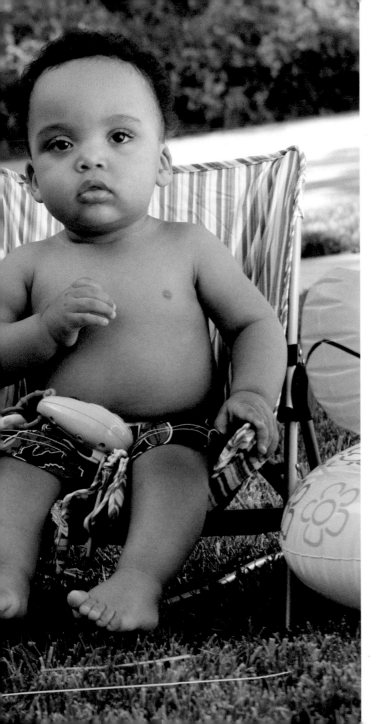

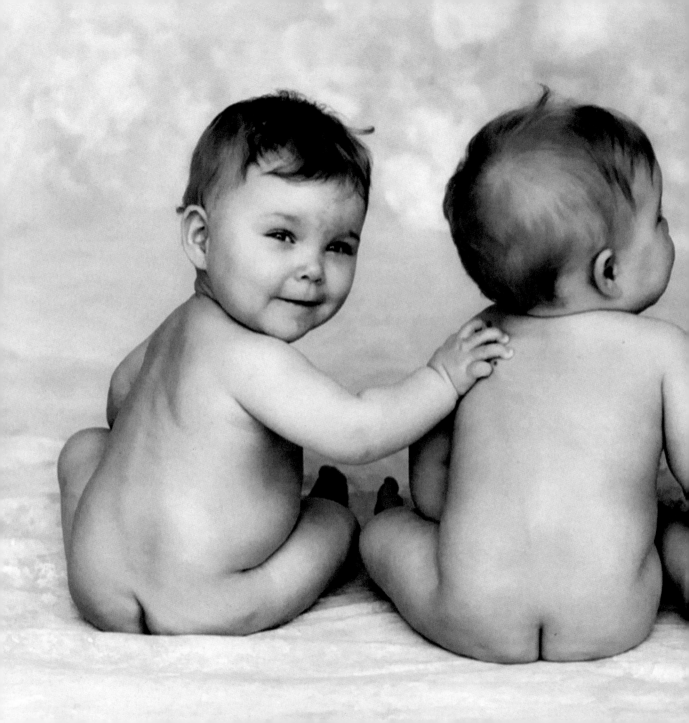

Every survival kit should include a sense of humor.

—ANONYMOUS

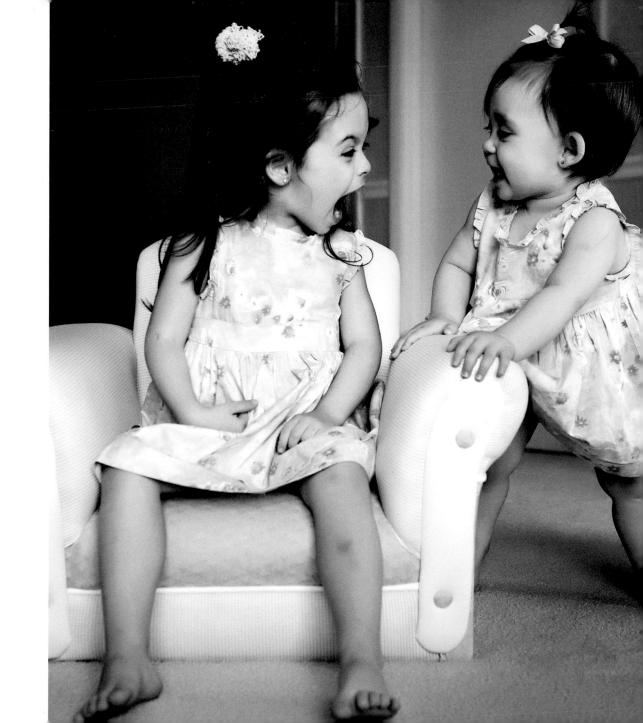

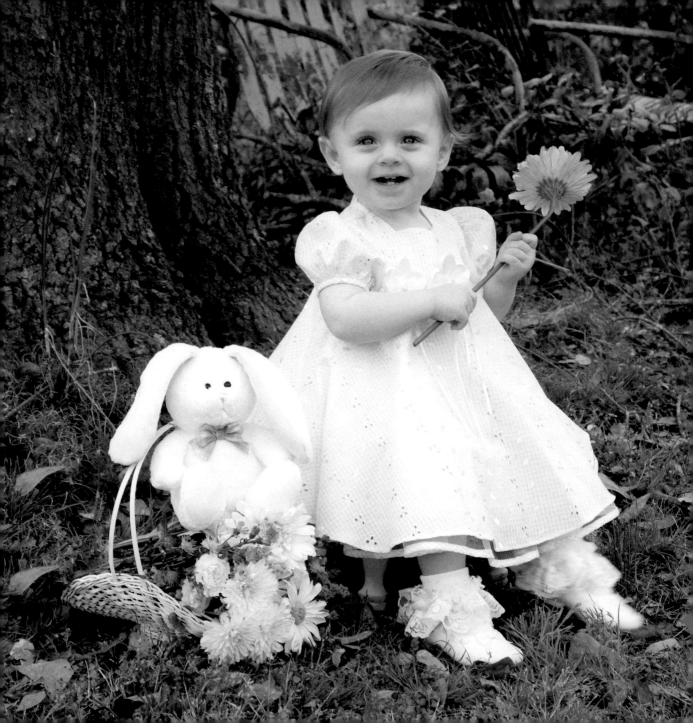

One day when she was two years old she was playing in a garden, and she plucked another flower and ran with it to her mother. I supposed she must have looked rather delightful, for Mrs. Darling put her hand to her heart and cried, 'Oh, why can't you remain like this for ever!' This was all that passed between them on the subject, but henceforth Wendy knew that she must grow up. You always know after you are two. Two is the beginning of the end.

— J. M. BARRIE

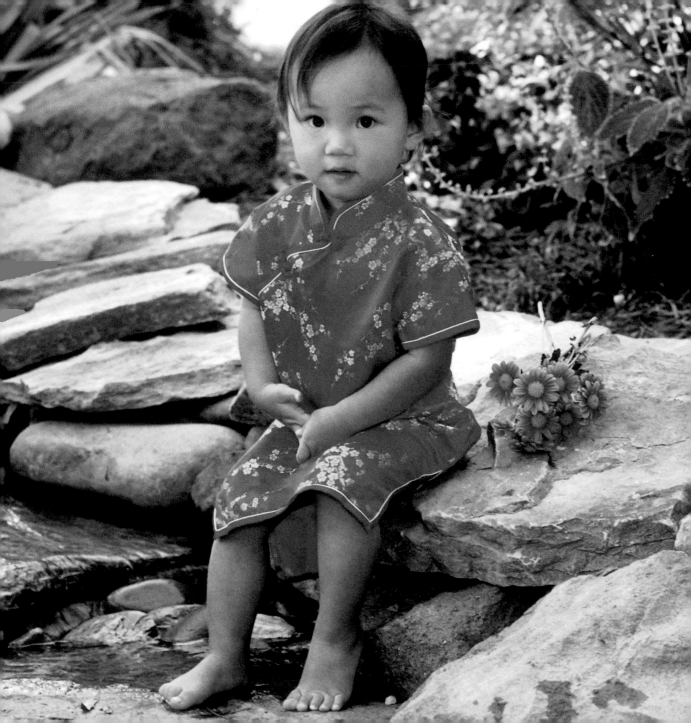

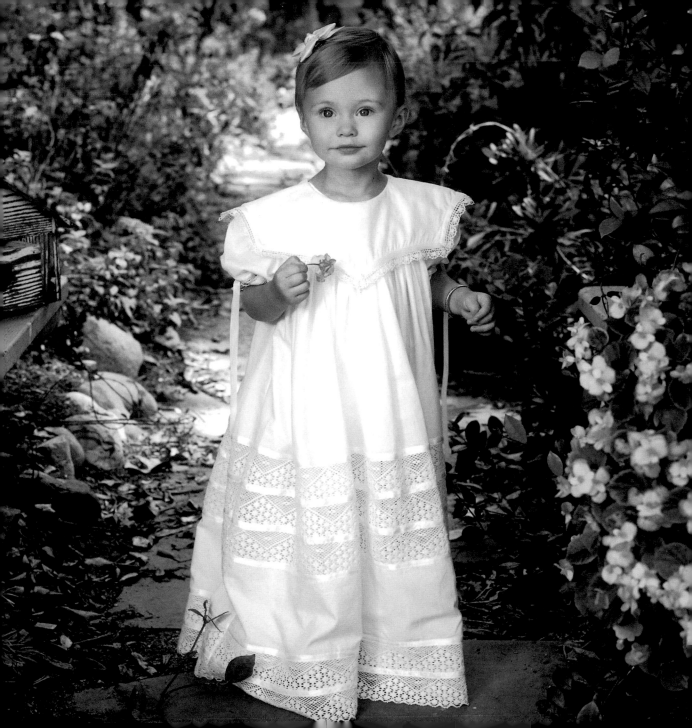

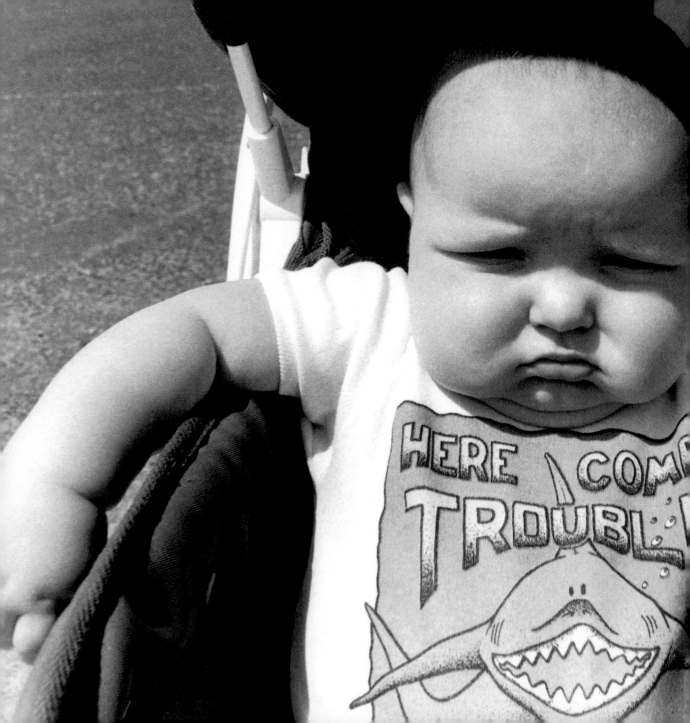

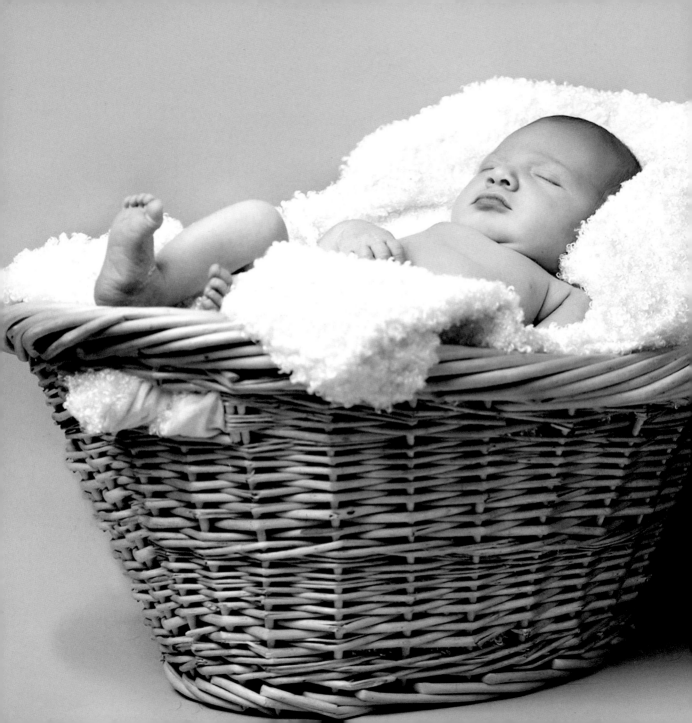

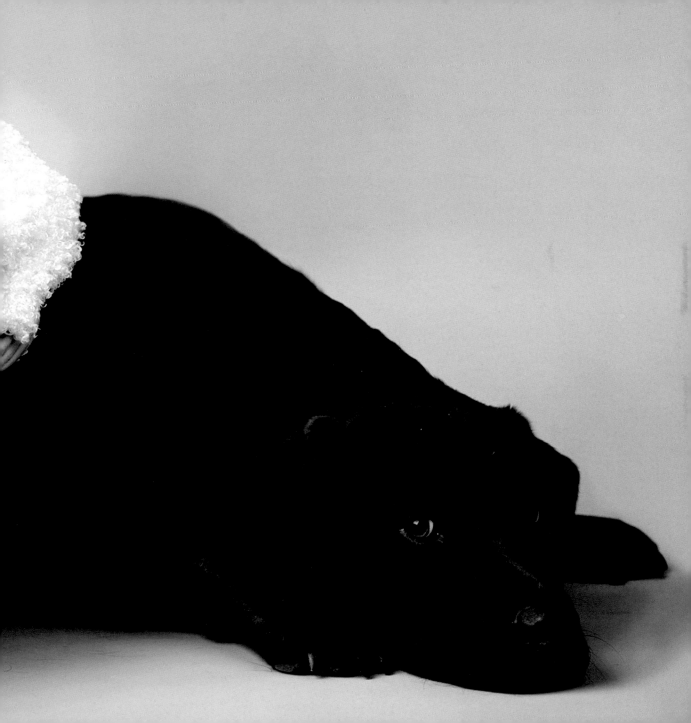

STONEFACE

My son Rafi, who is a year and a half, has absolutely no sense of humor. He is very serious. "Rafi," I say, and make clown faces and stick out my tongue. He looks at me and runs his hand through his black hair and sighs deeply. "Hey, look at silly Mommy!" I say, as his mother does a crazy dance that even makes me laugh. Nothing. He furrows his brow like he's running equations in his little head. We got pretty worried until the day we realized what was up. He saves his emotions for the dog. When the dog comes around, Rafi's a different person. He makes lots of noises and waves his arms: "Dee! Dah! Deedah!" If we try to share in his glee, it just blows the whole thing. Rafi shuts down. Maybe he thinks we're ridiculous.

—PAT CHUNDALU
Software Developer

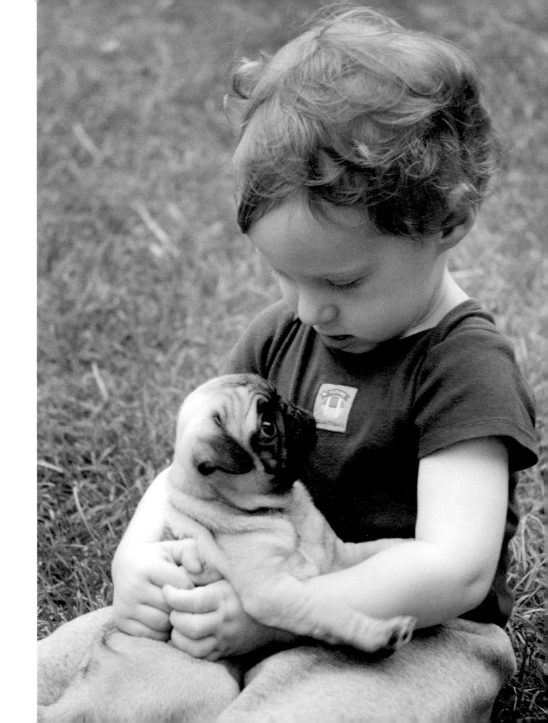

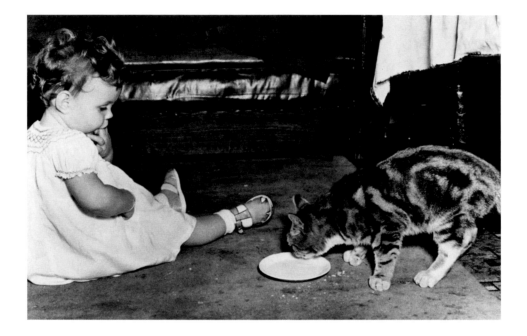

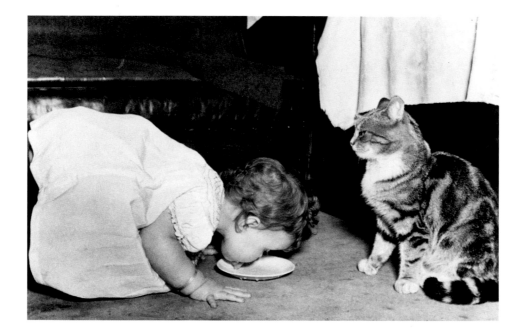

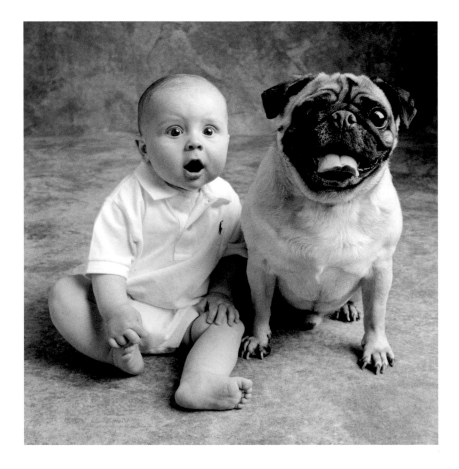

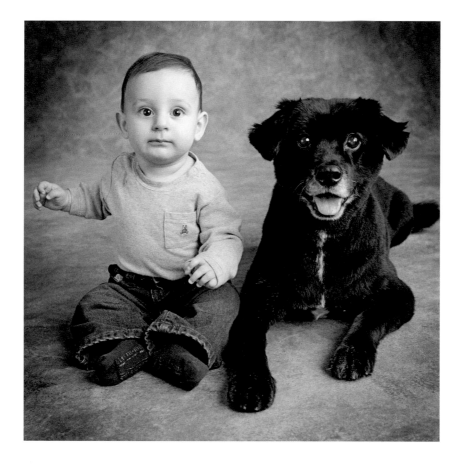

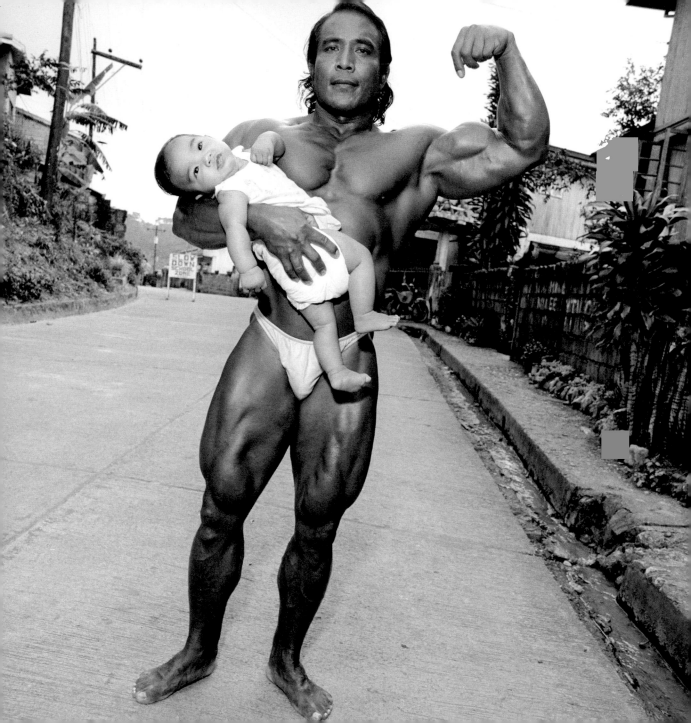

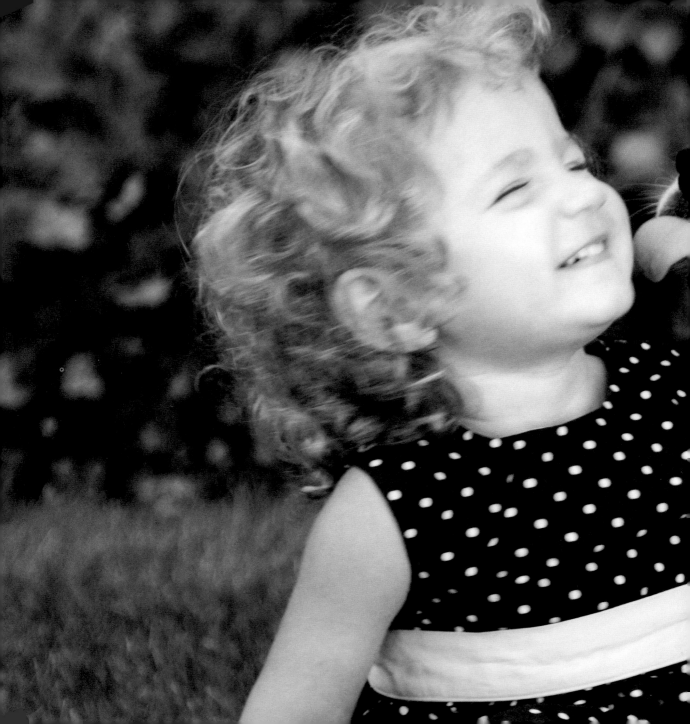

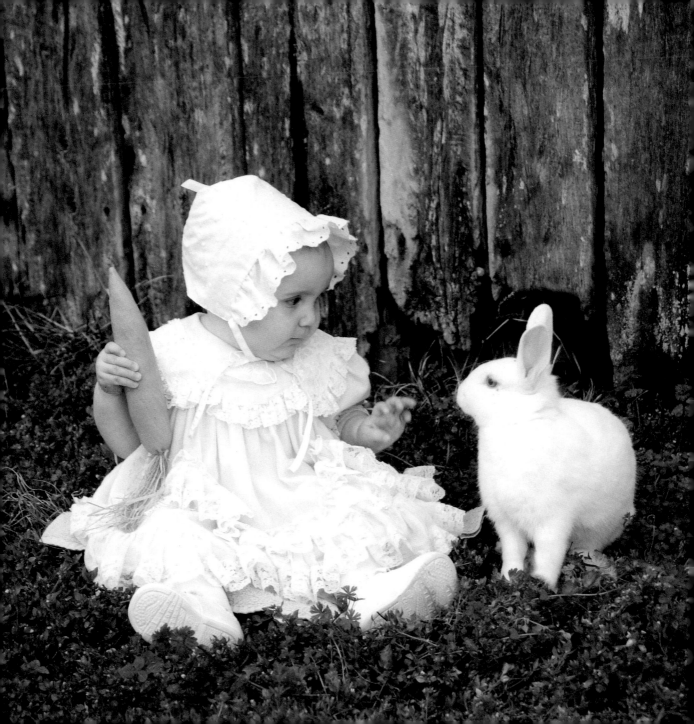

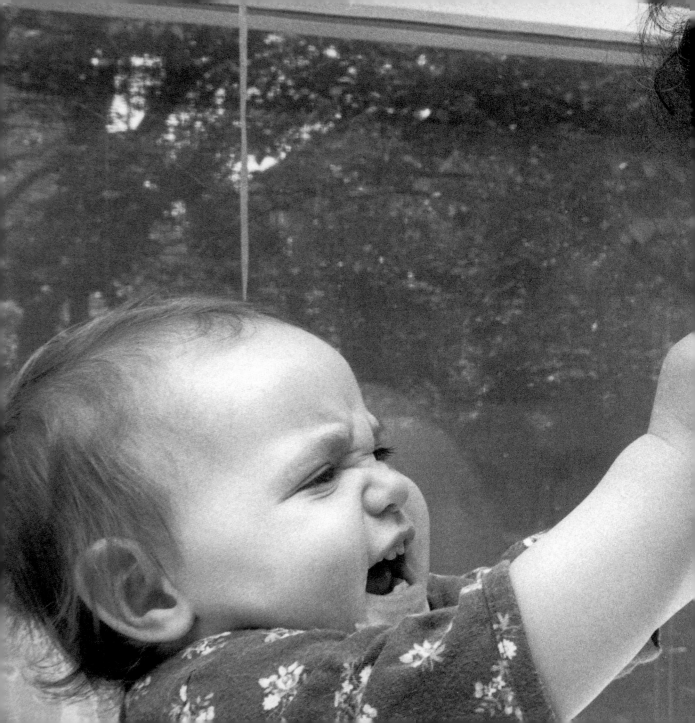

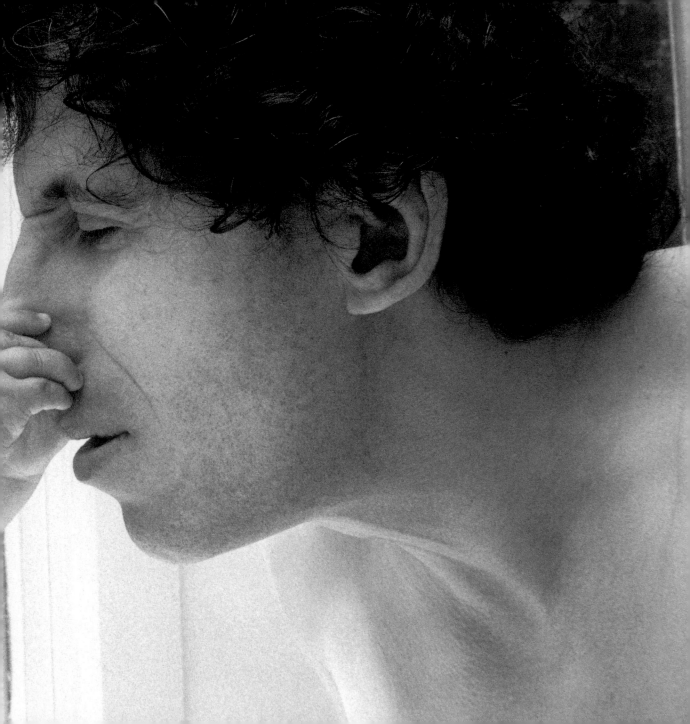

COMEDIAN

Jessie, my neighbor's daughter, has a taste for slapstick. She loves to laugh! She'll take a spoonful of strained carrots and fling it into the wall and laugh hysterically. Put her in front of a mirror and she can spend hours making funny faces and then hooting with joy. She loves to do things and then laugh about them. Bathtime to her is like a Laurel and Hardy movie no one else is watching. The duck splashed the water! What a riot! The washcloth flew into Mommy's face! Hee hee! Her parents are very sweet, but they're not really slapstick types. Her mother is a professor of religion, and her father is a tax lawyer. Serious genes. Yet they have this baby who in behavior bears more of a resemblance to Henny Youngman. Sometimes even after she's gone to bed, you can hear her in her crib, having a good guffaw before sleep.

—MARK CORELLI
Psychologist

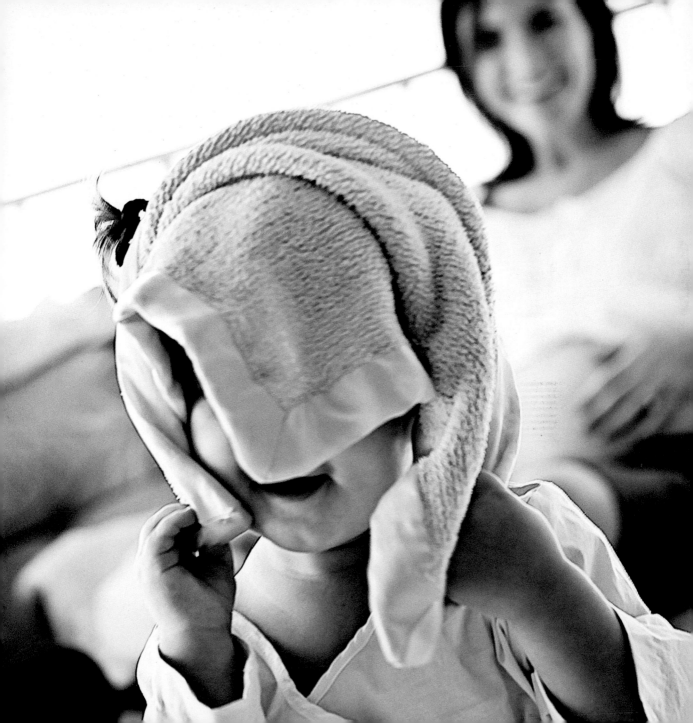

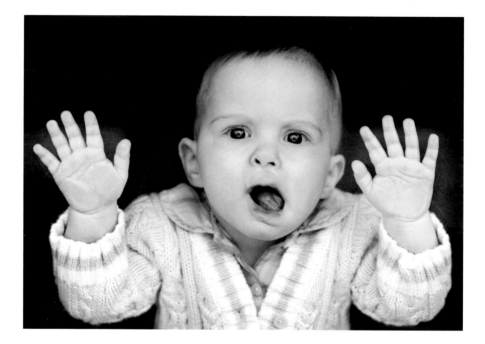

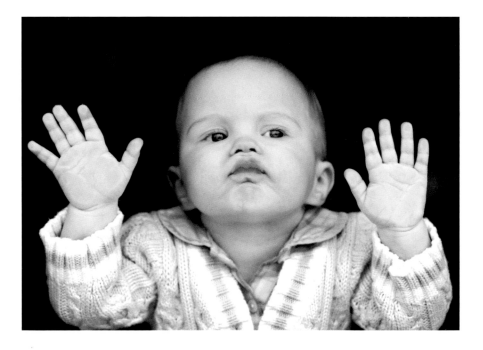

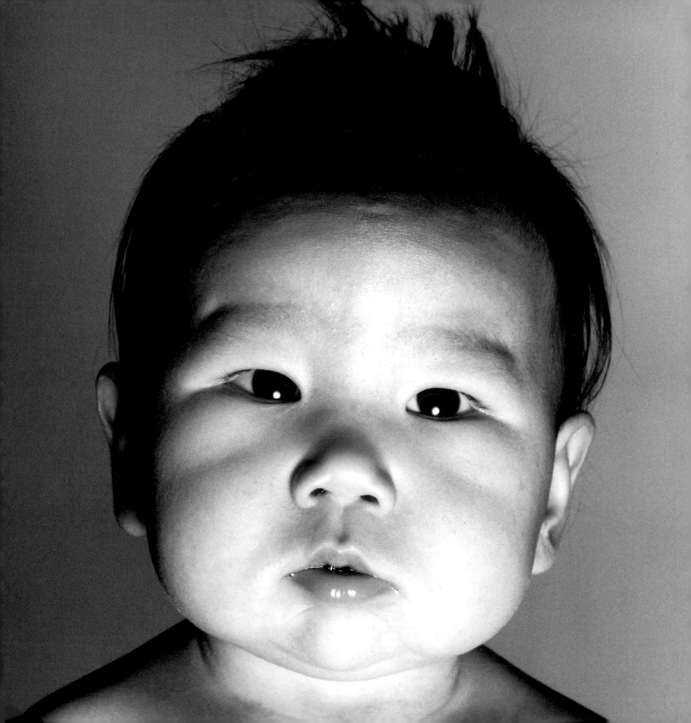

Anything can happen, child.
Anything can be.

—SHEL SILVERSTEIN

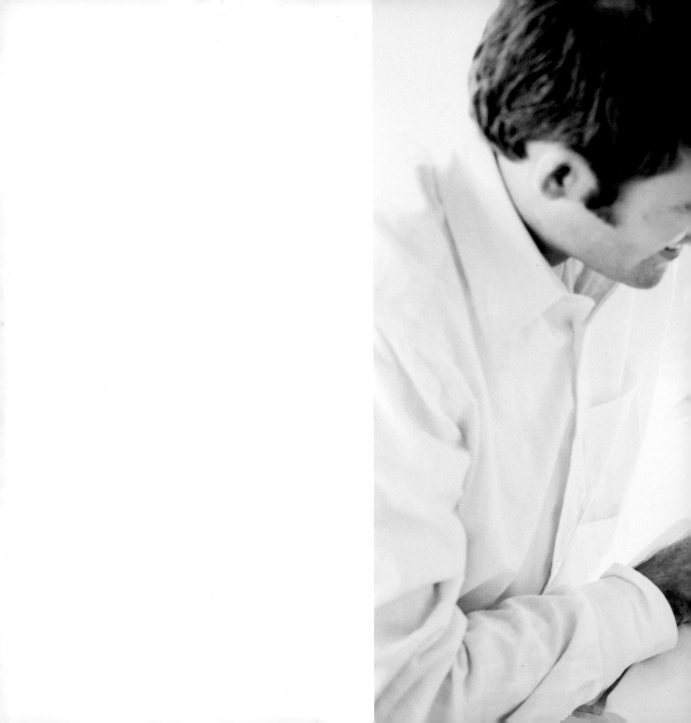

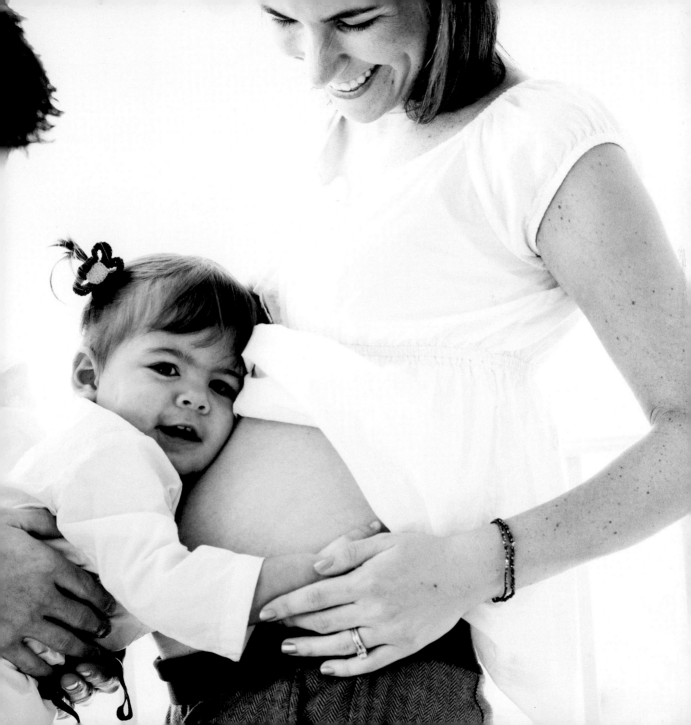

Babies are such a nice way to start people.

—DON HEROLD

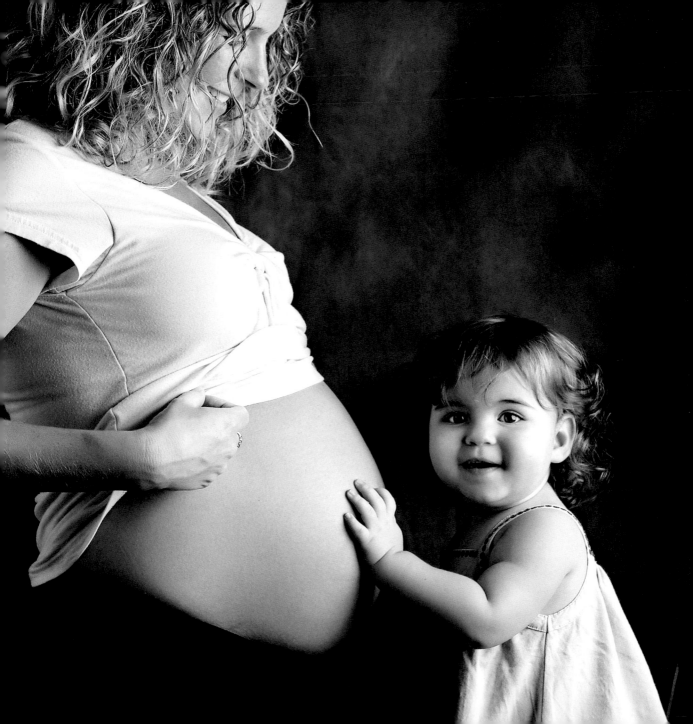

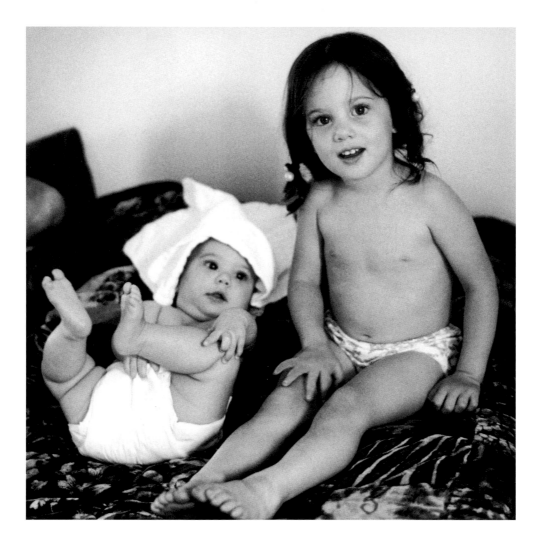

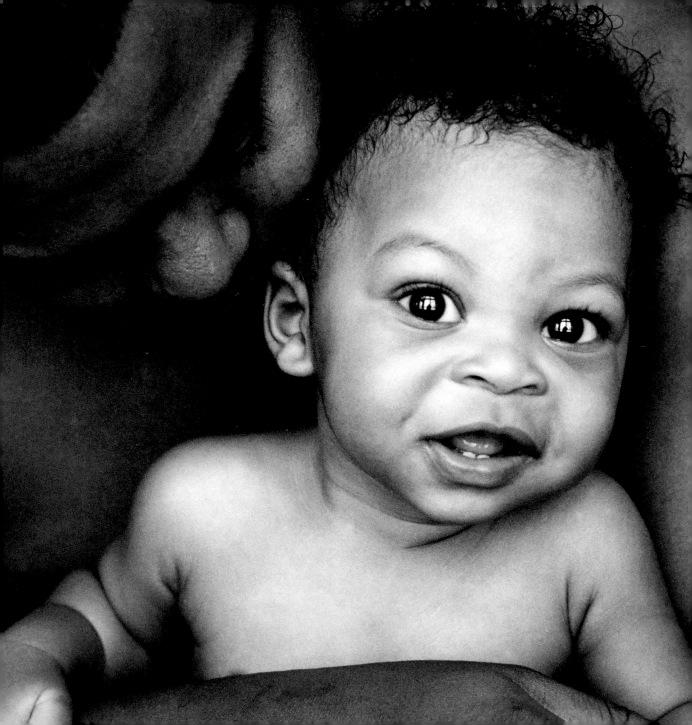

BRINGING DOWN THE HOUSE

We couldn't find a baby-sitter and we desperately wanted to go to the movies, so we took our daughter Shaniece. She'd always been so good—we raised her to be polite, and we never say bad words around her. But sometimes babies just call it like it is. The movie was a tender love story, the whole audience transfixed. We thought Shaniece was asleep. But she wasn't. Halfway through, during a very tension-filled romantic scene when the whole theatre was so quiet you could hear a pin drop, Shaniece came to life. She broke into hearty laughter, like I've never seen her do before or since, and pointed at the two on-screen lovers about to kiss. "See?" she said loud enough for everyone to hear. "Like Mommy and Daddy when they make boom-boom!" Five hundred people turned to look at us, every one of them roaring with laughter.

—CAROL JACKSON
Television Producer

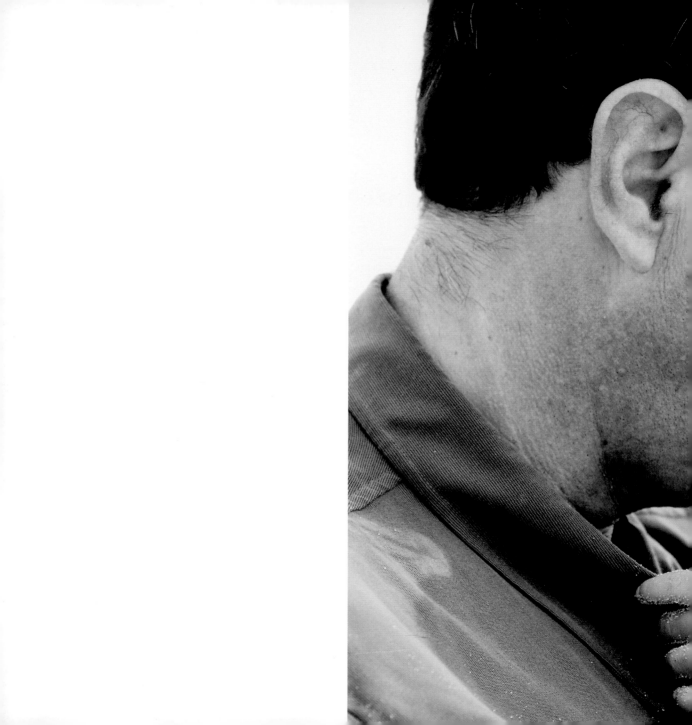

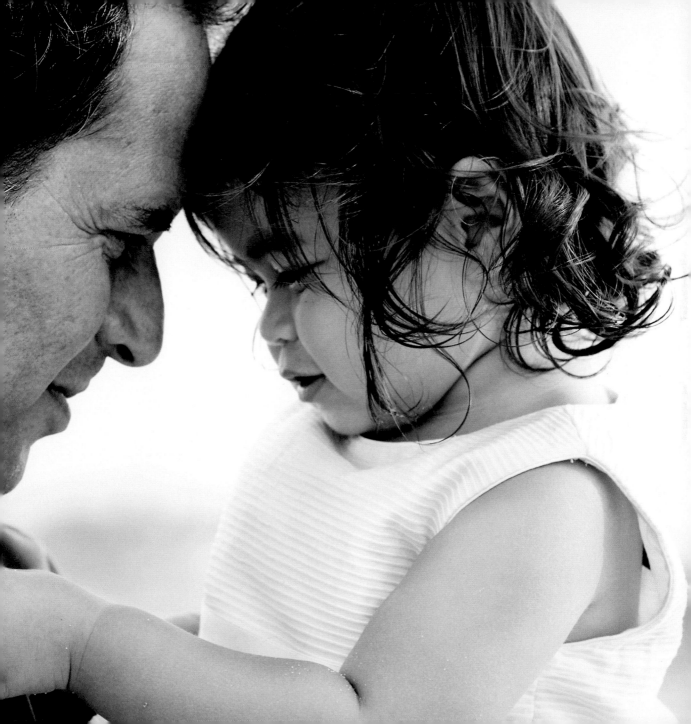

SHIFTING EXPECTATIONS

One of my graduate writing seminars was taught by an accomplished but frazzled professor. She tended to burst into class a few minutes late, usually blaming one of her three sons for her tardiness—a misplaced baseball glove, a snowball through a window, a trip to the emergency room.

Three months pregnant with my first baby, and coming from a female-dominated family, I felt a smug satisfaction while watching this professor's disorganized entrances. I trusted my family life wouldn't be so chaotic and full of mishap. No, my life would be focused and manageable: I was convinced I was having a daughter.

Six months later, my son was born. I was astonished by the weight of his wet body on my chest, the clutch of his tiny fingers on my hand, and his perfect ears, like a creviced map, full of valleys. I pressed his slippery head against my breast and his shiny black hair glided beneath my fingers. His deep red lips puckered and opened. His cinder eyes stared up at me like those of a luminous being from beyond. I realized then how wrong I had been about boys. He was the most beautiful, gentle and powerful creature I had ever seen.

Now, eight years later, with two sons and a husband, I live in a veritable den of testosterone. Yes, we have visits to the emergency room, mismatched soccer cleats, broken kitchenware, and poor toilet aim. And yes, they are absolutely the loves of my life.

—EMILY RUBIN
Writer

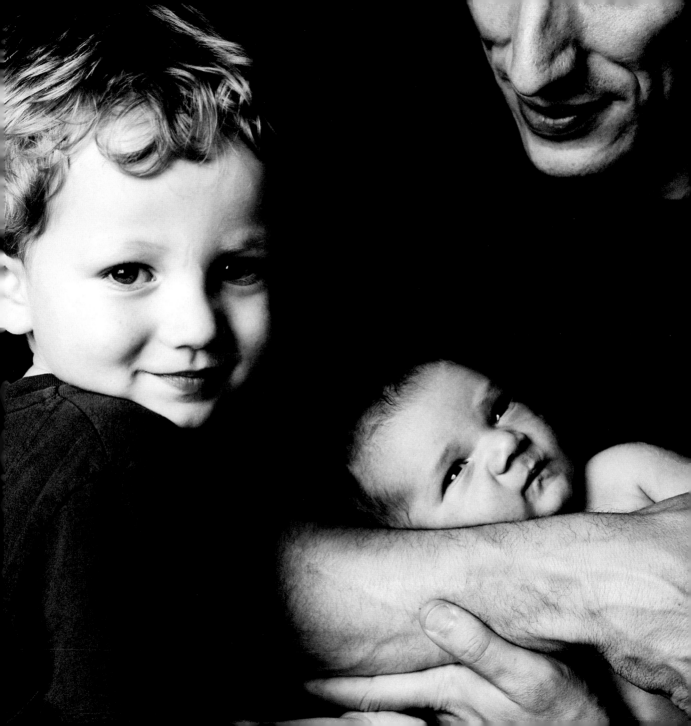

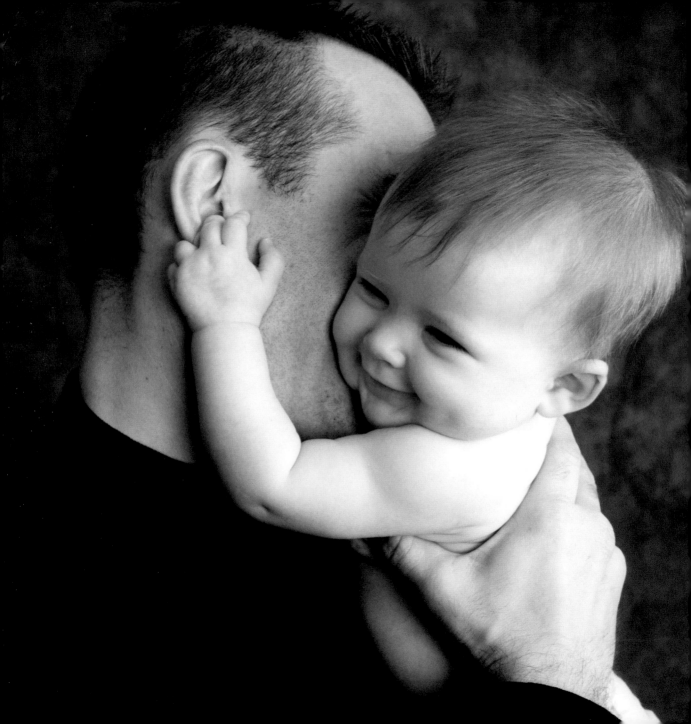

My lovely living boy,

My hope, my hap,

my love, my life,

my joy.

—GUILLAUME DE SALLUSTE

YUMMY MUMMIES

"Just bring him in close and he'll latch on; it's really very easy," my mum insisted. I sat propped against a "My Breast Friend" nursing pillow, staring blankly at a copy of *The Womanly Art of Breastfeeding*. Meanwhile, my precious newborn, Sam, born a healthy eight pounds but with a high palate, sucked feebly on my cracked and bleeding nipples until exhaustion eclipsed his hunger.

For the next four weeks I had regular visits from a lactation consultant. I learned the Womanly Art of attaching myself to a hospital-grade pump to fill bottles attached to tubes attached to my breasts, so that from this maternal dairy farm Sam got milk.

I'd heard that a baby's first smile comes when you need it most. A few weeks later, I found myself at a "playdate," sitting on an elegant sofa in an elegant Manhattan apartment attempting to breastfeed Sam. Among this elite group of "yummy mummies" the talk was not about their babies but their prenatal earning power and the necessity of upgrading their engagement rings. I had had to be "interviewed" for acceptance into their circle and was now desperately trying to think of an excuse to leave. Suddenly, the mummy next to me screamed, "Urggghh…I'm wet!" All eyes turned toward me. I looked down at Sam, who had just latched off. That's when I saw it. Milk! My milk was spurting all over the Ultrasuede. Sam licked his lips and gave me his first smile. And I smiled back at him.

—SARAH COLLIER
Photographer

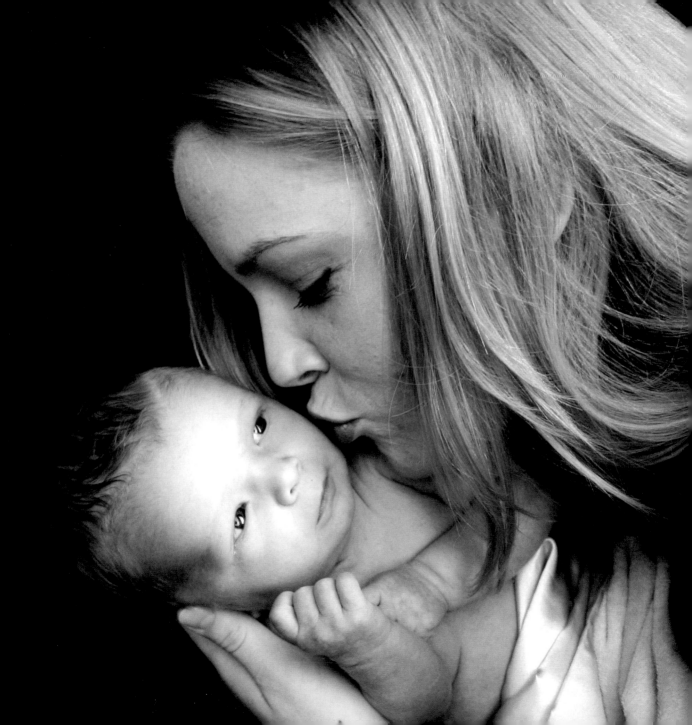

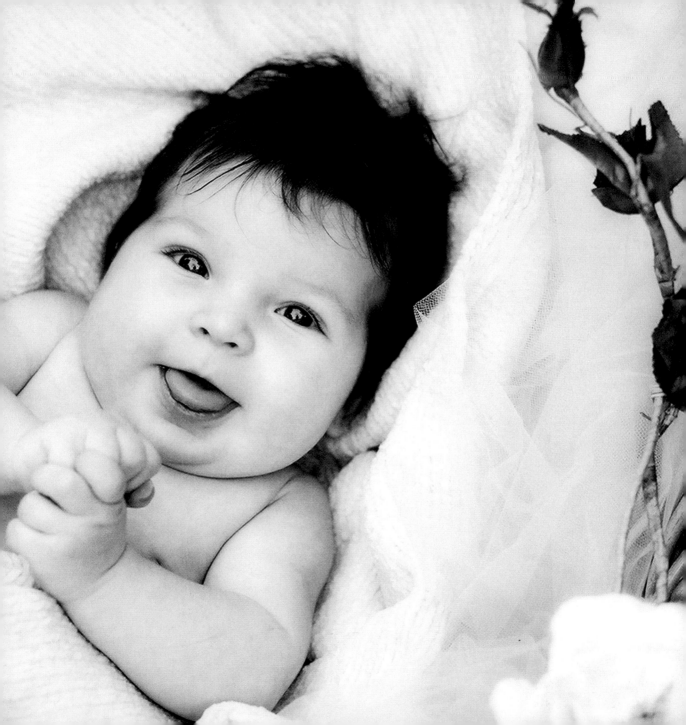

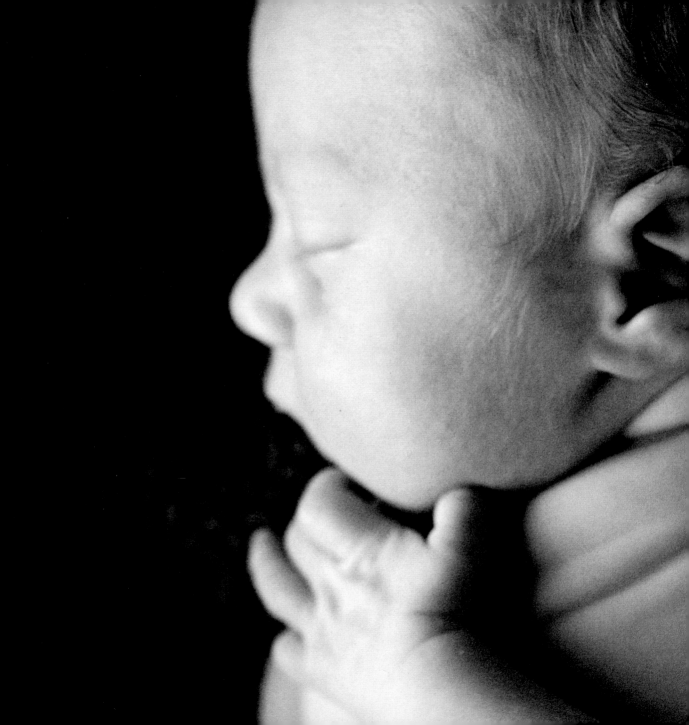

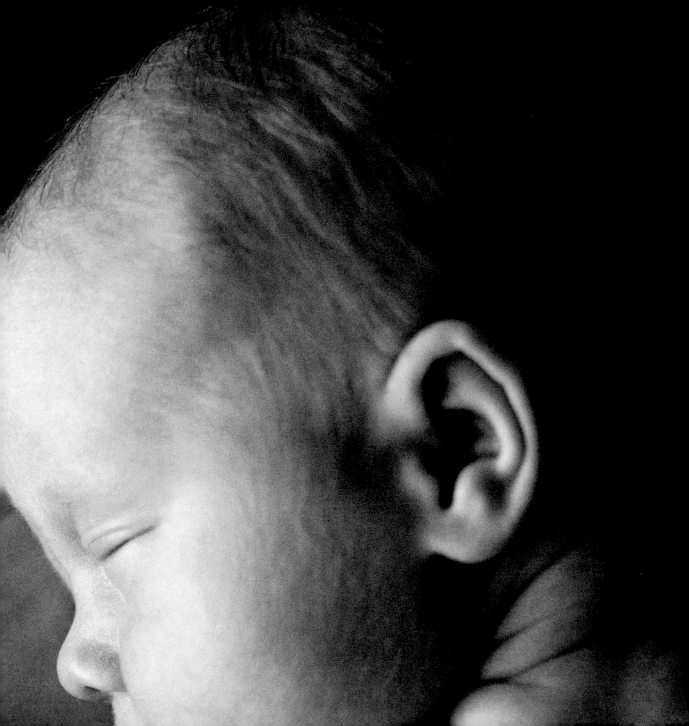

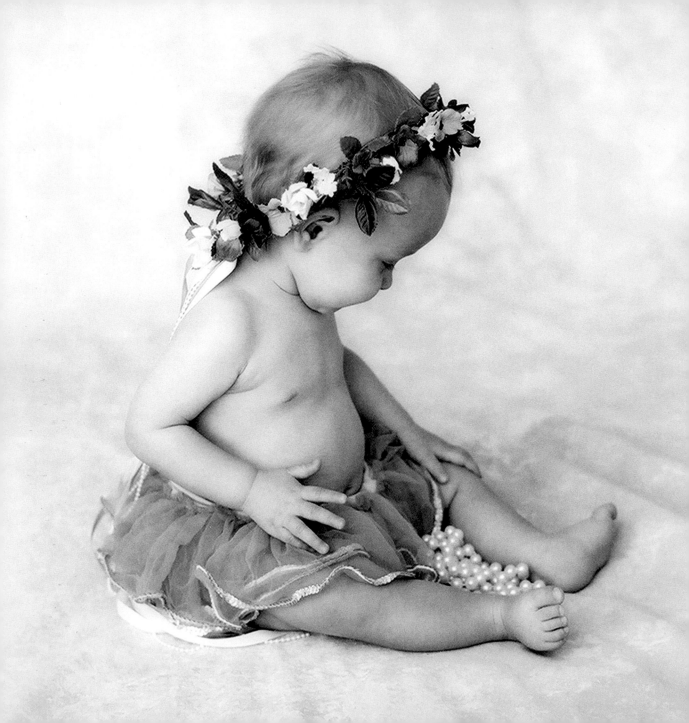

The most effective kind of education is that a child should play amongst lovely things.

— PLATO

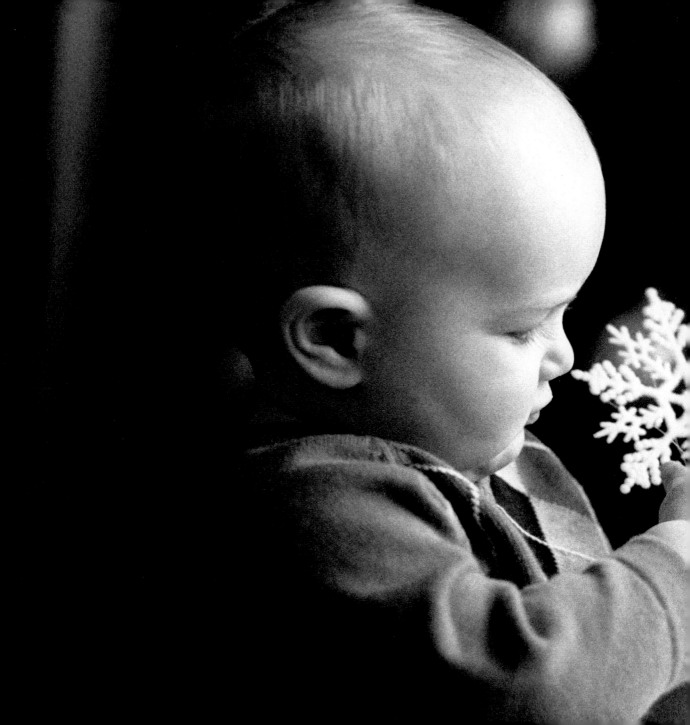

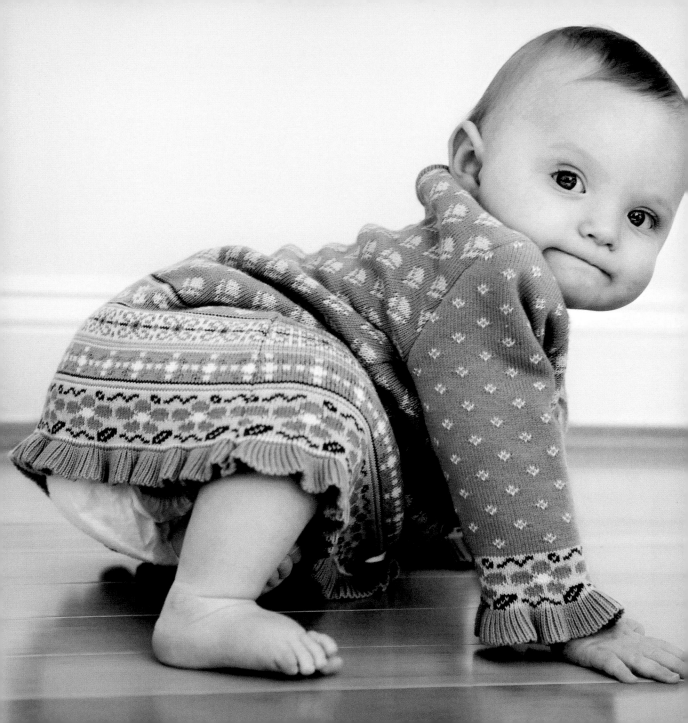

EVER SO HUMBLING

One of the most exciting things about expecting a child is the prospect of being able to project all your dearly-held ideals onto a teeny, tiny, totally malleable (or so you think) mini-me. I remember making a Target run while pregnant. I've always felt guilty frequenting big-box stores. So as I left, I swore that as soon as this baby was born, no more strip malls for us! Instead, we would frequent farmers' markets. I wanted the most pure lifestyle for my future perfect citizen, untouched by huge parking lots, jumbo bags of tortilla chips, and mass consumerism.

That was just the beginning. Only wooden toys, no plastic ones, I pledged to my husband. Pacifying toddlers with processed snacks at the grocery store (not that I'd ever shop there, of course)? Never! Television before age two? Please.

Well, I can probably count on one hand the number of times we've been to a farmers' market since Everett was born. We've as many plastic toys as the next family, and I have accepted that big-box stores have their place. (Where else can you kill a rainy afternoon with a fussy infant?) Let's just say that having a child was a lesson to my ego. It softened me, made me more tolerant.

Today, when I see desperate moms at Trader Joe's tearing open bags of Pirate's Booty for their toddlers, I simply smile in camaraderie—and ignore the dagger frowns of the expectant mothers in the aisle.

—EMMA SMITH
Writer

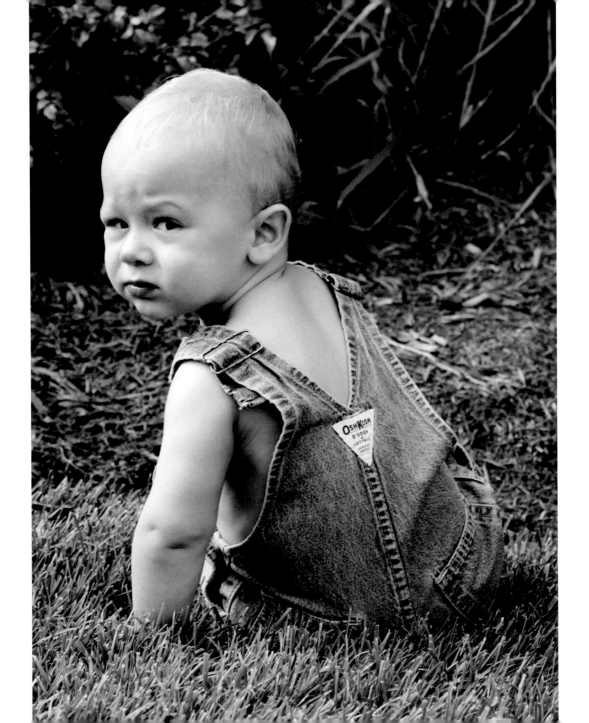

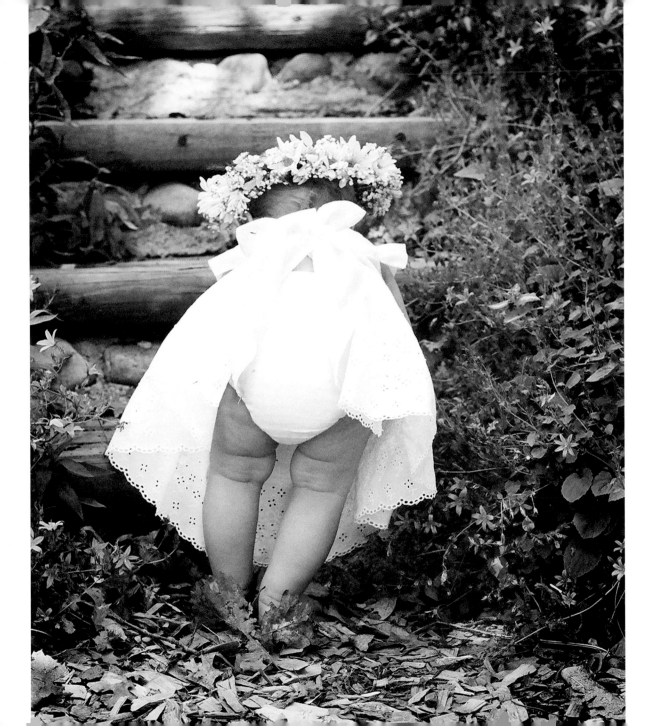

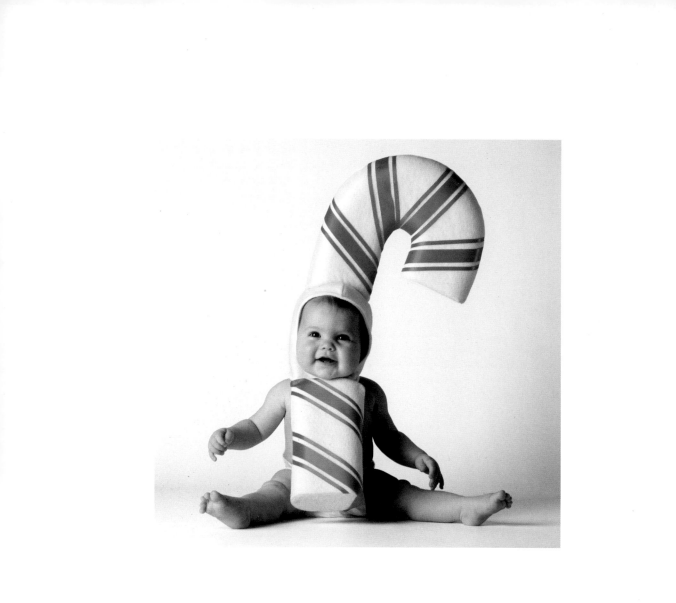

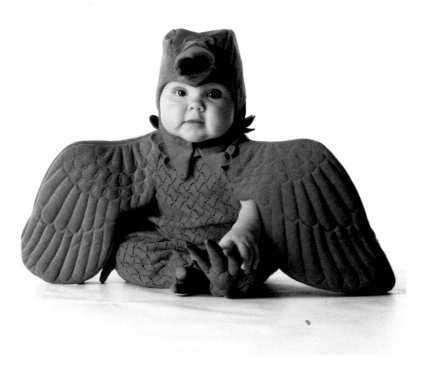

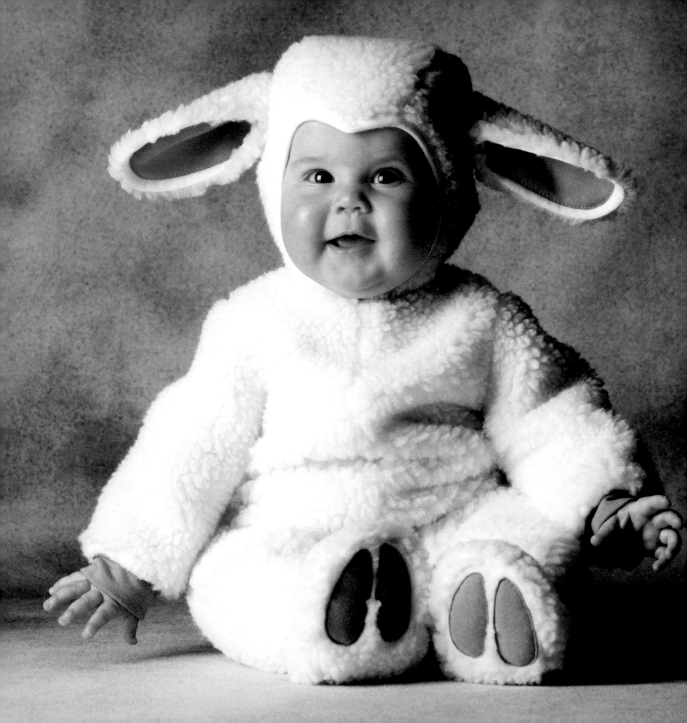

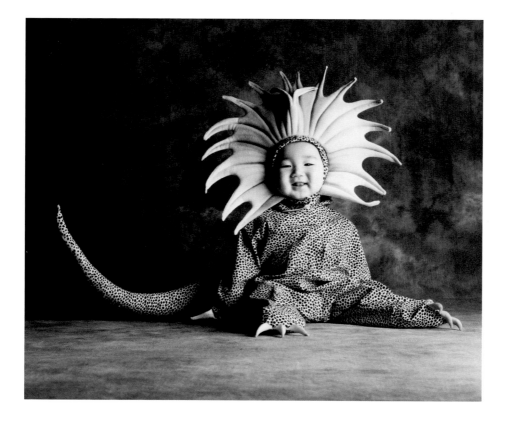

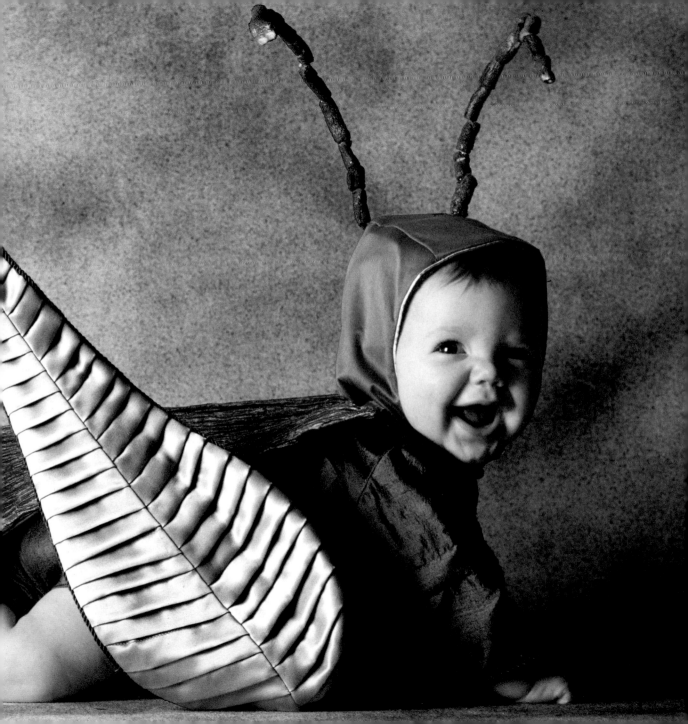

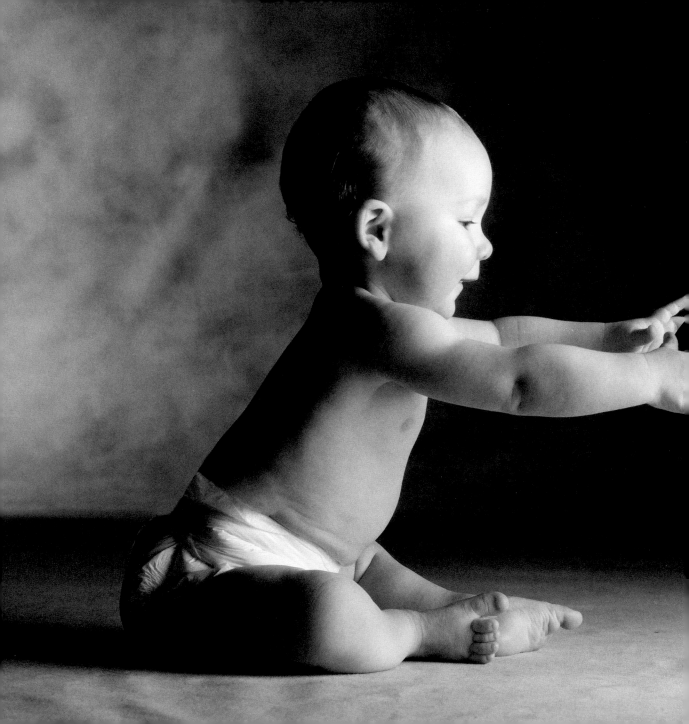

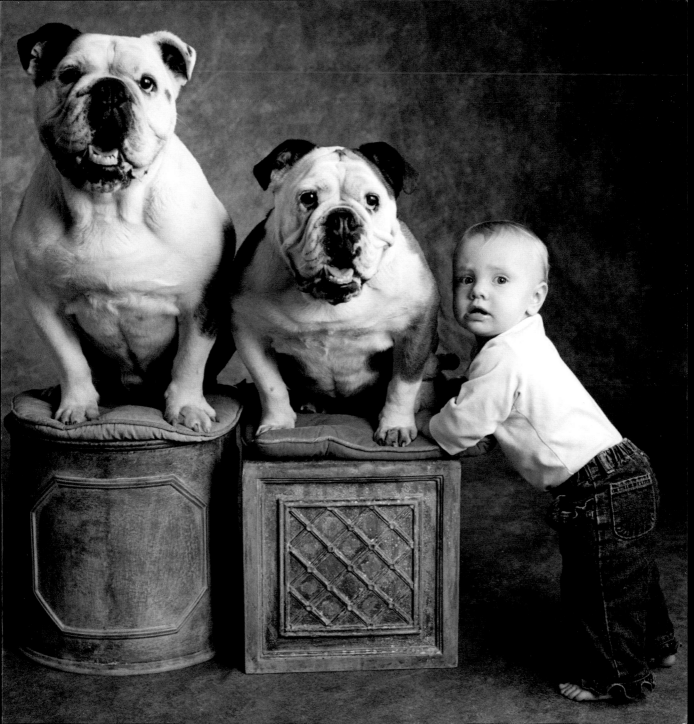

I kiss you and kiss you,

With arms round my own,

Ah, how shall I miss you,

When, dear, you have grown.

—WILLIAM BUTLER YEATS

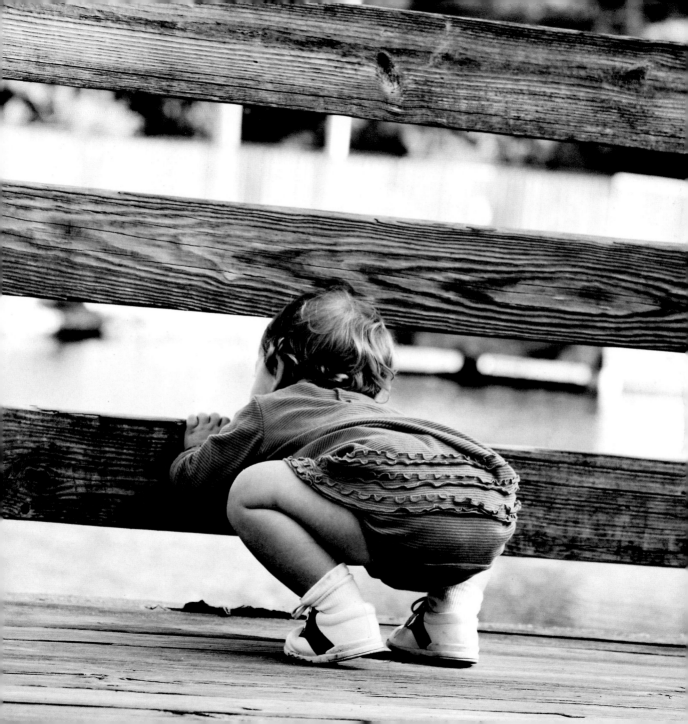

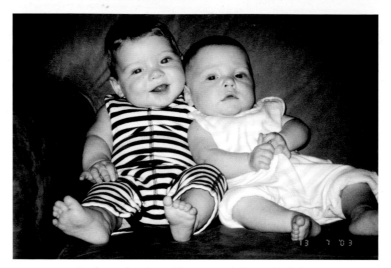

Dedicated to Anne Victoria and Owen Halliday.

PHOTOGRAPHY IDENTIFICATIONS:

Page 11: Babe Ruth holding infant actor Sunny McKeen, 1927

Page 126: Maurice Chevalier and Baby LeRoy in *A Bedtime Story*, 1933

Page 127: Actor Gregory Peck, 1917

Page 128: Broderick Crawford in *Butch Minds the Baby*, 1942

Page 131: W.C. Fields and Baby LeRoy in *The Old Fashioned Way*, 1934

Pages 132-133: Claudette Colbert and Gary Cooper in *His Woman*, 1931

Page 135: Princess Elizabeth with baby Prince Charles, 1948

Page 137: Elvis Presley with wife Priscilla and newborn daughter Lisa Marie, 1968

Page 140: Barbra Streisand with her son on the set of *Hello Dolly*, 1968

Page 143: Tallulah Bankhead in *Tarnished Lady*, 1930

Page 145: Mother Teresa with baby, 1985

Published in 2008 by Welcome Books
An imprint of Welcome Enterprises, Inc.
6 West 18th Street, New York, NY 10011
Tel: 212-989-3200; Fax: 212-989-3205
www.welcomebooks.com

PUBLISHER: Lena Tabori
PROJECT DIRECTOR: Alice Wong
ART DIRECTOR: J.C. Suarès
DESIGNER: Naomi Irie
PROJECT ASSISTANT: Kara Mason
PHOTO RESEARCHER: Lori Flemming
TEXT CONTRIBUTOR: Sara Baysinger

Library of congress Cataloging-in-Publication Data

Suarès, Jean-Claude.
 The big book of babies / by J.C. Suares. -- 1st ed.
 p. cm.
 ISBN-13: 978-1-59962-041-1
 ISBN-10: 1-59962-041-3
 1. Photography of infants. 2. Infants--Portraits.
3. Suarès,
Jean-Claude. I. Title.
 TR681.I6S83 2008
 779'.25--dc22

 2007043581

Printed in Singapore

First Edition
10 9 8 7 6 5 4 3 2 1